TARNISHED SILVER:
AFTER THE PHOTO BOOM

Essays and Lectures
1979-1989

For he that dares hazard a pressing to death (thats to say, To *be a man in print)* must make account that he shall stand (like the old Wethercock over Powles Steeple) to be beaten with all stormes.

— Thomas Dekker

All of writing is a huge lake. There are great rivers that feed the lake, like Tolstoy and Dostoevsky. And there are trickles like Jean Rhys. All that matters is feeding the lake. I don't matter. The lake matters. You must keep feeding the lake.

—Jean Rhys

TARNISHED SILVER: AFTER THE PHOTO BOOM

Essays and Lectures
1979-1989

by A. D. Coleman

A. D. Coleman

Boston 1996

Midmarch Arts Press
New York

Dedication

In memory of Sadakichi Hartmann (1867-1944)

and

for M. Richard Kirstel

Cover: Photographer unknown, *George Eastman*;
courtesy Eastman Kodak Company

Library of Congress Catalog Card Number 95-080903
ISBN 1-87765-20-2

Printed in the United States of America

Published in 1996 by
Midmarch Arts Press
300 Riverside Drive
New York, New York 10025

CONTENTS

Andres Serrano, *Untitled (Ejaculate in Trajectory)*, 1989, original in color; courtesy Stux Gallery, New York.

Acknowledgments

As ever, I am indebted to more people than I can thank, all of whom have contributed in one way or another to the making of this book. Appreciation for assistance above and beyond the call of duty goes to:

Tony Outhwaite for his patience, supportiveness, and organizational advice during the preliminary stages of this book's making;

Jonathan Silverman, briefly my agent and staunchest supporter, always my friend;

Richard Kirstel — photographer, teacher, colleague, long-time friend — for the quality of his disagreements;

Tom Drysdale, my chairman in the Department of Photography at the Tisch School of the Arts, New York University, who hired me to teach the criticism and history of photography during the phase of my work covered by this material, thus forcing me to synthesize my ideas at just the right time, and who created an educational environment supportive of my critical activities;

Jack, Jeff and Arnold Eigen of Corinne Offset, for cloning my work with such cheerfulness and professionalism during my pre-digital days;

and Neil Postman and Christine Nystrom of the Media Ecology program, SEHNAP, New York University, who assisted me in broadening my horizons.

I'm particularly indebted to the editors who sponsored my work during this period: Gerald Marzorati at *The SoHo News*, Kathleen Kenyon at the *Center Quarterly*, Don Owens at *Photoshow*, Barbaralee Diamondstein and Amy Newman at *ARTnews*, Robert Muffoletto at *Camera Lucida*, Cynthia Navaretta at *Women Artists News*, Stephen Perloff at *The Photo Review*, James Michael Trageser and Harlan Lewin at *A Critique of America*, Russell Joyner at *Et cetera: A Review of General Semantics*, and especially Willard Clark at *Camera 35* and Barry Tanenbaum at *Lens' On Campus*; each of the latter two made his publication a home for me, took much flak for doing so, and gave me free rein. During those years, too, Andreas Müller-Pohle began introducing my ideas to an overseas audience through the pages of *European Photography*; that opened doors into a number of other cultures. My deepest thanks to all these people.

Cynthia Navaretta's invitation to pull this book together for Midmarch Arts Press contained the tacit challenge to delve back into that phase of my work in order to reassess it and mine its mother lode. I found that provocation highly instructive. Embracing it has enabled me to make available in one volume a group of essays whose initial appearance was scattered across so many periodicals that no one reader was likely to have seen them all. This has given me a clearer sense of what I was about during that period — a rare gift in itself — and allows me to pass that along to the book's readers. Working with Cynthia has been a pleasure; her professionalism and supportiveness, from the outset of this project, have been invaluable.

Looking back through my output between 1979 and 1989 inevitably evoked many memories, reminding me that, among other experiences, I lost some good friends during those years: Ken Morais, John Cushman, Lee Witkin, Merle Steir, Sy Peck. They all died too soon; I miss them still. I like to think that something of them is in these pages.

—A. D. C.

FOREWORD

I suppose everyone involved in photography who lived through the 1980s has his or her own version of that problematic decade. This book, then, represents mine. It brings together in one place a substantial sampling of the shorter essays and lectures that I produced during the years 1979-1989, a time of remarkable change in the medium and its relation to our culture. The book's title derives from a passing comment of Richard Kirstel's: "The premise of photography is that silver tarnishes."

On one level, *Tarnished Silver* is intended as an extension of and companion piece to my first volume of selected essays, *Light Readings: A Photography Critic's Writings, 1968-1978*.[1] By design, the work I've chosen to preserve here continues and extends the critical project whose first phase is outlined in *Light Readings*. There are certainly similarities between the two. The contents of each span eleven years, and were produced for a variety of publications and readerships. Both books range widely and no doubt eccentrically over an ever-broadening field, speak in several different voices, and bring together essays with a number of diverse purposes. In these senses, *Tarnished Silver* complements *Light Readings*; taken together, the two provide, to my satisfaction, an effective survey of some central aspects of my work over the twenty-one years they encompass.

Yet I think it is important to point out that, with one exception, all the material collected here postdates the *Light Readings* period.[2] Also, unlike its predecessor and that work's immediate successor,[3] this book is not arranged chronologically; contains little that is journalistic and/or diaristic; includes only a few occasional pieces; and consists largely of polemics and ruminative essays. Its relationship to *Light Readings* notwithstanding, the present volume stands on its own.

Considered as a cross-section drawn from the second phase of my work as a critic, it feels much different to me. For one thing, my voice — or voices — appear to have changed. So has at least one major aspect of my self-defined job description: by 1979, when the years covered by this volume begin, I'd long since given up trying to survey the full range of activity in the field, and, with no general-audience forum regularly at my disposal, felt no urgency (even when I felt the urge) to voice an opinion on whatever was new and cutting-edge. That was a let-

down, in a way, but also liberating; with nothing breathing down my neck, I was free to follow my nose. This book is a retroactive map of where it led me.[4] On some issues, it may appear that I stepped out for a beer; and perhaps I did. But I also rethought my overall project, worked some key ideas through, and created a set of reasoned arguments that, as reference points, I was finding increasingly necessary.

Since the nature of my work has been shaped to a considerable extent by the circumstances under which I've labored professionally, some description of context seems called for. Let me begin by reminding my faithful readers and informing new ones that I am a working professional critic. This means, among other things, that I'm a writer for hire — or, as Sadakichi Hartmann once described himself, a "bread and butter writer." Writing is my livelihood — a good part of it, anyway; that makes me the commercial producer of a marketable commodity. This doesn't mean that my opinion is at the disposal of my customers; I've never "cut my politics to fit this year's fashion," in Lillian Hellman's phrase, and have chosen to remain a free lance in order to retain my autonomy as a voice. But it does mean that what I produce (and, perhaps more to the point, what I do not produce) is to some extent determined by the nature of the current market for critical writing about photography.

In the decade-plus covered by this volume I published most regularly in two periodicals: *Camera 35*, whose circulation was somewhere around 100,000 when it closed its doors in 1982; and, from shortly after *Camera 35*'s demise until *its* demise in the fall of 1986, *Lens' On Campus*, a non-newsstand bi-monthly that was distributed in bulk, free of charge, to 100,000 college-level photography teachers and students throughout the U.S. This at least put my work directly into the hands of what I consider to be one of my primary and essential constituencies. But my own search for other vehicles, through which my writing could be made available to the general public, continued during that stretch of time — and was rewarded at its end.

In the meantime, I adopted some practical strategies for extending my readership. One of these involved publishing different versions of the same core essay in diverse publications whose readerships did not significantly overlap. That has been the case with many of the essays included here.[5]

What did all of this mean, pragmatically speaking? More dealings with more editors over a given essay then ever before in my expe-

rience. The more careful shaping, and re-shaping, of pieces whose substance could sustain such attention. Recognition of the patent impossibility of building an extended line of reasoning within the pages of a journal that had commissioned only a single essay.[6] The consequent necessity of redefining my terms each time out, guessing at the level of sophistication of each new readership, receiving little feedback. The fragmentation of my energies and efforts. The frustration of seeing work reach only a small segment of its potential audience. The distress of discovering that it had actually disappeared without a trace. (Relevant here is the fact that so many of the publications in which these essays originally appeared are now defunct: *A Critique of America*, *Art Express*, *Camera 35*, *Camera Lucida*, *Lens' On Campus*, *Photoshow*, the *SoHo Weekly News*. I take some pride in having done my part to counterbalance this trend by serving from 1979-81 as founding editor of *VIEWS: A New England Journal of Photography*, which as of this writing is still alive and kicking.)

Two essays elsewhere in this book — "Damn the Neuroses! Full Speed Ahead! or, Thoughts on the Free-Lance Life" and "Choice of Audience/Choice of Voice" — speak to this set of issues; further elaboration here would be redundant. Suffice it to say that, as a working writer, I found it a period of struggle and consolidation. But, as has generally been the case, the choice of subject and approach remained largely up to me; what I chose to work on and found outlets for during that time, as reflected in this book and a forthcoming one,[7] was self-determined, rarely assigned.

Obstacles, in any case, exist as opportunities for growth. In my personal life, I spent that decade making a home and raising my son as a single father. Professionally, I immersed myself more fully in teaching, on both the undergraduate and graduate levels; developed the more scholarly aspect of my temperament, in writing and in formal study of mass media and communications theory;[8] explored what I wanted to explore, honed my skills, and bided my time. It felt like what jazz musicians call *woodshedding*; I thought a lot about Sonny Rollins on Brooklyn Bridge. In 1988, a door opened at the *New York Observer*, and — with my son grown and leaving home — I decided to step back through it into regular reviewing once again, bringing the ideas and capacities I'd been developing to bear on an ongoing discussion of photography in the '90s.

For the purpose of sketching my concerns during that period, I

have divided this book into five sections. The "Prelude," "Choice of Audience/Choice of Voice," synthesizes some of what I thought I'd learned by 1979 about the situation of the critic in our time. "Barometric Pressures" addresses the state of photography criticism and photography education, power shifts in the contemporary photography establishment, the influence of corporate and governmental sponsorship, the emerging international photography scene, and other noteworthy aspects of photographic activity. "Paradigm Shift" brings together three interlocking essays on the "snapshot aesthetic": discussions of two of its practitioners and one of its institutional champions.

The search for pan-stylistic linkages was already an undercurrent in my work by the late 1970s. Increasingly, I've felt the urge to trace connective relationships between images, theories, and ways of working, to seek evidence of pattern, the spoor of morphology. The ideal outlet for that yearning, in my opinion, is the well-illustrated critical survey in book form. Numerous such projects of mine have been formulated, but only one of them — *The Grotesque in Photography* [9] — has been fully realized. While some of the rooms in this "museum without walls" exist only in my head, others have been sketched out on paper. My essay on "The Directorial Mode" in *Light Readings* is one instance. Four more of these — on the autobiographical mode, the still life, the erotic, and hybrid forms — have been included here, three of them in the section of the book titled "Revisionism and Gap-Filling" and one in the section that follows. They represent my attempts to build larger, more coherent wholes out of the heaps of contemporary work. This section also contains brief meditations on such issues as the historiography of photography, and color photography and the criticism thereof.

Finally, the concluding section brings together four essays on issues of sex and censorship in photography, one of my areas of continuing concern. In retrospect, these seem sadly prophetic of the way things went toward the end of the '80s.

It's my hope that the book's structure will reward the reader who chooses to travel through it from beginning to end; at the same time, since each essay was created to stand as a self-contained statement, the pleasures of browsing should not be precluded. The editing of this volume has provided the opportunity to bring these component essays, separately created, together as a coherent unit for the first time. As a result, I begin to have some sense of what they represent in aggregate.

It is in this regard, I suspect, that my critics will be most useful to me in their interpretations of this book, as they were with its predecessor.

Given its omissions, and its idiosyncratic obsessions, I'd be surprised if this book captures the flavor of anyone else's 1980s except mine. I make no apologies for that. I found it a difficult decade, to say the least. Nonetheless, as is my wont, I kept busy, and tried to use my time well. I hope these distillations of those efforts reward your attention.

—A. D. C.
Staten Island, New York
December 1995

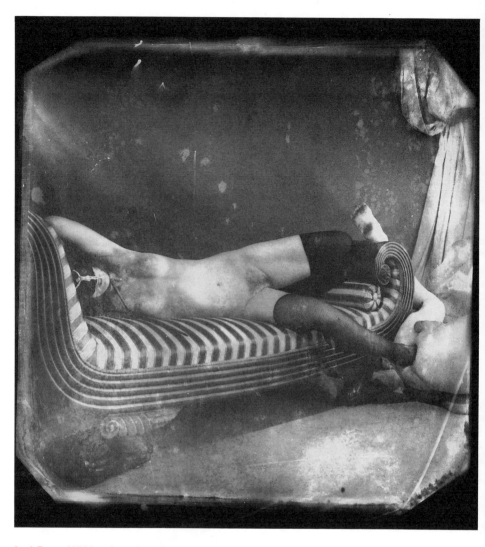

Joel-Peter Witkin, *Journies of the Mask:*
The History of Commercial Photography
in Juarez, New York City, 1984;
courtesy PaceWildensteinMacGill, New York.

INTRODUCTION

The responsibility of the writer is to excavate the experience of the people who produced him.

— James Baldwin, 1973

The ability to convert observation into meaning is both the art and the craft of writing; A. D. Coleman has shown this ability for over a quarter of a century. Yet he is also a working writer, one who knows the vagaries of the rewards and punishments life holds for those so audacious as to seek a living from a passion for putting words on paper. In the realm of creative transformation, where sight becomes vision, his words link simple communication to understanding and appreciation. When his motive is a brutal honesty, as it often is here, imagination and observation contend in a language of translucent emotion. The task of rendering this intellectual and emotional enterprise useful to the arts requires a creativity of its own.

Coleman's command of the critical essay as a form is evident from the following excerpt from a 1989 review of an exhibition by Doug and Mike Starn that included a discussion of a new edition of *The Diary of Anne Frank*. (This essay appears in his recent book *Critical Focus: Photography in the International Image Community*.) Here, it would appear, the literary seeds for the title of the present collection were first sown:

> Aside from the direct memories of a diminishing few, paper is what we have left of [the children who died in the Holocaust] — paper coated with tarnished silver, paper inscribed with fading ink. What power there is in these flat scraps, dormant like seeds until they find fertile soil in the imaginations of strangers. Those who would own the world at any cost had best remember that even a 15-year-old girl who's almost half a century dead can reach a paper finger up from an unmarked mass grave to point them out.

If the reader has somehow missed Coleman's interpretations and observations in the more than 75,000 words from the decade of the '80s gathered here, *Tarnished Silver* is a second opportunity to meet a most prolific writer mid-career. However, anyone interested in the nature and aesthetics of photography will surely have encountered his writing, which has been translated into 19 languages and published in 26 countries. In fact, since 1968 he has produced more than 1000 essays on photography, and Coleman's bibliographic archive at the Center for Creative Photography runs to more than 1800 items.

In the decade of the '70s, Coleman found photographers

exploring historical processes and wide-ranging aesthetic interests; he opened the door to their public recognition through his articles in the *Village Voice*, The *New York Times*, and a host of photography and art publications. Thus he was a prominent figure in the rebirth — after the fragmented '60s — of interest in photography as a distinct art form. In the '80s, as this volume reveals, Coleman examined ethics, as well as aesthetics, politics and the marketplace, education and publication, censorship and "pornography," with an especially intricate inquiry into criticism itself.

His foreword to the present selection of 27 essays could serve as a primer for the education of critics. A deeply personal, self-analytical portrait of the professional "voices" making up his writing over the years, it takes a critical look at the evolution of a free-lance writer who no longer felt the need to ride the razor blade of ever-changing, so-called "cutting-edge" issues in photography. Coleman describes himself as a professional critic and writer for hire, invoking the spirit of the Voltairean critic and essayist, Sadakichi Hartmann, who lived by his wits as a "bread and butter" writer.

But Coleman is far from the tragic figure of Hartmann, who wrote himself into isolation and relative obscurity through an uneven talent and lack of focus. Coleman more resembles the intellectual "image" of Hartmann, who could comment that "I was always somewhat of an aesthetic sybarite, looking primarily for manifestations of Plato's fine frenzy, Aristotle's purification of thought and sentiment, and Schopenhauer's moments of cognition."

Although he holds a master's degree in English literature and creative writing and is a doctoral candidate in communications theory, Coleman remains quick to assert his primary professional status as a working writer. Yet, while acknowledging only a sometime, part-time interest in teaching, he is nonetheless an ardent teacher in his every essay. His consistent, careful research into the roots of knowledge and history that precede an event, circumstance, or aesthetic issue, and his incorporation of that information into the work, consistently lead the reader through a learning process akin to the best in pedagogic methodology. Coleman's essay on "Identity Crisis: The State of Photography Education" is the best summary of the history of teaching artists and the development of universities, academies, and polytechnic institutes from the Middle Ages to the present that this writer has seen in print.

But it is his layering of fact and history with wit and clarity in an aggressive polemical style that earns Coleman his reputation as an opinionated writer. He punishes insincerity, or failed integrity, with exposure, albeit only when the failure is egregious in an ambitious way. Naïveté is rewarded with silence. His radar for distinguishing the real from a weak imitation thereof is that of Hemingway: "The most essential gift for a good writer is a

built-in, shock-proof, shit detector."

In the pages that follow, Coleman also demonstrates his iconoclastic approach to all topics, as in his analysis of public funding of the arts: "No method of showering *largesse* can avoid the corruption of power; no artist or critic scrambling for it can avoid compromise." And again, in his thoughts about the photographic book: "At a time when the classic silver print is dying out . . . it seems to me a very natural evolutionary step for photographers to move away from original-print form — or at least to free themselves from absolute dependence on it — and to reassert the primacy of the photograph as a multiple. Not just a high-priced, limited-edition, precious-object multiple, but an accessible one."

Such ardent independence from the accepted norms of the field has not always won Coleman an appreciative audience. But had the members of that audience been listening with an interest greater than self-interest, they would have found in his work a basis for objective debate. Whenever Coleman seems to be smashing one or another icon, it is expressly to challenge the graven images of injustice. The essays he has selected for inclusion here are all about justice and fairness, in one form or another. Such a stance is not a comfortable one for either writer or subject, but the process it encourages is essential to any art that would escape decadence or complacency.

If writing on photography, critical as well as general, historical as well as theoretical, is to have a lasting impact on medium and audience alike, the fear that personality and personal issues are somehow a betrayal of objectivity must be overcome. It is precisely from the open, unshielded view of A. D. Coleman, and those who write in a similar style (Oscar Wilde, George Bernard Shaw, Sadakichi Hartmann, Ezra Pound), that questions of aesthetics and ethics gain humanity. To argue ideas such as those addressed in *Tarnished Silver* in the abstract, from academic or philosophical isolation, would be to relegate them to history without having made them human — rendering theory, as it were, the only reality. We can be grateful to find in these pages a personal dialogue with photography itself, Coleman's own version of what W.H. Auden meant when he called the best of criticism: "a casual conversation." His perspective, and the threads of content he has revealed, will enable the medium's future historians to weave a finer tapestry of meaning.

<div align="right">

James L. Enyeart
Anne and John Marion Professor of Photographic Arts
The College of Santa Fe
December 1995

</div>

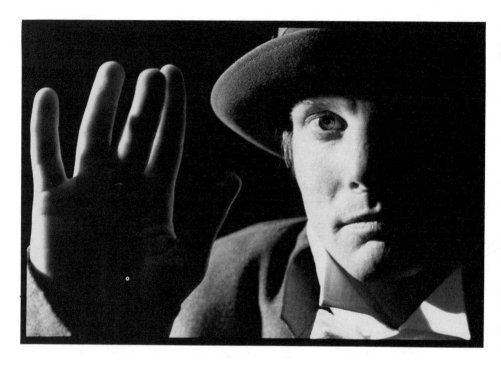

f-stop Fitzgerald, *Bill Irwin, "Regard of Flight," Victorian Theater, San Francisco, CA,*
ca. 1983. © f-stop Fitzgerald 1983; courtesy of the photographer.

I
Prelude

CHOICE OF AUDIENCE/CHOICE OF VOICE

Recently, in the Northwest, I found myself in conversation with a professor of literature who is much involved with photography and devotes a considerable amount of his time and energy to writing photography criticism. Let's call him L.

L describes himself as an "eight-draft writer." By way of contrast, I am generally a two-draft writer and (though hardly ever) an occasional four-draft writer. These differences reveal much about our intellectual histories, perhaps even about our basic personalities — they may, indeed, be traceable back to our childhoods. Be that as it may, we are both photography critics — by which I mean that we work actively at evolving and articulating a theoretical overview of the medium and applying it to the work of individual photographers, and vice versa (that is, contemplating the work of individual photographers and identifying the generic themes, ideas, issues and styles therein). We both do this in public and in print, occasionally even within the pages of the same publications.

Our gestation periods may in fact not be too dissimilar, but our production schedules have little in common. L's output does not exceed four essays a year; mine has recently stabilized at about two dozen, and for an extended period in the past was double and even triple that volume.

There is no implicit value judgement here, in either direction. Quantitatively, I may be more frequently visible than L, and — by virtue of my choice of voice and forums — may maintain a higher public profile. At the same time, a greater percentage of my writing may well be considered ephemeral — useful once around, but disposable thereafter. This doesn't bother me at all, though I suspect it would drive L crazy — and there's that difference in personality again. No doubt that's what makes me a professional writer and L a professional scholar.

Having introduced these characters — who, I should add, seem to enjoy and respect each other enormously — let me get on with the story. L was speaking about the work of a particular photographer — P, for short — whose work L admires, is provoked by, and has written about at length for one of the larger of the medium's "little" magazines. P had recently mounted a major exhibit in the Northwest, and L was

bemoaning the fact that none of the local critics (*i.e.*, those who write about the arts in that area's newspapers) had even attempted to respond in print to P's work.

The divergences between L's approach to critical praxis and my own may be indicated by the fact that my instinctive sympathies lay as much with the local critics as with P. P's work (which provokes me also, though I have yet to write about it) is hermeneutically-oriented and often self-referential; it involves a dense serial layering of images concerned with a variety of languages and communications systems. In their physical appearance alone they look like little else produced in the medium, and the exegetic unravelling of even a single work is a tortuous process of decoding, translation, inference, and wild speculation. Even L was forced to admit that though he believes there may ultimately be a specific message in each of P's works, he — L — had yet to pinpoint even a single example to his own satisfaction.

So I said to L, "Imagine you're the art critic for the *Northwest Sunday Times*. It's your work (and it's work you enjoy) to introduce readers to all the different kinds of artwork — including photography — being exhibited in your region. You probably have no specific background or training in photography history or criticism, but you've read Beaumont Newhall and Susan Sontag.

"Periodically, you're obligated to write about photographs. Fortunately, you can usually find occasions to do so where the work in question is emotionally and conceptually accessible to both you and your readers. There was a big Ansel Adams show last year, for example, and the Paul Strand retrospective two years ago, and that Imogen Cunningham tribute, and even a Robert Frank exhibit somewhere in there. All that stuff looked like photography; some of it even looked like art.

"But now here comes a big batch of P's stuff. It looks a little bit like some kinds of contemporary art, and a little like film, though it's certainly a set of photographs. But it seems to be about mathematics, calligraphy, television and boxing (boxing?!), among other things. It's accompanied by all kinds of credentials, including a long, chewy essay written by a guy named L, complete with footnotes to books you've never even heard of and terms like *signifier* and *closure* and *caesura* sprinkled in like almonds on the string beans. You've never heard of the photographer before, never seen the work before, and if you're going to deal with it critically you have to come to terms with it in less than three

weeks (because the show's only up for a month) and in no more than 1200 words. Would you be likely to leap to that challenge, or would you be more prone to put your attention elsewhere in the hope that P's work would just go away before anybody noticed the omission?"

L winced, and then we all began to chortle, and after another cup of coffee we left L to his ruminations and headed south to Portland.

•

What I'm getting at in my roundabout fashion is that the relationship between any given body of work, critic, critical vehicle, and audience can be thought of as an equation.

In theoretical mathematics, equations do not always balance; since theory is a process of questioning, unresolved and even unresolvable equations are means for provoking the mind into new understandings. But in practical or applied math, it's the function of equations to balance. And in what I propose we think of as practical or applied criticism, the same holds true.

It's been my observation over the years that very few photography critics have ever thought through and balanced their own personal/professional equations. The specific consequences of this failure can be disastrous. I know of people who've lost forums because they failed to match the level of their discourse to the publication and its audience. I've also watched critics who disdain their audience snobbishly talk down to and alienate their readers for years. On a more general level, I continually observe what I think of as the "ships that pass in the night" syndrome: valid, useful and even excellent essays whose impact is nullified or whose energy is blunted by presentation in inappropriate forums to the wrong audiences. (Let me note here, too briefly, that some of the burden of responsibility for this surely devolves upon editors.)

In the abstract, of course, there may be no such thing as an absolutely inappropriate forum; one never knows when fortuitous coincidence will marry the right writer and the right reader on the altar of a printed page. Sometimes, as I'll indicate shortly, deliberate inappropriateness can even be used as a tactic. And, in the last analysis, any attempt at controlled communication is a gamble of sorts. But one can play the percentages in different ways. What I will try to offer here are some specific strategies that may help to swing the odds in the critic's favor.

•

The four key elements of the critical equation, as I suggested earlier, are (1) the work, (2) the critic, (3) the vehicle or forum, and (4) the audience. Each of these represents a wide range of options; furthermore, each individual case is in a state of continual change.

(a) *The Work.* The work does not exist to serve the critic; nor does the critic exist simply to serve — *i.e.*, to promote, approve, and market — the work. The critical equation I've proposed functions to serve all its components. But the work comes first.

And the critic's first task in relation to it is to select those aspects or segments of the work on which he or she will concentrate. Some may be more eclectic than others in the span of work they discuss over a period of time. Some may range more widely through the medium's entire history. Some may concentrate on only a few facets of image-making. The permutations and combinations may not be infinite, but they are not in short supply.

Locating one's own areas of interest and concern, pinpointing these territories within the larger *corpus* of photography in general, is the critic's beginning task. Some of us know from the outset what we want to write about; others, like the sculptor from India queried about his stone rendition of an elephant, have to "chip away everything that's not an elephant" to locate our true subject — that is, to write something about almost everything in order to watch our own predilections emerge.

(b) *The Critic.* Once the critic has named the task, he or she must proceed to become the right tool for the job. Let us assume a basic articulacy and ability to write functional prose. These are prerequisite to any resolution of the critic's first dilemma, *getting heard*, which will necessitate the evolution of some combination of lung power (or its equivalent in print), eloquence, style, and substance. Beyond that, the critic must develop a coherent set of understandings and working definitions, along with an adequate vocabulary. Some people come to their critical work full-fledged in this regard; others, as I've suggested, may work it out piecemeal.

Self-education or even formal training in specific areas of individual critical emphasis may be called for, especially if the critic wishes to be thought of as authoritative in discussing the relationship of photography to another discipline. But the eclectic generalist also has a significant role to play in any critical dialogue.

Whether it takes place before one's entry into the field of criticism or during one's public practice of the craft, this shaping of oneself

into an instrument appropriate to one's purpose is a central act of self-definition. It is that shape to which I am applying the term "voice," and it will have a pervasive influence on the critic's individual role within the larger critical dialogue.

(c) *The Vehicle or Forum.* Publications (and such other occasional forums for serious criticism as TV shows and radio programs) are rarely created or controlled by individual critics. Infrequently, a publication's staff — sometimes including its regular critics — formulate editorial policy. More commonly, the nature of a given forum is determined through a system of checks and balances involving the editor-in-chief, the publisher, the readership, and even the advertisers (if any).

In that sense, any forum tends to be a *fait accompli* insofar as the critic is concerned. The critic rarely has any control over such crucial matters as frequency of publication, size and nature of readership, length of articles, editorial:advertising ratio, orientation of advertising, design and layout, pricing and distribution. Yet each of these factors will have a strong effect on the way the critic's writing is perceived, and may in fact serve to shape it in the making.

(d) *The Readership.* Of all three elements outside of him/herself, the readership or audience is the one over which the critic has least control, and which in fact is most difficult to define.

It is only after the critic has established a public presence and identity over a period of years that he or she can assume the existence of a personal constituency — *i.e.*, a group of readers specifically interested in what that particular critic has to say and willing to seek out his or her writing in whatever vehicle(s) the critic chooses. Prior to achieving such a relationship with the audience, the critic must assume that the reader's allegiance is to the periodical (or other forum), to the particular work being written about, or to the medium within which the work is created, and not necessarily to the critic's own viewpoint.

•

With those as the essential elements, we can now approach the process of determining the givens, the variables, and the unknowns in any particular critical equation.

It is safe to assume that at any point in time in any critical equation at least one element will be in a state of change. Readerships are not constant: they shrink and grow, their interests shift, and their levels of knowledgeability fluctuate. Publications change — sometimes with

their readership, sometimes with their editorship, sometimes for economic reasons, and continuously in terms of their longevity and stature in the field. The thrust of contemporary work in any medium changes regularly, and shifts in the hermeneutics of performance require adaptations in the exegetics. Finally, critics change.

Thus any critic at the outset of his or her critical activity would be well advised to ask a specific set of questions of him/herself, and to re-ask those questions periodically, especially when changing vehicles in mid-stream, as critics are so often forced to do.

The crucial question is, *To whom is my work addressed?* To put it another way, who do you think you're talking to? By this I mean, quite specifically, what audience do you as a critic desire and direct your work towards conceptually?

There are many alternatives, after all. One can write to the artists, to other critics, to the hard-core art audience, to the general public, and to teachers and students. One can address those within a particular geographic territory, correspond with those outside that region, or ignore physical location altogether. One can parlay such factors in many ways.

The only option one does not have is pretending that the question is irrelevant. Brecht once cautioned writers who allowed themselves to be "relieved of concern for the destination of what [they have] written" with these words:

> I . . . want to emphasize that "writing for someone" has been transformed into merely "writing." But the truth cannot merely be written; it must be written *for someone*, someone who can do something with it.[1] (Emphasis his.)

The answer to that question, then, taken in tandem with the answer to the question of what the critic wishes to write about, forms in effect a statement of intent. This gives the critic a stable jumping-off point. The answers need not be forever fixed and immutable, but lack of clarity in these decisions leads to internal conflict and will increase the difficulty of writing effective criticism on a long-term basis.

Conversely, clarity in answering these questions makes it possible to answer other questions more easily. The next one would be, *What work is addressed to the same audience the critic has chosen, and what work beyond that is pertinent also?* Going back to the story with which I began, we could say that the work of the photographer I called

P was not addressed to the audience of the *Northwest Sunday Times's* critics. P has created a body of work whose appreciation requires an extensive knowledge of photography's history, visual communications and linguistic theory, and other reference points not commonly held. Consciously or not, P has chosen to direct his work to a very small segment of the audience. Not coincidentally, it's a segment to which L's criticism is also directed, and a segment reached fairly effectively by the primary vehicle for L's work. A balanced equation, in short. But we might also agree that it would be difficult and perhaps futile for the *NST*'s critics to try to make P's work accessible to a readership that lacks the necessary reference points, and that it would be unrealistic for P (or L) to expect that either the *NST* critics or their readership would be drawn to this work.

Does this mean that P shouldn't show his work, or that he should not show it in the Northwest, or that the Northwest audience will never understand it, or that no critic could conceivably make that work accessible to that audience? No.[2] But that audience's understanding of photography will have to be nurtured by one or more local critics committed to educating an audience for photography by starting at the beginning and establishing the appropriate and necessary reference points.

The best way to do so will be to use as examples work with which the audience can establish some kind of harmonious and rewarding relationship on its own, without the critic's exegesis being the audience's only route of access to it. Only after such a critical groundwork has been patiently laid could we expect P's work (or L's explication of it) to be met with anything more than blank stares. Such criticism as this groundwork mandates may well seem simplistic to the already sophisticated; most critics scorn it — and, implicitly, discount the audience that needs it in order to progress. Yet such criticism surely serves a useful function. Those who choose to teach elementary school are teachers nonetheless.

We now come to the matter of the forum, and the issue of the real versus the ideal. Aside from every writer's perennial desire for complete freedom of expression, sufficient space to build any line of reasoning, adequate compensation for one's labors, and compatibility with the editorial staff, what kind of vehicle is appropriate for one's particular brand of criticism?

Is it essential that your writing be accompanied by illustrations — and, if so, what reproduction quality do you consider necessary? To

what extent will frequency of publication affect your personal working rhythms? Is the frequency of publication of a particular periodical suitable to your critical style and emphases, or counterproductive? (For example, spontaneous response to first encounters with bodies of work is better fitted to weekly-newspaper format than is scholarly meditation.) Does the forum in question have an emphasis of its own — for example, darkroom craft, visual anthropology, photo education? Does that emphasis connect with your own areas of concern? Do you have an emphasis, and is it relevant to the magazine's purpose? Do you want to appear in a publication whose contributors share a common set of ideas and attitudes, or do you prefer an active divergence of opinion? Do you prefer to appear in a periodical that specializes in your medium, or in the arts, or would you rather be writing in a more generalized context?

Linked directly to this are the questions of who the actual readership of the periodical is (as distinct from the critic's ideal constituency); what the readership's relationship is to the general thrust of the publication; what the critic can reasonably expect of that readership, and vice versa.

These last questions, unfortunately, are among the most difficult to answer, because the necessary information is hard to obtain. Few publications can provide accurate readership profiles to prospective contributors, although most editors know — or think they know — who their readers are. Thus the writer is generally forced to combine intuition, hearsay, and speculation with extrapolation from the usually small amount of direct feedback from and personal encounters with readers that an author receives. Consequently, it can take a long time — years, in fact — of writing for a particular publication before a writer develops a clear sense of who is actually reading what he or she is saying, and how that statement is being understood by that constituency.

I think it's implicit in what I've said so far that, from my standpoint, the ideal situation for a critic is not only to be operating on the basis of a fundamentally balanced equation but, additionally, to have a long-term commitment to (and from!) at least one appropriate vehicle. Long-term involvement with an inappropriate vehicle — one in which the critic's emphases and ideas are pronouncedly unrelated to the actual readership's interests — will achieve little but the generation of frustration and stress on both sides.

Frequently there is value in making a one-shot appearance in such a forum; it's a variety of guerrilla tactic that keeps all concerned on

their toes. Similarly, there's nothing innately wrong in making one-shot appearances in a diversity of sympathetic publications. However, the consequent necessity of establishing one's reference points for a new audience in every essay is time-consuming, tedious, and ultimately counterproductive, since this is the most difficult way of all to construct a coherent, consistent, and useful line of reasoning and contribute effectively to a critical dialogue. "Same time, next week" (or month, or quarter) is unquestionably the most desirable assumption for a critic and his or her audience to be able to make concerning their relationship.

•

If some of what I've outlined here seems applicable to artists and their decisions about the relation of their work to its audience, that isn't coincidental. I consider it relevant also to editorial staffs of publications, and to members of the audience who may very legitimately ask if the criticism they're getting is pertinent to their concerns and reference points.

For the critic, the equation I've suggested is a way of evaluating publication opportunities and of identifying the path of least resistance and optimum flow — which, I should add, is not necessarily the route one should always follow. For artist and audience, it may be a means for understanding the set of relationships that pertain between the work, the critic, the forum, and the audience, and of evaluating the performance of critics operating within particular configurations thereof.

(1980)

II
Barometric Pressures

CONTEXT AND CONTROL

Once upon a time (December of 1979, to be precise), I turned on my TV and there on the late news was Stephen Shames.

I'd just been in the kitchen during a commercial, brewing up some tea a friend from California had sent me and preparing to settle in for an old movie. I'd clicked the set on and left the room; when I walked back in, there was Steve, big as life. It was a bit of a shock. Disorienting, too: I knew I knew the face on the screen, and the voice was familiar, but it was so unexpected that at first I didn't recognize him.

I'd known Steve for a couple of years, and I'd known a couple of Steve's pictures even longer. Steve was in New York at that point, working for *Parade* magazine (a Sunday newspaper supplement). But he had been on the West Coast a decade earlier, making photographs that were distributed principally through a pioneering but now-defunct alternative/movement agency, Liberation News Service.

LNS, as its acronym read, disseminated many important stories and images of American life in the 1960s and 1970s. An anthology of some of those photographs — *Shots: Photographs from the Underground Press*, edited by David Fenton and LNS — was published by Douglas Books/World Publishing Co. in 1971, and it's worth looking up. Half a dozen of Steve's pictures were included, among them the book's penultimate image (a young protestor in gas mask, running out of a cloud of tear gas trailing from the canister in his hand, heading toward the viewer like some avenging angel) and its cover image.

That photograph, reproduced here, was made in San Francisco in March of 1970. It shows an American student, arrested outside the Fairmont Hotel by San Francisco police during an anti-Vietnam War demonstration. The occasion was an appearance by David Rockefeller at the International Industrialists' Conference at the Fairmont.

Like most of Steve's work from that period, it struck me as a very effective, unequivocal, straightforward image. It left me with no questions as to where the photographer's sympathies lay. Yet all the protagonists were permitted their human identities along with their *personae*. And, at the same time, the image's point was clearly made, its meaning in the political context of that era unmistakable.

Anyhow, I came back in from the kitchen to catch a glimpse of

this image on the screen, with Tom Jarriel (of ABC's "Weekend Report") rounding off his introduction in words that didn't quite register; then there was Steve, full screen. And he said, "I feel that it's, you know, if you go back to the 1930s and what happened in Nazi Germany, I see what's a similar thing. I feel it's a big lie. When we took these pictures we were against certain policies of this country but we weren't against the country and the American people and I feel that the country actually saw our point and America has got out of the war in Vietnam and I'm very upset that the Iranian government and the Iranian students are using my picture. I'm upset as a journalist, I'm upset as an American."

Then Jarriel wrapped it up: "Photographer Stephen Shames, the Vietnam era protestor of the early 1970s who says he would like to be on the first American military plane to land in Iran if military action ever became necessary."

I had no idea what to make of this, of course. What had made Steve volunteer for military duty on the front lines in Iran? What had the Iranians done to his picture?

It took a while to piece it all together, but I finally learned that this image of Steve's — along with another cop-student clash image by Nacio Jan Brown, from the same city and era (and from the same book) — had been co-opted and redefined by propagandists in Iran. These images — reproduced poster-size and distributed in quantity on the streets of Teheran, held aloft and displayed indignantly at demonstrations outside the U.S. Embassy — no longer meant what they did originally. Now — according to those responsible for their appearance in the thick of the Iranian crisis — they had become evidence of the American police's brutal mistreatment of Iranian students presently living in America, in vindictive reprisal for the taking of American hostages in Iran.

That's quite a transformation. Here we had photographic imagery made in early 1970, explicitly summarizing not only a particular incident but a prolonged ideological struggle. Yet it was obviously susceptible not only to misinterpretation but to deliberate and complete reinterpretation over which the photographer had no control whatsoever.

Recontextualization was the key. The time frame was easily altered, because the picture contains no information that would be rendered glaringly anachronistic by a decade's leap. And since it also contains no visual indication of the event (the I.I.C. conference) that trig-

gered this incident, it was simple to redefine that unportrayed context by captioning.

Simple indeed. Frighteningly simple, in fact. How vulnerable to subversion the photographic image is — and how unguarded that leaves us in our still-childlike faith in it veracity. . . .

One could use this to chastise the Ayatollah ("Even a nation grounded in the principles of Islam can deliberately manufacture deceitful propaganda and toy with truth," and so on). Or to point up a relative visual *naïveté* on the part of the Iranians (though I suspect Americans too would have bought the reinterpretation, if no one had seen the photograph before and the protagonists in the image were never identified).

But I think there's a more important understanding to be drawn from it. We're less than four years away from George Orwell's target date for entrenched totalitarianism. All the sophisticated visual technology that he projected as necessary underpinning for fascist technocracy is already in existence. The strategies involved in using that communications technology to fabricate and alter history are already in operation. The profound amorality necessary to tamper thus with reality is obviously universal.

So we can undoubtedly look forward to a decade of rapidly accelerating manipulation of visual communications — more, better, and faster propaganda. Five-second TV commercials. Holographic halftones. Magazines that talk. Pocket cameras capable of encoding two hundred and fifty images on a silicon chip. Can it be that we are still not teaching photography to all children in grade school?

In this constantly shifting environment, the photographers to watch will be those who find ways to gain and retain control over the structure, meaning, and presentation of their imagery. Regardless of the particular mode in which one chooses to work, there will be no avoiding the possibility of having the thrust of one's work bent to the purposes of someone else, whether it's a politician, a curator, or a corporate PR executive. The struggle to maintain the integrity of one's own statement has been a constant one for photographers of all persuasions — a central issue, for example, in the life's work of two such different image-makers as Alfred Stieglitz and W. Eugene Smith. If anything, that struggle is now intensified.

"How fragile the truth is," Shames said to me in a subsequent interview. "The misuse brought home to me how important it is for

[photojournalists] to watch the context in which our images are used." That's the voice of experience, the words of a man who had his image misused twice.

Yes, twice. Once by the Iranians, as already discussed.[1] And once by Jarriel and ABC News. Because when Steve was originally interviewed by Jarriel, he'd expressed a desire to be in Iran, *photographing the revolution.* But he never got to say that on camera. Instead, Jarriel introduced Shames by asking, "How does the one-time college protestor feel about his photograph being used against the U.S.?" And then, after Steve made the short statement quoted at the beginning of this article, Jarriel wrapped it up: "Photographer Stephen Shames, the Vietnam era protestor of the early 1970s who says he would like to be on the first American military plane to land in Iran if military action ever became necessary."

And there you have it — another image wrenched askew to suit someone's purpose. You'd just seen Steve on the screen — personable, obviously not the violent type. But Jarriel had him virtually volunteering for combat duty with the shock troops. And him a peacenik, too! How about that! The Iranian crisis is enough to make even a pacifist take up arms!

A long, long time ago, a friend and I — late one night, and in our cups — concluded that although we both strongly opposed capital punishment we also felt that degradation of the language was a hanging offense. Perhaps Islamic justice would be more appropriate in this instance — chopping off the tongue, say. . . . But that's no real solution. Is there one? My advice is to keep a close watch on your retinal synapses and to not believe everything you see. Brace your eyes: the 1980s are here.

(1980)

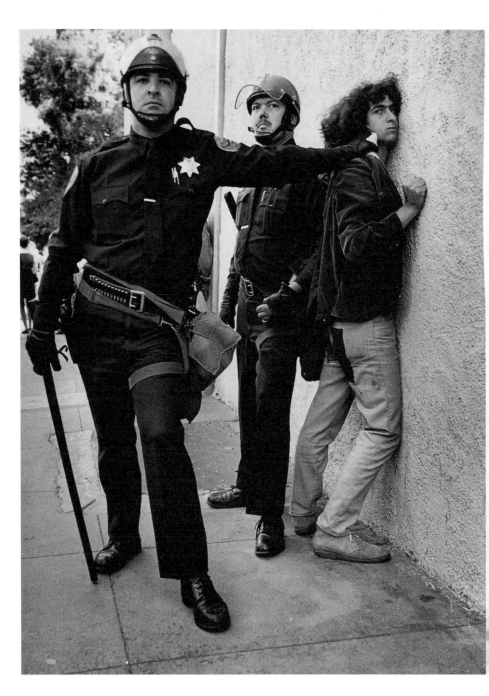

Stephen Shames, *Up Against the Wall*, San Francisco, 1970;
Matrix International.

THE FOX TALBOTS WERE IFFY

I'm not gruntled. It's been one of those months when the world puts its handbasket into overdrive and the microcosm of photography seems to embody all the entropic foolishness of what surrounds it.

Early in November I wangled my way into the weekend-long AIPAD convention at New York's Roosevelt Hotel for an afternoon. AIPAD stands for Association of International Photography Art Dealers, an organization of gallery owners and private dealers. The convention — officially named the Fine Art Photography Exposition — occupied the Roosevelt's Grand Ballroom, where only a month before I'd taken part in the American Writers Congress, a vital, catalytic and certainly historic event. Then the hall had been filled with writers of all stripes arguing about and voting on such issues as writers' rights, unionization, censorship, conglomerate publishing and American foreign policy. Now it was stuffed with gallery representatives, private dealers and collectors, all trying to sell high-priced photographs to each other.

So far as I could determine, few of them were successful. Les Krims, representing himself, pulled off another coup by selling several copies of his extraordinary elephant-sized new portfolio, *Idiosyncratic Pictures*, but for virtually everyone else there was nothing shaking, saleswise. The collectors, on the whole, were looking but not buying; the merchants were wandering about in a state of shock, whispering to each other about the market "going soft," a phrase that makes the cultural connection between money and male sexuality explicit.

What was most revealing about this state of affairs was that the work on display, for the most part, was safe, eminently decorative, certified and even venerable. Landscapes and still lifes, classical nudes and portraits; Adams and Weston and Curtis and O'Sullivan and a flock of well-established current academics. If anything should have been selling, it's this stuff — this is what's been most insistently hyped in the past five years.

There's a monthly newsletter called *The Photograph Collector*, which bills itself as "the sole publication devoted to collecting photography as an art and as an investment." *TPC*, as the newsletter abbreviates itself, has developed a "Comparative Auction Index," with which it "tracks the photography market by comparing each season of auctions

to prior seasons using an index of 25 categories of prints" — these being "blue-chip" photographers or specific images whose significance is considered to be established beyond question. Safe investments, in short.

The *TPC* Index is also correlated with the Dow Jones Industrial Average. An accompanying *TPC* subscription form boasts, "from 1975 to the spring of 1981 *The TPC Comparative Auction Index* rose from 815 to 1680 for a gain of 865 points. During the same period the Dow rose by only 187 points to 1002. Collectors and investors in photography did 400% better!" Very reassuring, no doubt, to those with stockpiles of "vintage" photographs for which there are no buyers, and to those who've paid record prices for work over the past few years, only to see the "photography boom" peak and subside.

At one point I found myself standing on the ballroom's balcony, waiting to be interviewed by Joel Levinson for a videotape documentary of the event. I leaned over the railing, chatting with the young female artist from Brooklyn beside me, and looked out over the room. I must have been gazing down on some three million dollars' worth of Art Photographs (figuring, conservatively, that each of the fifty-odd dealers had brought material that would be insured for an average of $60,000).

I remembered how the photography scene as I've known it started out — in little, now long-defunct storefront galleries like Exposure and the Underground on the lower East Side, showing work by people who couldn't have been in it for the money because there wasn't any money in it. Was it just my nostalgic romanticism, or did those photographers work with a kind of passionate commitment that's the polar opposite of today's business-like operators, who talk grandiosely about "passion" while efficiently cranking out "product" that has all the earmarks of Art Photography but no substance whatsoever?

For the life of me, I couldn't figure out how I — make that *we* — had gotten to this point. Is this where we were heading all along, or did we reach some crucial crossroads and change paths, knowingly or not? Much of the work in that room was historically important, unquestionably; but little of it, "vintage" or new, spoke to the issues or concerns of our own time in a compelling voice.

Had a fire broken out on the spot, I found myself thinking, I could cheerfully have watched most of it go up in smoke. There were only two things in the room, out of all I'd seen that day, about which I felt strongly enough that I'd have matched their makers' risk-taking

with an attempt to save them. One was the Krims portfolio, which didn't need me because its maker was there to see to its security. The other was the work of Joel-Peter Witkin, an obviously deranged, obsessed and brilliant visionary whose ghastly hallucinations have a Bosch-like inexorability and power. Only those two seemed to me to be tending the fires; everyone else was too busy minding the store.

 Later in the month, on November 20th, I showed up at the Friends of Photography's second annual "Peer Awards in Creative Photography" ceremony to watch the goings-on. I'd attended the previous year's festivities, and had fond memories of the free *hors d'oeuvres*.

 For the second year in a row, the event was held at a private club so exclusive that the press is requested not to mention its name. The place is one of those major watering holes on the old-boy network, brass-doorknobbed and wood-panelled and reeking of old-school-tie.

 The Friends give two awards at these ceremonies: one for "Distinguished Career in Photography," the other for "Photographer of the Year" (respectively nicknamed "The Gold Watch" and "The Hotshot" by unsavory elements in the press corps). Each includes a framed certificate and a $1000 check. Last year's awards, the organization's first, went to Harry Callahan and Lee Friedlander. This year, Aaron Siskind got the Gold Watch and Joel Meyerowitz the Hotshot.

 Is there some pattern to this? Perhaps. Callahan and Siskind could be thought of as the candidates of the Center for Creative Photography in Tucson, which already owns their archives; Friedlander and Meyerowitz, by the same token, can be seen as representing the Museum of Modern Art, both being members of the Szarkowski clique. Ansel Adams, chairman of the Friends, can be seen as mediating between the two — Tucson has his archives, and he bought his major retrospective at MoMA ("Yosemite and the Range of Light") by endowing a chair there.[1] (Only two days earlier, MoMA had hosted a ceremony at which the King and Queen of Sweden had presented Mr. Natural with the 1981 Erna and Victor Hasselblad Gold Medal and the Hasselblad Award of $20,000. The poor got babies.)

 However you figure the connections, it's a cinch the Friends are playing it safe. I'm an admirer of some of the organization's activities — I'll be writing about its remarkable publications program in the near future — but these awards can hardly be described as going to under-recognized or financially needful artists. So far, they've all been male,

white, well-established, thoroughly funded and critically acclaimed. According to Jimmy the Greek, the smart money for next year is already down on Frederick Sommer and Garry Winogrand.[2]

Of course, no matter how much you've got, gifts of cash never hurt. Still, I can think offhand of two or three dozen people in each awards category for whom this recognition and support could really make a difference. The Friends' innate conservativism seems to dominate these proceedings, disappointingly. It would be exciting to see them use the awards creatively and courageously, rather than timidly resanctifying the already canonized.

Siskind was there to accept his award in person; Meyerowitz, according to his wife Vivian, was somewhere in the air over JFK International Airport. She accepted the certificate and check for him, and read a lengthy, pretentious and self-flattering telegram from him (I seem to recall the word "passion" recurring several times) to salve our grief at his absence.

By this time I'd discovered that there were not and would not be any *hors d'oeuvres* whatsoever — just drinks, and a few bowls of peanuts and potato chips that had been severely depleted and were not being refilled. I grabbed some of the nuts (more protein) and exchanged a salty handshake with Dale W. Stulz, Vice-President of Christies', who specializes in photography at that auction house.

Stulz began telling me about the round of photo auctions held in New York a few weeks earlier (just after the AIPAD convention; these things are coordinated, you understand, all these people know each other). "It seems the market has gone soft," Stulz said soberly. Major twentieth-century photographers — Man Ray, Callahan, Siskind, Steichen, Stieglitz, Weston, Bourke-White — were rock-solid. Others whose reputations are not so unimpeachable, or who have many prints on the market, were shaky; much such work didn't reach its asking price and had to be bought back. (Stulz's mixed feelings of indignation and disgrace at this admission were visible and — as a student of mine recently wrote, on another subject — "heart-rendering.")

The real shocker, according to the auctioneer, was that much important "vintage" material — 19th-century VSOP stuff, guaranteed museum-worthy, as safe as churches — didn't move either. "Even the Fox Talbots were iffy," Stulz exclaimed, referring to prints by the British inventor of the negative-positive process, William Henry Fox Talbot.

Instantly the line rang in my mind with that peculiar sonority which tells you a notable moment in history has acquired its epitaph. I asked Dale to repeat himself, just to be sure I'd heard him right; he looked at me askance, but acquiesced. There it was: "The Fox Talbots were iffy." It hung in the air briefly, like a hovering bat, while I made a mental note of it.

Then the conversation shifted and I went for more peanuts. The combination of liquor and lack of sustenance was turning me ugly. I've been diagnosed as borderline hypoglycemic, and can only go a few hours between serious snacks; in my debilitated state I become disoriented and prone to attacks of low-grade gonzoitis. It started to hit me right then; I found myself taking out my own mounting surliness by busily spreading the rumor that Aaron intended to blow his entire award check on coke. Then I left for dinner in the company of the two scruffiest, most disreputable characters I could find, whose names — like that of the hoary institution at 1 West 54th Street from which we were departing — must forever remain a secret.

And who did we encounter in the corridor on our way out? None other than Joel Meyerowitz himself, looking wild-eyed, harried and slightly jet-lagged. I reassured him that Vivian had followed his instructions to keep the check, and we went our separate ways. I'll bet there wasn't a single peanut left by the time he got to the reception, and he had to settle for the money. Is that what they call poetic justice?

POSTSCRIPT

This essay's publication evoked the following response from Ansel Adams. In the spirit of full-frame printing, a Group f.64 tenet, the photographer's distinctive spelling and punctuation have been retained.

February 26 1982
Mr. Lief Ericksenn, Editor in Chief
CAMERA 35
155 East 55th Street
New York City NY 10022

Dear Mr. Ericksenn,
I find it difficult to understand how one of your Contributing Editors, Mr. A,D, Coleman (also a well-know [*sic*] writer and critic in the world of photography) could stoop to such "low blows" displayed in his "Light Readings" column in the March issue of CAMERA 35.
Be assured I can take personal criticism of my work at any

level but I cannot tolerate errors-of-fact [*sic*] and low intentions when they concern reputable individuals and institutions.

My wife and I funded the Beaumont and Nancy Newhall Curatorial Fellowship at the Museum of Modern Art because of our admiration for the Newhalls, John Szarkowski and the Museum. This was done long before I was approached on the exhibit. To say I "bought" the exhibit is not only rediculous [*sic*] but it is evidence of a thoroughly nasty attitude revealed by the writer. I am amazed that you would publish such drivel.

This same destructive attitude if [*sic*] found in Coleman's remarks on the Friends of Photography, their program, and the Award. I serve as Chairman of the Friends and it is gratifying to observe the progress of this organization over the years — especially under the recent leadership of James Alinder. I wish to inform Mr. Coleman that the latest publication of the Friends is a handsome book by Roy deCarava [*sic*], the great black New York photographer and teacher. We are not racist or chauvinistic as Mr. Coleman implies. If he would note the list of our exhibits over the fifteen years of our existance [*sic*] he would observe that we have shown 175 individuals, from the earliest years of photography to the avant garde. Among these were about 45 women (Imogen Cunningham to begin with). In addition, we have had about 33 group shows.

We have most excellent relations with the Center for Creative Photography in Tucson. An old friend and patron of photography secured the Award Presentation space at #1 West 54th Street (New York). Mr. Coleman owes an apology to both the generous patron and the institution.

very truly yours,

/s/ Ansel Adams

At the editor's request, I drafted the following response, which would have appeared along with Adams's letter in a subsequent issue of the magazine.

A. D. Coleman replies:

The web of personal and professional relations between the Adamses, the Newhalls, and the Museum of Modern Art is elaborate and long-lived, going back at least to Adams's instrumental role in the founding of MoMA's Department of Photography in 1940. The connections between that triumvirate and such corollary institutions and individuals as John Szarkowski, The George Eastman House, and the Center for Creative Photography merit serious scrutiny — certainly

much more than the fragmentary address I've provided in my own writings in these pages and elsewhere.

The fellowship in question was inaugurated in March of 1977; Adams's retrospective (and the monograph based thereon) debuted in the fall of 1979. Given the logistics and timing involved in mounting a major exhibit at MoMA and coordinating the production of a major book to accompany it, planning for the Adams retrospective could not conceivably have begun any later than the summer of 1977.

It was perhaps overly simplistic of me to suggest that the former event *bought* the latter. But surely it is no less simplistic of Mr. Adams to propose that these two events — both orchestrated by the hand of John Szarkowski, and only two years apart — are entirely coincidental and bear no relation whatsoever to each other.[3] If Mr. Adams would care to speak to the specifics of this matter, these pages are open to him and I am at his disposal as an investigative journalist and interviewer.

It appears that Mr. Adams interprets any skeptical or negative commentary on any aspects of the activities of the Friends of Photography as evidence of a "destructive attitude." Yet the implications of racism and chauvinism that he ascribes to my "low intentions" are inherent in the facts of the Friends' awards selections to date. Mr. Adams is in no position to object to an elementary statistical analysis thereof.

I am indeed aware of the Friends' recent publication of a Roy DeCarava monograph, just as I'm sure Mr. Adams is aware of essays of mine on DeCarava dating back to 1969. I'm also sure we're both aware that DeCarava is the only Black photographer — and, so far as I know, the only photographer from any racial or ethnic minority — to have a monograph sponsored by the Friends since the organization was founded in 1967. Its exhibition history is equally devoid of minority figures in general, though women have been relatively well represented in the exhibitions program.

I don't think it's wrong-headed or inappropriate of me to state, as I did, that the most courageous and venturesome aspect of the FOP program is its publications series. It can hardly be out of line to gauge the organization's other activities as comparatively conservative. It is strictly reportorial to note that its cash awards and certificates of merit to date have gone to four white males — Siskind, Callahan, Meyerowitz and Friedlander — who are neither under-recognized nor under-financed. One would hope that if such obvious imbalances are not conscious and intentional, the FOP Chairman would appreciate having them brought to his attention, so that they could be studied and perhaps corrected in the near future.

Finally, it's in no way clear to me why Mr. Adams feels I owe an apology to the institution that hosted the Friends' awards ceremony, or to the "generous patron" who arranged that occurrence. I described the setting briefly, as befitted such a personal account, but did not violate the Friends' request that the institution not be named, and identified it no more precisely than Mr. Adams does in his own letter.

The only complaint I leveled about the accommodations that could be construed as offensive concerned the shortage of *hors d'oeuvres*. I assumed (it being the Friends' party) that this tight-fistedness was theirs, and found it ironic and symbolic in the context of a ceremony involving boasts of record-breaking membership levels and the exchange of thousands of dollars among well-to-do men. I didn't make much of that, but I did mention it. If it seemed I was blaming the host club for the Friends' chintziness, I regret the unclarity.

In the meantime, before this exchange could be published, *Camera 35* suddenly folded. So I wrote the following letter to Ansel Adams.

April 4, 1982
Ansel Adams
Route 1, Box 181
Carmel, CA 93923

Dear Ansel:

As you've no doubt heard by now, *Camera 35* has closed its doors. The possibility exists that it will resume publication in the none-too-distant future, under another name. However, the inevitable time lag, plus the probable change in publisher and editorial staff, make it unlikely that there will be much continuity between the magazine that was and whatever comes next.

Which means that I'm lacking a forum; and, more to the point, that there's virtually no likelihood that your letter of February 26 and my response thereto will be published in *Camera 35* or its offspring (if any). I think that's most unfortunate, because I'm a firm believer in the importance of public debate and think that the exchange would have been instructive for the magazine's readership. I certainly regret the fact that you have been, in effect, cut off without the opportunity to reply to me in the magazine that published my comments. I'm sure you understand that the magazine's problems went far beyond our disagreement, and that the circumstances were beyond my (or almost anyone's) control.

This does not mean that the issue is resolved, however, nor that it should end without some resolution. I've enclosed a copy of the

response I drafted when your letter arrived at the *Camera 35* office and was slated for publication in the June issue. Unfortunately, I can no longer make good on my offer therein to make *Camera 35*'s pages open to you for further exploration of this matter.

However, I'm sure that another vehicle could be found for a candid discussion of the matters in question. Thus I can affirm that I will remain "at your disposal as an investigative journalist and interviewer" should you care to pursue this further. As it happens, I'm taking a sabbatical of sorts in northern California from July of 1982 through July of 1983, so the occasions for this will not be difficult to find, should you be interested.

In any case, if you feel that you need to make a public response to my article in order to set the record straight, let me suggest that an appropriate vehicle for that purpose is close to your hand: the *Newsletter* of the Friends of Photography. I'm sure that its editors could be persuaded to run your letter and my response. I'll gladly give my permission, in advance, for such usage of my reply. If you do decide on such a course, I'd appreciate some advance notification, since I'd want to append a brief footnote on *Camera 35*'s demise.

Sincerely,

/s/ A. D. Coleman

Need I add that I never heard back from Adams, nor from the editors of the *FOP Newsletter*?

(1982)

William Henry Fox Talbot, *Leaf*, 1839, photogenic drawing
(salt print from a paper negative); collection International
Museum of Photography at George Eastman House,
Rochester, N.Y.

WEEGEE AS "PRINTMAKER":
AN ANOMALY IN THE MARKETPLACE

There's a story — perhaps apocryphal — which holds that Edward Weston, on being asked who his favorite photographer was, replied "Weegee!"

If there's any truth to the tale, it suggests that Weston was looking to bypass any possible accusations of favoring the Group f.64 circle, of which he was an essential part, by naming a photographer of obvious excellence whose relationship to the medium was radically different from his own. For, aside from the fact that they both used cameras to produce their imagery, Weegee and Weston had almost nothing in common; their approaches to the medium of photography were diametrically opposed.

So it is curious to find that, posthumously, "original prints" of their images coexist in the relatively new market for photographs as art objects, as though those prints were somehow equivalent in kind and different only in quality, scarcity and price. In fact, they are fundamentally different in kind: Weegee's photographic prints are not to his body of work as Weston's prints are to his *oeuvre*. The market's failure to recognize the essential distinction between them signals its continuing confusion over and misunderstanding of photography as a printmaking medium (a confusion due in part to laxity and/or venality on the part of critics, curators and gallery/auction-house personnel). This in turn suggests that bewildered and uninformed collectors are acquiring material without a solid grasp of how this material relates to the actual working methods of the photographers who generated them.

Back in 1960, in an essay on his own work for the book *Under the Sun*, photographer Walter Chappell proposed that the primary components of photographic image-making were *camera vision* and *the art of printmaking*.[1] The implication of this was a conceptual distinction between the photograph as image and the photograph as object.

From this we can infer a dialectic: Each photographer establishes his or her personal version of the relationship between camera vision and the art of printmaking. This choice determines the inherent significance of any physical form in which that photographer's images are objectified.[2]

Virtually every photographer produces (or authorizes the production of) photographic prints of his or her images. But the purposes for which those prints are generated are diverse; in many cases, they are not intended to function as "original prints" in the fine-print arena, and treating them as such simply muddies the waters.

In Edward Weston and Weegee we have two people equally involved with camera vision, though they emphasized very different aspects thereof. But, even aside from the obvious differences in their imagery, they stood at opposite ends of Chappell's dialectic.

Weston was thoroughly committed to the art of printmaking. He preferred to have the viewer experience his imagery through direct visual contact with a print he'd made himself, feeling that only in this way could the full, complex relationship of shapes and tones be perceived as he intended them to be. Any other forms in which the imagery was rendered — including the finest reproductions — were less than fully satisfactory to him as realizations of his vision. For Weston, the original photographic print was the goal, the intended end product.

For Weegee, on the other hand, a photographic print was usually nothing more than a by-product. Weegee's prints served as the matrices from which halftone and gravure printing plates were made (by others) for reproduction in magazines, books, and newspapers. Weegee intended these mass-produced multiples, and not the photographic prints themselves, to be the final forms for his imagery. Weegee's approach to the craft of photographic printmaking was shaped primarily by the requirements of reproduction technology in his own time. He clearly had little concern for the tonal nuances and structural subtleties so essential to Weston, since they could not be reproduced effectively in the publications where his work appeared. He did not expect or intend his work to be experienced in the form of photographic prints.

It can certainly be argued that intermediary steps or matrices such as Weegee's "original prints" are important objects in the study of a major figure's output. And it can even be argued, reasonably, that Weegee was in his own way a printmaker — halftone/offset lithography/gravure processes are printing processes, and their products are prints.

But, if that's the case, the intermediary steps can't be considered *more important* than the final statements in the mode the printmaker chose — those gravure and halftone book, magazine and journal pages. And certainly those intermediary artifacts should not be studied more

closely or valued more dearly than the final versions in whose service they were produced. To misemphasize them thus is to skew our understanding of the artist's relationship to process; I'd consider it equivalent in wrongheadedness to recording a musician's rehearsals rather than her concerts.

The prints of Weegee and Weston bear eloquent witness to this crucial conceptual divergence. The latter's prints are invariably impeccable: carefully spotted, pristinely mounted, thoroughly washed (as testified to by the general absence of residual chemical stains even fifty years later), and flawless. Most of Weegee's surviving "original prints" look like he slept in them: made on whatever paper was handy (at times, one suspects, not by Weegee's own hand), hastily spotted, unmounted, stained, variously cropped by divers hands, with their backs and sometimes their fronts covered by pen and pencil annotations.

Surely these prints of Weegee's have much to teach us about his solutions to the problems of disseminating a highly personal vision through the mass media — and about the shaping effect that external editorial forces exert on such a vision in those circumstances. Since Weegee's images were often and diversely cropped for reproduction to suit his own or other people's purposes, they exist in many different versions. These reproductions are particularly instructive when studied in conjunction with each other, especially in their relation to any extant full-frame prints; this provides a context within which Weegee's "original" photographic prints and the final reproduced versions can be meaningfully considered and compared.[3]

But to place a Weegee print — even one he made himself — next to a Weston on the wall is to drag a red herring across the trail of the viewer's understanding of photography. This is not to say that either man was a better photographer, or a more important artist. It simply acknowledges that Weston was a dedicated printmaker and Weegee was not. Thus we can conclude that it's inherent in Weston's approach to the medium that his prints are significant objects, since he defined them in practice as the principal vehicles for his images. Conversely, we can say that for Weegee the photographic print was not inherently significant — and that, consequently, regardless of their cash value in the art market at any time, they are not essential to any collection of fine prints as such.

Let me offer another example to amplify this point. Robert Frank's major contribution to the medium is a single work — not an image but a set of images presented in a book, *The Americans*. It was

this *book* — not any individual image therefrom, and not that same set of images in original-print form — that influenced an entire generation of photographers. It was this *book* that one critic recently called "a major twentieth-century work of art." In representing Frank in a collection, I would therefore begin by seeking out copies of the first French and U.S. editions of *The Americans*. Only then, if at all, would I supplement that representation with a Frank print.

What does this mean from the standpoint of the collector? Simply put, it suggests that in considering the acquisition of work by any photographer the collector should investigate and contemplate that photographer's emphasis in the camera vision/printmaking relationship, in order to determine the physical form of imagery that most meaningfully represents the photographer's intentions. After all, actual photographic prints — prints made from the negative on light-sensitive paper — are only one of the many forms in which photographers choose to embody their imagery. Looked at in that light, we might conclude that the collector basing his or her selections on *inherent significance* would certainly find a Weston print to be the most desirable form for representation of Weston's vision, but might in the case of Weegee seek out not prints but copies of his books and issues of the newspapers and magazines through which his images reached the audiences for which he intended them.

Were Weston alive today to see the prices that his own prints command, he'd doubtless feel they were justified and that his own devotion to the fine print had been vindicated. Weegee, witnessing the current reverence for and cost of his prints, would have good reason to laugh.

(1984)

Weegee — A Biographical Note

Born Usher Fellig in Zloczew, Austria in 1899 and rechristened Arthur Fellig by an immigration official, he took the name Weegee in 1938 — according to legend, as a phonetic version of the Ouija board, whose prophetic abilities he was reputed to possess.

Actually, what he had was a police radio in the trunk of his car, which kept him apprised of the more spectacular and nefarious goings-

Weegee (Arthur Fellig), *Harry Maxwell shot in car*, ca. 1941.
Included in Museum of Modern Art exhibit "From the Picture
Press," 1973, curated by John Szarkowski; courtesy
Museum of Modern Art, New York.

on in New York City, where virtually all of his important work was done. He began his apprenticeship in photography in 1913 as a tintypist, later served a stint as a passport photographer, and then worked as a darkroom assistant for Acme Newspictures, which would shortly become UPI Photos.

He left Acme to become a free-lance newspaper photographer, made friends in the Manhattan Police Department, got permission to install his two-way radio and began to scoop every press photographer in the metropolis. The images produced by "Weegee the Famous" (as he eventually styled himself) became definitive visions of mid-century American urban life, full of the crush and fever and energy of this country's prototypical "big town." Published widely here and abroad, Weegee's photographs made him into a household word — perhaps the first news photographer whose presence at an event was often thought to be as significant as the event itself.

Aside from a four-year staff position with the short-lived newspaper *PM*, Weegee remained a free lance throughout his career. He published a string of books, the first and best of which — *Naked City* (1945) — inspired a Hollywood movie and a successful television series. Consequently he spent time in Hollywood, working as a film consultant and a bit player. He made several short films himself, had his work shown at the Museum of Modern Art and in Russia, traveled through Europe and died in New York, the city he embraced with such generous passion, on the day after Christmas, 1968.

(1981)

INTERESTING CONFLICTS

Any time you find yourself eating cucumber sandwiches twice in one week, you'd better examine your life from the bottom up. That's one of my rules of thumb. I'm willing to concede, for the sake of argument, that a solitary encounter with cucumber sandwiches may be purely coincidental (though I know, in my heart of hearts, that there are whole classes of people excluded from such happenstance). Twice in a week, however, is no accident; it's a sign.

There I was, sitting on an unfamiliar couch in front of three dozen people I didn't know, staring at a platter containing the week's second offering of burpless dainties, trying to figure out where my life had gone wrong.

I should have known better, I suppose. I'd made the mistake of accepting an invitation from a curator friend to participate in an informal discussion series sponsored by the museum for which she works — a series whose meetings rotate among the homes of the museum's wealthier patrons. Each session's hosts take upon themselves the challenge of providing suitable food and drink for the series' subscribers, who themselves pay a pretty penny for the privilege of attending these conversational gatherings.

That's why I was in a posh East Side living room with a Sol LeWitt fresco on the south wall, surrounded by strangers — including the four other critics who, along with myself, made up the evening's "panel." All that my friend, as moderator, did was to announce our names and turn us loose. Because my colleagues did much of the talking, I had some time to try to meditate on the epiphany of the finger food and search my soul.

I found it hard to concentrate on this, though, because the performance of two of the other critics was unusually engrossing. Apparently they work as a team in their various activities (more of which in a moment); someone, in fact, has gone so far as to describe them as "the Sartre and de Beauvoir of the East Village avant-garde" — a profound insult to that extraordinary couple, in my opinion.

Their act was quite remarkable. Most of the audible talking was produced by the man. He would elaborate a line of reasoning — while she, in counterpoint, would simultaneously mutter away at his side, *sotto*

voce, loudly enough to make everyone aware that she was speaking but not quite loudly enough to make her words intelligible. Periodically, the tone of her murmuring would shift from assent to argument, gradually rising in pitch and increasing in volume until it drowned out his voice. At that point he would stop talking altogether, turning expectantly to her. Staring wide-eyed at the wall dead ahead of her, she would provide some corrective to whatever he'd been expounding, which he would accept with a nod. She'd be still for a moment; then he'd resume his commentary, and the process would begin all over again.

I watched and listened to this with that fascination evoked by encountering some new and unfamiliar species. Their presentational style had the eerie, droning rhythm and power of locusts in summer heat. I was so intrigued with their form that I wasn't paying much attention to the content of their collective statements.

Suddenly I was brought up short. I realized that I'd just heard them announce quite matter-of-factly — in their eccentric, tandem way — that, in their teamwork, they wrote and lectured together, curated exhibitions, served as consultants to individual and institutional collectors of art, and acted as dealers or agents for many of the artists as well. That is, not only do they write about art work but they also sponsor its presentation, advise people to buy it, and even do the selling. They only stop short of manufacturing the stuff themselves.

I couldn't believe that I'd heard them correctly, so I asked them to repeat this — which they did quite cheerfully. No one else in the room seemed at all perplexed; so, in my most collegially diplomatic tone, I inquired as to whether they felt any conflict of interest existed among these various endeavors. She rolled her eyes at my foolishness; he gave me a look full of pity for my *naïveté*, but dignified my query with an answer, no doubt out of professional courtesy.

The only way they would see a conflict of interest, he informed us all, would be if they believed that any of the art involved in this process were "second rate."

In other words, their taste patterns are the only necessary validation of their ethics. This announcement left me dumbfounded. I'd made a promise to myself, upon accepting the curator's invitation, that I would behave myself by not getting into any fights, so as not to spoil everyone's pleasant evening. The discussion quickly moved on to other, surely more important topics, leaving me there with my mouth hanging open. So I took the only course of action left that seemed appropriate: I stuffed a crustless cucumber sandwich into it.

•

Thinking about this afterwards, I was reminded of an episode involving — is there a pattern here? — another brace of critics who wrote under a joint byline. For a time, their work appeared in the *Village Voice*. I recalled a particular series of items with which they were connected. The first was a jointly written essay on the work of Helen Levitt, the purpose of which was clearly to establish her in the pantheon of the photography gods. (This subsequently turned into a catalogue essay for an exhibit of Levitt's work.) The second, appearing a few weeks later, was another co-signed essay extolling the importance for collectors of limited-edition portfolios of original photographic prints. The third, which appeared about a month after that, was an ad in the *Voice* for a limited-edition portfolio of original prints by Helen Levitt, published by an outfit bearing the name of one member of this team.

•

As I'm writing this, a poster announcing a major thematic exhibit and an accompanying limited-edition portfolio of work by the exhibitors arrives in the mail. The show — and, hence, the portfolio — is a juried one. Two of the three jurors have work in the show and portfolio — which can only mean that they entered a competition in which they were the judges. With one of them (an aggressively mediocre picture-maker with a deep commitment to the craft of self-promotion) this comes as no surprise. But the other is a major artist whose integrity has served many of us as a standard.

•

I can remember a time when it would have been considered inappropriate to include your own work in a show you were curating. I can also recall a time when critics who were economically involved with artists would keep that complicity secret — or, at least, wouldn't brag about it. That time is not too far in the past. But the concept of conflict of interest as a crucial ethical issue is eroding rapidly in the arts — converted, semantically, into a courageous willingness to engage with interesting conflicts. (After all, corruption is a dirty job, but somebody's got to do it.) It's not that I disagree with the ethical decisions being made; it's that they're not even perceived as ethical decisions in the first place.

This condition becomes most easily aggravated when people take on a multiplicity of roles, roles that are not inherently compatible with each other though the knowledge bases involved may overlap con-

siderably. It's not uncommon nowadays to find one person functioning variously as artist, critic, curator, collector, dealer, artist's-grant panelist, artist's-grant applicant/recipient. . . . Under such circumstances, it's hard to keep the ethical waters from getting muddy.

Relying on one's own inner compass to determine right and wrong in those situations is risky at best; who among us is immune to self-seduction? It's precisely in such contexts that firmly established, communally determined, external standards of behavior are invaluable. We seem to be forgetting the utilitarian value of principles against which one can weigh the various complex tuggings of personal/professional motives. Lacking such navigational instruments, we're cast adrift on an ocean of behavioral options; the best we can improvise is a situational ethics whose only evaluative gauge is whether anyone was hurt by the action.

I certainly couldn't prove that any of the behavior I've cited here specifically hurt anyone, including me. But isn't the cynicism about art that inevitably breeds in this atmosphere of self-serving moral opacity and venality an injury to our very relation to creativity itself?

(1986)

ON THE DOLE:
REVAMPING PUBLIC FUNDING FOR THE ARTS

The issue of public funding for the arts — or, more accurately, the multitude of issues gathered under that umbrella concept — is the focus of widespread debate at present. This debate ranges from the brouhaha at the National Endowment for the Arts resulting from the NEA's suspension of its Art Critics Fellowship program to the uproar in New York City centering around Richard Serra's "Tilted Arc" and the legal/political/social/aesthetic questions the installation of this site-specific sculpture has raised.

On a parallel front, the Reagan administration, desperately seeking any area other than defense in which to economize, regularly proposes massive cuts in federal funding for the arts. Congress — supported by polls indicating that the American public strongly supports that funding — consistently beats back the hatchet-men. The arts community calls for increases in arts funding, citing everything from the intangible social benefits of art to the tangible economic benefits of "the arts as business" in support of that demand.

From my standpoint, this part of the argument is fruitless — in fact, pathetic, because the amounts involved are piddling. Dancer/choreographer Merce Cunningham, testifying before Congress, analogized that if you pro-rated the cost of a single nuclear sub according to its length, the annual budget of the National Endowment for the Arts represented one foot's worth. The U.S., where the arts are reduced to fighting over table scraps, lags far behind most western nations in the *per capita* amount devoted to the arts, a sad comment in itself. There is no logic to this, especially when the electorate has indicated that it wants things otherwise. Eventually that voice will make itself heard.

In the meantime, the dialogue that currently is most bitter but promises to be most fruitful is that which engages the more specific question of how public monies for the arts should be allocated. Often foolish, dependably acrimonious, the interchange on this subject at least addresses matters more substantive — because there seems to me to be no question that the current system of providing public funding for the arts is severely, if not terminally, corrupt.

Discussion of the concepts of "public art" and "public support of the arts" is a healthy phenomenon; this should be a periodic, if not ongoing, concern of all thinking citizens. These will always be thorny issues, permanent solutions for which are not likely to be found. But provisional strategies, carefully thought out and articulated, can provide the basis for progressive experimentation; appropriately, the arts encourage a creative, fluid relation between themselves and their context.

One would assume, therefore, that professionals in the arts — particularly critics — would welcome the occasion for widespread dialogue on these subjects, especially if (as is now the case) the interchange were national in scope rather than merely regional or local. Yet what has been evoked by it, generally, is a combination of rage and defensiveness — diatribes against Philistinism coupled with the pulling of wagons into a circle.

This is ascribable in part to the prevailing political atmosphere of this decade, notably the Reagan administration's blatant hostility to even such conservative arts-funding projects as the Institute of Museum Services and the National Historic Preservation Fund. There is no question that, at the present moment, those cultural activities that we broadly term "the arts" are embattled.

But I'm convinced that's only part of the reason for the reaction from most artists and critics. I say that because the same reaction occurs whenever the question is raised of how — not *whether*, but *how* — the arts are to be funded. Indeed, the art community tends to conflate those two issues. This is counterproductive and confusing; the Reagan attacks notwithstanding, a recent Louis Harris poll showed that, over the past decade, Americans have consistently increased their support for the arts as both practitioners and audience. Clearly, the arts are not a low priority in our public life.

If that's the case — if there's ample evidence that funding for the arts as such is not in long-term jeopardy due to public disrepute — then there's a simple explanation for the knee-jerk reaction to any examination of the methodology: most of us (I include myself, as a one-time grant recipient and a sometime applicant)[1] know full well that the system is corrupt. We're therefore tacitly complicitous, at least — and, in many cases, actively so.

Please understand that I'm not implying malice, nor criminality (though artist and critic Richard Kostelanetz, currently suing the New

York State Council On the Arts, has amassed impressive evidence point-
ing in such directions). Nobody I know of is embezzling public monies
to line their own pockets. (Even if they were, the Pentagon's periodi-
cally disclosed excesses would make any arts-funding misappropria-
tions or collusion pale by comparison.) What I'm talking about are de-
cisions made by people who believe themselves to be acting in good
faith, in the public interest, and in support of art — or critical approaches
to art — that they believe to be valid and substantial.

Understand, too, that while I'm talking specifically about pub-
lic monies — that is, local/state/federal tax-supported grants and fel-
lowships — what I'm saying could certainly be applied to the activities
of private and corporate foundations. Such organizations are, for the
most part, based on endowments of tax-exempt dollars that would oth-
erwise have entered the public coffers; in effect, their operating funds
are displaced tax revenues whose application is prescribed but whose
control remains in private hands. Hence the public has no voice in, and
no oversight over, decisions made by those thus empowered. But that's
a discussion for another time.

•

The corruption of which I speak is not something that has *hap-
pened* to the public arts-funding structure, not a taint that has been brought
to it from outside. It is systemic, intrinsic, immanent — built into the
structure itself.

The area that consistently proves most controversial — for good
reason — is that of grants to individuals, principally artists and critics.
For example, it was such a grant — to an artist whose "project" in-
volved throwing rolls of toilet paper out of an airplane, if I recall cor-
rectly — that earned headlines when Sen. William Proxmire selected it
for one of his "Golden Fleece Awards." Yet a great many contemporary
art works, and even approaches to art-making, that have proven them-
selves powerful for artists and audience alike could easily be made to
sound equally ridiculous with a simplistic, decontextualized descrip-
tion. The problem, so far as I'm concerned, lies not with the sponsorial
choice of this artist over that one, but with the very structure of the
sponsorial system itself.

Consider, for example, the NEA's grants to photographers. Ac-
cording to public statements by those who administrate this division of
the NEA, somewhere in the environs of three thousand portfolios are
submitted in this grant category alone, each time these grants are of-

fered. These are submitted with the understanding that — as the NEA's guidelines mandate — the portfolios will be reviewed by a "peer panel" of accomplished photographers.

Such a panel is duly assembled whenever the grants are offered (currently, every other year). But, needless to say, there's no way in hell anyone can look at three thousand portfolios in a week, much less try to evaluate them comparatively, without running gibbering from the nation's capitol. The eyes start to glaze after the first two hundred; the brain calcifies shortly thereafter. So, to ease the burden of the panelists, it has been the practice of the staff of the Endowment's photography program to isolate the best two to three hundred portfolios for scrutiny by the panel when it assembled.

You can, I hope, see the catch here. The NEA photo program's staff — entirely composed, I am sure, of well-intentioned people — contains no established working artists, no working critics or historians. They are arts bureaucrats whose credentials may be a Ph.D. in art history or an M.F.A. in some medium or other, but may also be an M.B.A. Yet ninety percent of the portfolios would be rejected not by the peer panel but by an officeful of questionably qualified administrators and office workers. More significantly, the work from which the peer panel would select was pre-filtered by people with far less expertise than the panelists themselves. Finally, none of those rejected would be informed as to whether their work failed to meet the standards of a select group of fellow artists and critics or simply didn't suit the taste of some desk jockey.

Since the NEA identified the reality of this process nowhere in its literature, what we had here was a straightforward case of false advertising. Yet, I'm suggesting, this was inevitable; what other way was there of handling three thousand portfolios? Indeed, the problem can only grow worse. It will be compounded as the number of people formally trained in the arts increases, for the line between the working professional and the sophisticated amateur necessarily blurs under those conditions. This may be healthy as a sign of the democratization of creative activity, but it makes the allotment of money to applicants extremely problematic.

Everyone I know who keeps tabs on the grants system has a personal list of notable figures — artists of national and even international stature, or artists with powerful but under-recognized bodies of work and long track records — who have never managed to catch the

eye of enough jurors to persuade a panel into support. There's an opposite side to that coin, of course. One critic I know received $20,000 worth of NEA support in several consecutive grants without having published more than a dozen essays. The late Sam Wagstaff, a private collector of photography, received a sizeable NEA grant to support the national tour and catalogue of an exhibition from his private collection — a collection that, thanks in part to the publicity this tour provided, he eventually sold, at enormous profit, to the privately-owned Getty Museum in California. On a considerably more grandiose scale, there's the artist Meredith Monk, who works in many media — music, dance, theatre, performance art, film — and who, by applying to various programs of the NEA, in 1985 received approximately a quarter of a million dollars in federal support of solo, collaborative, and group ventures.

Demonstrably, the process is riddled with politics, cronyism/networking, personal prejudice, trendiness — virtually everything *but* dumb luck. In short, it's a rigged game.

Several years back, music critic and musician Stanley Crouch came up with a variant of an idea I'd been kicking around for awhile — that of debugging the game by turning it into an actual lottery. Crouch proposed that work should be judged blindly — *i.e.*, without the artists' names attached (unfeasible, in my opinion, given the recognizability of many "signature" styles); once it reaches what he calls "the finals" of panel evaluation, it should be given a number, with winners publicly drawn out of a hat.[2]

My own notion, at that time, ran somewhat parallel. To eliminate string-pulling and taste-mongering on the part of the panelists, and prior filtration by the NEA staff, eliminate the portfolios entirely — thus eliminating the need for any panel at all. Instead, establish some guidelines: at least ten years out of school; a ten-year track record of production and public exhibition of one's work; at least ten solo shows (perhaps this would be two- or three-tiered, with additional categories — and more stringent requirements — for more mature artists). . . . Anyone who meets those requirements gets a lottery ticket for a public drawing *à la* Crouch.

That would eliminate much of the unsavory potential of the current system. There are other steps that could be taken, too. For instance, I'd recommend requiring a statement of income and assets from applicants — recent federal tax returns, just like the politicians have to pro-

vide; successful applicants whose wealth exceeds a specified amount should receive the honor of the award but not the stipend. (A number of quite well-off folks — unconscionably, in my opinion — have taken both.)

•

But I've come to the conclusion that this would merely be the patching up of an unseaworthy ship that should never have been launched. My proposal is even more drastic: Do away entirely with direct governmental grants of public monies to individual artists simply for the pursuance of their own work. The government has no business deciding which artists should receive such outright gifts of tax revenues. (The same would hold, of course, for grants to critics.) No method of showering *largesse* can avoid the corruption of power; no artist or critic scrambling for it can avoid compromise.

This proposal would not eliminate the commissioning of artists and critics to produce work that would then become public property (though the concept of "public art" needs to be reconsidered from the ground up). It would not prohibit funding the purchase of artworks by institutions committed to collecting, preserving, and presenting artworks to the public; nor would it prevent arms of the government from purchasing art for the various public collections, or for display in government buildings.

What it would encourage would be the decentralization of arts funding, the dissemination of public monies for art to regional and local organizations that, due to their smaller scale, are able to be both more attuned and more responsive to the art-making and art-appreciating components of their constituencies — and more directly accountable to those constituencies for their actions. (In criticism, this could take the form of encouraging the creation of regional projects modeled after the pioneering Center for Arts Criticism in the midwest, or of providing matching grants for recipients of such awards as the Reva and David Logan Grants in Support of New Writing in Photography, administered by the Photographic Resource Center in Boston. Workshops, lectures, textbooks, anthologies, translations — all these are desperately needed in the field, and could certainly be supported with grant monies.)

This may not be the solution; and, even if it is, it may not be acceptable. It seems inarguable to me, though, that revision of all government-sponsored arts programs — not only the NEA Art Critics Fellowships or photography grants — is sorely needed. So long as it's un-

derstood that the goal is to redefine governmental arts funding rather than to terminate it, the best way to achieve this is to close down the present system of grants to individuals for several years. (By the way, this does not mean that the same amount, or more, of federal funds for the arts shouldn't be budgeted or allocated during that period. They should. Put them in escrow to create an actual *endowment*. As it now stands, the NEA is less an endowment than an *allotment*.)

With the system temporarily closed for renovation, there would be ample opportunity, at last, to rethink the issues thoroughly; to encourage discussion and debate within the related professional fields; to poll the citizenry and stage a major referendum. Establishing a national consensus on the subject of public support for the arts would provide, for the first time, a sound basis on which to determine future policy and practice.

The effect of such a decision on a generation of artists (and critics) who've become habituated to living "on the dole," as the British put it, would be salutory. It would remind all concerned of where "government funding for the arts" really comes from: the pockets of their fellow citizens. It would weed out the summer soldiers. And it would instruct the rest in an all-but-forgotten truth — that it is possible to be an artist, or a critic, without receiving a grant. We could even consider it a form of art education, following the advice of Sherwood Anderson, who wrote, "Those who are to follow the arts should have a training in what is called poverty. Given a comfortable middle-class start in life, the artist is almost sure to end up by becoming a bellyacher, constantly complaining because the public does not rush forward at once to proclaim him."

(1985)

Damn the Neuroses! Full Speed Ahead! Or, Thoughts on the Free-lance Life

Is free-lancing a psychiatric syndrome?

To my astonishment, that was the title of an unusual article I came across in the pages of an irregular publication issued by a graphic-arts workshop in New York City.[1] Its thesis was that free-lancing is an inherently neurotic activity and occupation. The goal of its author — identified as an "MD, Psychiatrist, and Psychoanalyst" who, according to my phone book, both lives and practices the "talking cure" in a comfortable lower-Fifth-Avenue setting — was to persuade as many free-lancers as he could reach to find regular full-time employment.

A few excerpts from the article will indicate the author's overall tone and attitude.

> I have found that in general the free-lancers I have been exposed to, fell within the entity of neurosis. I would admit exceptions, naturally. ... The origin of the term, as seen in a good dictionary, is provocative: A mercenary soldier (a knight) in the Middle Ages. Despite the phallic significance, the term has persisted throughout the years. Wouldn't an old-fashioned term like *tinker* or *mercenary* have served just as well? No, because the strongest feeling one gets from a free-lancer today is his or her consciousness of being an outsider, and somewhat shady. Almost like he was doing something he was not supposed to do. ...
>
> I must say, I don't personally envy a free-lancer. His life is hard and uncertain. Let me make some quick psychological assumptions which might stir up some resistance, resentment, or controversy, but on the other hand might be helpful to free-lancers in understanding themselves. ... Though his courage in confronting a new situation so often may be admirable, he may need these frequent confrontations to support a powerful developmental character programming. As an outsider, for example, he can prove to himself that his sexual identity is masculine, and as a by-product that his sexual drives are not incestuous.[2]
>
> The constant need to show a portfolio reveals some more or less strong exhibitionistic impulses. Showing the portfolio is like saying, "Here, this is my intimate self. I'm not afraid of your looking at me." Whereas the truth is that the individual is confronting his great-

est fear, which is, being seen in his natural and tabooed state. He thus proves that he has no aggressive or sexual aim to cover up his guilt about thoughts of just those things. If he took a steady job, then he would be found out and suffer the (imagined) consequences. But as a free-lancer he can fool his temporary employer and co-workers, which if read as substitute family makes apparently good sense.

The above are just some of the psychological comments why some gifted artists remain in the lowly status of free-lancers all their lives. I personally think that freelancing is the most insecure and unsatisfactory way of making a living that our society has to offer. . . .

The publication of such a glib, superficial and ill-considered "psychoanalytic" attack on free-lance activity beneath a sensationalized headline was obviously intended as a provocative act; I found myself impelled to respond. A great many of my professional colleagues and close friends — artists, writers, photographers and others — have chosen to exist in what this remarkable diagnosis so condescendingly calls a "lowly status," and they don't strike me as inherently any more neurotic than the average late-twentieth-century North American.

I've made my living as a free-lance writer in New York City for seventeen years, so I can speak with some grounding in personal experience on this subject. There have been periods when the bulk of my writing was done for one or two primary outlets (the *Village Voice*, the *New York Times*, *Camera 35*); stretches when I've concentrated my efforts on the production of books; and intervals during which I've contributed pieces to a diversity of publications in a relatively irregular fashion.

I don't share the doctor's bias toward conformity, office jobs, or the therapeutic establishment's primary goal of normalcy. As a free-lance writer with an area of specialization (media criticism), I do feel that it's valuable to have one or two primary outlets for my work — because that's essential to building an audience, sustaining an ongoing train of thought, and developing a set of reference points in a dialogue between myself and my readership.

But that doesn't mean that you have to be on anyone's payroll. And to choose not to be a full-time corporate employee is hardly sufficient evidence that one "fell within the entity [sic] of neurosis." (Whatever neurosis may be, an "entity" it ain't.)

The proferred "etymological" explication of *free lance* is fundamentally erroneous. The term is not, nor has ever been, an automatic

synonym for either *mercenary* or *tinker*. The *tinker* was an itinerant mender of pots and pans, usually unskilled and often incompetent (hence the derogatory usage, *tinkering*). The *mercenary* was a soldier of fortune, available for hire to the highest bidder. Both of these are terms of opprobrium.

On the other hand, the *free lance* — according to *Webster's* — is "a person who acts on his own responsibility, without regard to party lines or deference to authority." One can see why many psychotherapists would disapprove of such a stance; it is indeed the position that the doctor describes as that of the "outsider." But it is in no sense "shady," except to a conformism-oriented mind. The posture of the free lance is, at its best, anti-authoritarian, self-sustaining, and independent. To suggest that it is equivalent to the mercenary's amoral willingness to espouse any cause if the price is right or to the tinker's lack of significant craft abilities is inaccurate, even insulting.

Equally questionable is the subsequent assertion that "the free-lancer can at times produce inferior work, perhaps to show he doesn't care." The exact opposite is generally the case. The free-lancer's reputation is on the line with every piece of work. A job badly done will preclude future income from the source — or, at best, will result in a client's demand that the work be redone *at the free-lancer's expense.* The employee is in a better position to slip through a mediocre effort — and, even if the work does not pass muster, gets the employee chewed out, and needs redoing, the employee will usually be paid for his or her time on revisions.

The good doctor's closing statement, expressing his hope that his article will be "helpful in getting one or two individuals to think about moving out of [free-lance] status," makes it clear that he thinks the free-lance life is bad for people: unenviably "hard and uncertain." The life that he does think is good for people is described both explicitly and implicitly throughout the article: soft, certain, secure, free from anxiety, and employed full-time by someone else (or some corporation) so that their economic needs are dependably filled.

In short, our healer proposes that people are best off when their condition is that of children within a solvent nuclear family: he recommends striving for the status of the worker-drone who, safe in the bosom of an office "substitute family," is presumably free from worry over where his or her next meal will come from and shielded from the stresses of competition in the marketplace.

What a bizarre perversion of psychiatry — prescribing infantile agoraphobia as a remedy for independence! Here is a prime example of what Philip Rieff laments so damningly as "the triumph of the therapeutic"[3] — the betrayal of Freud's analytic ideal, the conversion of psychiatry into a substitute religion aimed at making people "feel good."

Full-time white-collar work surely offers no sanctuary from psychic strain — witness the high incidence of ulcers, alcoholism, nicotine and drug addiction, nervous breakdown, divorce, and suicide in the white-collar ranks. And it provides no protection, in the long run, against the inherent perils of earning a living in a capitalist system: full-time workers are fired, laid off, passed over for promotion, manipulated, used as pawns in inter-office politics, often underpaid and sometimes "even cheated" by their employers.

The fact is that, in the amoral structure of the corporate state, all workers — full-time or otherwise — are free-lancers *de facto*, if not *de jure*; the corporate mentality takes no responsibility for its cogs, and virtually anyone who works within it may find him- or herself out on the street at a moment's notice, looking for the next job. Effective free-lancing — that is, surviving and thriving in that reality — involves discarding one's illusions about the corporate state and trading off certain fringe benefits (major medical insurance, expense accounts, paid secretarial help) against others (setting your own hours, turning down jobs that don't use your talents well or that you find morally repugnant, selecting and overseeing your own projects).

I would be the last to suggest that free-lance living is for everyone, or that there is no price attached to the decision to take on that status. Certainly there is, as there is whenever one chooses any option and lets the alternative(s) pass. But economic and psychic insecurity are endemic to capitalist society; indeed, President Reagan's proposed elimination of the minimum wage would put every job on a continual auction block. Under such circumstances, I would suggest that free-lancers might well be better prepared to cope and even get ahead than those who are habituated to "permanent and less insecure positions."

I would never claim that either full-time employment or free-lancing is psychologically healthier. That depends entirely on the makeup of the individual; it is simply a set of options. Neither of these can or should be thought of as inherently "neurotic." Nor is paying the price implicit in one's choice "neurotic." Football and basketball players generally end up with damaged knees; women who decide to have large

families usually acquire stretch marks. But deciding to play professional sports or to bear many children is not neurotic, even if some of the consequences thereof are negative.

Admittedly, I'm a layman with only a little formal education in psychology, but I disagree strongly with the definition of neurosis proposed by this psychoanalyst. Neurosis, as I understand it, does not consist of choosing one or another way of making a living, nor of paying the inevitable price for one's choice. Rather, neurotic behavior would be (a) consistently failing to examine the consequences of one's alternatives before making one's choices, and/or (b) complaining endlessly about the predictable consequences of one's choices after making them.

Perhaps it is the latter forms of behavior that led the doctor to conclude that the free-lancers he has "been exposed to, fell within the entity of neurosis." Given the biases and prejudices that resound throughout the doctor's piece, however, I would guess that his diagnosis of their neurotic tendencies had very little to do with their choice of free-lancing. Indeed, I'd be willing to wager that the doctor rarely, if ever, finds someone in his office who is *not* neurotic, regardless of occupation. People who aren't neurotic aren't prone to visiting psychiatrists, for one thing; and for another, the quickest way for any creative and independent person living in a troubled society to catch a severe case of neurosis is to step through the office door of a psychiatrist who is committed to the advocacy of conformism and who offers "quick psychological assumptions" in print.

(1981)

IDENTITY CRISIS:
THE STATE OF PHOTOGRAPHY
EDUCATION TODAY

During a class break one warm spring day, I was astonished to hear one of our imminently graduating seniors complain that his course of study had not provided him with employable skills that he could easily convert to a job in today's labor market. My immediate response was that not only was this true but that it was as it should be — and that, if he'd expected otherwise, he was, like Humphrey Bogart in *Casablanca*, "misinformed."

To understand my astonishment and my response, you'll need a bit of background. I teach the history and criticism of photography in a Bachelor of Fine Arts degree-granting undergraduate photography program within the Tisch School of the Arts, one of the seven colleges comprising New York University, which is among the oldest institutions of higher education in North America.

It has never been the function of universities, fine-arts programs, or undergraduate departments to *train* students in any practical skill that would automatically render them employable upon graduation. The baccalaureate degree represents only entry-level awareness of any field, of course. Beyond that, the philosophy of these systems, in fact, distinguishes between education and vocational training; their purpose is *education*. The inappropriateness of this student's expectations was as ludicrous as Bogey's claim that he'd come to Casablanca "for the waters." The difference was that, unlike Bogey, our student wasn't making a joke.

I pursued the discussion, in order to discover whether the student was ignorant or, instead, dumb. (This is a useful distinction propounded by my colleague, the Baltimore Oriole: Ignorance is a condition, dumbness is a commitment.) While the dialogue that ensued persuaded me that this student was deeply committed, subsequent discussion with his classmates revealed that most of them — roughly ninety-five percent, by my casual estimate — didn't realize that there were significant differences between graduate and undergraduate education (beyond a vague assumption that, back in what they call "the olden

days," the higher you went the tougher it got), nor that the historical mandates of university, fine-arts academy, polytechnic institute and workshop education were not only radically different but often fundamentally, even diametrically, opposed.

How had they gotten so (let me be generous) ignorant? Part of the answer is to be found on the academic letterhead of another colleague, Robert Muffoletto, editor of the new scholarly quarterly *FRAME/ WORK*. Bob is forced to teach, ignominiously, in an oxymoron: the California State Polytechnic University in Pomona, whose founders were evidently unaware that the polytechnic institute arose precisely to oppose the European university system, with a socialistic agenda deliberately antagonistic to and incompatible with the premises of university study.

Let me be generous again: If our students are ignorant of the nature of the very contexts in which they study, perhaps it's because the teachers and administrators who inhabit those contexts are equally ignorant. This is particularly the case, I suspect, with North Americans, as none of the currently predominant contexts of photography education is indigenous to us; they are all European by birth. So it might be useful to reiterate the origins and purposes of these different approaches to education, so as to provide a basis for any subsequent discussion of their present-day manifestations and the differences between them.

•

From time immemorial, people have gathered — singly or in groups — to study with those they thought had valuable skills, knowledge, or wisdom to impart. In primitive societies, the tribe's best hunter, flint-knapper, shaman, and medicine woman passed along their expertise to selected members of the next generation. Here lie the beginnings of the master-apprentice relation.

As tribes grew and merged, forming larger societies, the connections between teachers and their prospective students became less immediate and more arbitrary. A novice might decide to sit at the feet of someone he or she had never met and knew only by reputation, even to travel a great distance in order to do so. Certain teachers attracted numbers of such students — people who came to them, voluntarily, for the purpose of learning.

Though not the earliest, the model most familiar to all of us is that of Socrates and his circle. Socrates taught workshops, open to the public. They were workshops in thinking: his students brought their

best ideas, submitting them to the cleansing fire of Socrates's criticism. (Let there be no mistake about it; "All criticism is destructive, especially self-criticism," as Man Ray said.) The purpose of criticism, Socrates proposed, was to find the weak spots in the concept so that you could build a better one next time.

Aside from monasteries, a few atypical conclaves of scholars, and certain schools connected with the Catholic Church, there was nothing even approximating the formal institution of higher learning until the invention of the university early in the twelfth century.[1] In some ways, the university can be seen as an outgrowth of the *studium generale* — a type of school attached to some cathedrals — but there are no earlier models of formalized higher education. The university is generally conceded to be uniquely medieval — no less typical of the Middle Ages than the parliament and the cathedral.[2] As Nathan Schachner puts it, "Three all-embracing institutions characterize the Middle Ages — the Church, the Empire, and the University. Of these the first two were derivative; only the University was peculiarly a medieval invention."[3]

The fundamental idea of the university is that of an interdisciplinary community of scholars. Though, in the minds of many, it has come to represent a system encompassing all knowledge, the term *university* itself simply meant aggregate or collection. "Historically, the word university has no connection with the universe or the universality of learning; it denotes only the totality of a group, whether of barbers, carpenters, or students did not matter."[4] Universities, then, were essentially guilds of masters and students — unsubsidized by state or church, organized for such practical reasons as collective bargaining with townspeople to keep the prices of food and lodging down. Colleges were subdivisions of universities — initially, nothing more than endowed hospices for indigent scholars.

Excluded from the universities of students (*universitas scholarium*), professors formed guilds of their own (the *universitas magistorum*), with admission thereto by examination only. The certificate awarded to those who passed these tests, the license to teach (*licentia docendi*), "thus became the earliest form of academic degree," according to Charles Homer Haskins.[5] Among the defining aspects of the university, the same source tells us, are "the notion of a curriculum of study, definitely laid down as regards time and subjects, tested by an examination and leading to a degree"; the multiple faculties and colleges; and "its main business, the training of scholars and the maintenance of the

tradition of learning and investigation."[6]

First and foremost, then, one went to the university to learn how to study, to acquire knowledge for its own sake. In that process, the student learned to teach. A "bachelor's" degree qualified one only to tutor students less knowledgeable. An advanced degree entitled its bearer to teach anywhere — or else to practice law or medicine, or to enter the ministry. Beyond that, there was not much one could do with a university degree. In reading the following passage, bear in mind that the "vocational motive" of which its author speaks was restricted to the occupations just mentioned:

> Not only was the vocational motive a strong incentive to study in the medieval university, but there was much enthusiasm for knowledge and much discussion of intellectual subjects. The greater universities, at least, were intellectually very much alive, with something of that "religion of learning" which had earlier called Abelard's pupils into the wilderness, there to build themselves huts that they might feed upon his words.[7]

Most authorities credit the "influx of new knowledge into western Europe . . . chiefly through the Arab scholars of Spain — the works of Aristotle, Euclid, Ptolemy, and the Greek physicians, and those texts of the Roman law which had lain hidden through the Dark Ages"[8] with generating the heated intellectual environment in which the university idea could flourish. Law, medicine, science, theology, philosophy; these were the concerns of university study on its highest levels. The basis of the curriculum were the seven liberal arts: the *trivium* (grammar, rhetoric and dialectic) and the *quadrivium* (music, arithmetic, geometry and astronomy). More emphasis was placed on the former than on the latter, until the 13th century.

"To medieval men the collegiate skills were called 'liberal arts' because they were arts that liberated those who practiced them," Strasser indicates. "Once acquired — and they do not exist outside of those who possess them — the liberal arts are enriched capacities to perform well in certain lines of endeavor. This is why a liberal art is recognizable only in its use. It is a liberty born of strength. It follows that this liberty can be displayed only by the person who knows that in his field there is more than one way to achieve ends."[9]

Thus the original universities are best understood as "schools of philosophy, mental and physical, [where] the attention of students in [liberal] Arts was chiefly directed to the logic, metaphysics, physics,

and ethics of Aristotle."[10] The thrust, then, was theoretical, abstract — what would come to be called *the life of the mind.* "Then as now, the moral quality of a university depended on the intensity and seriousness of its intellectual life."[11]

A brief summary of the curriculum of the University of Paris will indicate how this "moral quality" was achieved. Students could enter the university at the age of 14; a knowledge of Latin — acquired in what were called grammar schools — was required.[12] They took courses two and three times over, the first time from a master, the next from a bachelor, for review purposes. ("Bachelor" was understood as an intermediary degree.[13)] The shortage of books (all texts were manu-scripts, this being well before Gutenberg), along with the cost of paper/vellum, meant that the oral tradition remained strong — involving stu-dents and teachers in much repetition of texts and memorization.[14] This period of study was followed by stringent oral exams: first, private de-bates (*responsiones*) with a master in his discipline; then public exami-nation (or *disputationes*) by a board of masters, depending much on rhetoric, logic, and verbal performance.

The student who survived these trials went on to work as a full-time faculty member in his discipline for two years. Finally, after a private examination conducted by four masters, he became a candidate for the master's degree, the ceremonies for which included a presenta-tion of his arguments to the entire academic community. The signifi-cance of these rites of passage is summed up well in the following passages:

> [B]y cultivating in its students the arts of disputation and teaching, the medieval university was re-establishing in its own way the an-cient Greek ideal of education as virtually synonymous with rhetoric. . . . [T]his emphasis on oral expression produced much more than mere fluency of speech. What it was intended to provide . . . was a *mastery* of whatever information a student had acquired. It is in this sense that the 13th century may be said to have retained — or, rather, recovered with the help of Aristotle — the classical idea of educa-tion: the idea that our knowledge is complete only when we can ex-press it.[15]
>
> . . . most 13th century graduates did not intend to embark upon a teaching career. The point is that at the time of graduation they were accomplished in the performance of their craft: the two-fold craft of knowing how to assimilate difficult materials and how to communicate them.[16]

When, and only when, students could express their knowledge well enough to hold their own in a public debate with their masters were they themselves acknowledged as masters.[17]

The value to the individual of such an education seems self-evident. Yet we must keep in mind that this system primarily served the wealthy. Few in the working class could afford the expense of supporting their offspring through such a lengthy course of study; barring subsidy from some patron, that society had no assistance to offer the student, the teacher, or the dedicated scholar. University education, and the choice of teaching as a profession and/or the pursuit of research, therefore must be seen as privileged from the outset; certainly it was so understood once the university system was entrenched, at the beginning of the Renaissance.

•

By the end of the Middle Ages, artists were being trained in a rigorously controlled apprenticeship system within what were essentially production houses for patron art. Prior to the apprentice system, art was largely church-sponsored, taught and produced within the monasteries. "This transition from the theological to the secular sphere marks a watershed in the history of art; it made possible communal participation," argues Albert Boime.[18] Thus the cultural situation of art production shifted dramatically; artists, as workers, found themselves practicing and marketing their skills in the same social environment as other craftsmen and artisans.

This secularization of art-making both expanded the client base for artists and forced artists in turn to widen the range of their skills to serve the needs of this increased variety of customers. "Under both commune and princes the [Renaissance] artist fulfilled an important function in the life of the city, since the Church, the nobles, and wealthy merchants were in constant need of his works. He could satisfy all these different demands since, because of the apprentice system, he was a versatile craftsman."[19]

That versatility, characteristic of Renaissance artists, resulted from early training in several crafts achieved through a hands-on, learn-by-doing instructional system. In Helen Gardner's description,

Each well-known artist had a shop (*bottega*) — forty-one of these are recorded in Florence (total population about 150,000) between 1409 and 1444 — which a boy could enter at the age of ten or twelve as an

apprentice. [Others suggest that the earliest one could start was age 14.] There he learned how to grind colors, prepare a panel of seasoned wood for painting, use gold leaf, and transfer cartoons (the master's preliminary drawings) to the panel or wall. After some years spent in mastering these and other fundamentals of his craft, an apprentice was entrusted with the execution of minor parts of an altarpiece, usually following the design of the master.[20]

Such education was a two-way street, of course. The master in turn accepted the responsibility of training his own competition. He "was obliged to teach the apprentice, through practical training, all that he knew of his art. The young artist was immediately confronted with the object to be produced and became technically trained before being introduced to theoretical principles. [When] the apprentice progressed to the next level of training, that of the *compagnon*, or journeyman, . . . he participated to a much greater extent in the master's work."[21] Eventually, if he so chose, he left the master's shop, was entitled to apply for certification, and if approved was admitted to the painters' guild as a master himself, with the right to set up a *bottega* of his own. To go from apprentice to master took from 6 to 16 years, depending on one's field.

Though it emerged towards the end of the Renaissance, the art academy was less a Renaissance phenomenon than a Mannerist response to the post-Renaissance.[22] "The first academies were founded to provide a sense of security in an insecure time by establishing artistic rules based on the ideals of the High Renaissance. Nostalgia for the achievements of the 'great masters' and a conscious search for formulas as a means of attaining perfection provided academic criticism and rules to plague the painter," Gardner tells us at one point.[23] Elsewhere she suggests that, "As an outgrowth of the individualistic and rationalistic spirit of the Renaissance, the traditions and standards of the shop system were gradually relaxed during the fifteenth century and virtually disappeared by the latter part of the sixteenth in favor of instruction in the academies of art."[24]

Whatever the causes, this represented yet another shift in the production context of art. The establishment of artists' workshops had meant a transfer of power, from the church as a controlling force to the guild or union. Next there occurred a "transition from the guild-controlled arts sanctioned by the Church to an academic system sponsored by the state."[25]

This evolution began in Italy, where the guilds "metamorphosed

into schools and the concept of an academy emerged. The academy reasserted the equality of the plastic arts with the liberal arts, a principle it now declared by virtue of its theoretical instruction."[26] In effect, the art academy thus declared itself to be of equal stature to the university. This symbolized a change in the cultural status of art, an increased respect for art and artists; it also dictated that certified artists would thenceforth more likely be drawn from the upper classes and the emerging bourgeoisie than from the working class that had, to a considerable extent, made up the artisanal cadre of the workshops.

From its genesis in Italy, "this advanced state of art instruction was transplanted on to French soil by the Valois kings whose Italian conquests had brought them into close contact with this aspect of Italian culture."[27] However, unlike its Italian counterpart, "The original [French] Academy . . . never wholly relinquished ties with the old corporations [*i.e.*, guilds] from which it borrowed the formal structure. . . . The Academy added to this formal structure the theoretical foundation for the arts that it had borrowed from the Italian system and the School of Fontainebleau."[28]

State sponsorship of the arts, then as now, always had its price; and art education was not exempted from that toll. Indeed, the increasing presence of visual art throughout European culture, on all class levels — for inexpensive woodblock prints and other images in multiple were already circulating widely among the population at large — made state control over visual art imperative. Direct authoritarian censorship is the most obvious form of such control, but more subtle, insidious methods were available, and quickly put to use:

> . . . a common-sense principle was invoked by the Academy over and over again until deep in the nineteenth century: *Control instruction and you will control style.* The Academy retained the institution of apprenticeship as a preliminary stage in the artist's education. The pupil neither painted nor carved at the Academy; he received his practical instruction in the atelier of his master, with whom he lived and worked, as formerly in the corporation. Drawing alone was taught at the Academy and the Academy emphasized it as the theoretical element uniting all the branches of art (dessin). This separation of the artist's instruction into the practical and the theoretical was retained intact until 1863. . . . The Academy was made-to-order for Louis [XIV] and Colbert [his minister]; the prestige of belonging to it lured artists into giving up their independence and the King could impose his de-

sires more easily upon a body of Royal Academicians than upon a private group or corporation.[29]

When the Academy — identified with the aristocracy — fell with the French Revolution, it was replaced with the Institut de France, no less conservative.[30] Universities in France suffered a similar fate. Both art academies and universities continued to flourish elsewhere, of course, and eventually re-established themselves in France. However, in the wake of the Revolution a new form of educational system arose: the *polytechnic institute.*

In the new schools that arose after the Revolution had established itself, the studies that had been pursued by the aristocracy were discarded. Purely speculative subjects were forbidden, as were all archaic subjects (dead languages, religion); history, literature, even grammar received short shrift. The emphasis was on science, particularly hard or applied science. This led to the development of that attitude which the French would later dub *scientism* or *the scientistic* — a way of thought that seeks to minimize human individuality by emphasizing the collective and quantifiable aspects of social behavior, its supposed "rules" and "laws."

The thrust of the polytechnic posture was *practical* rather than *pragmatic* (to use William James's distinction); its tendency was instrumentalist. For the polytechnic student, *engineering* was the fundamental model, blueprint-making the basic skill. Not surprisingly, these schools were hotbeds of socialism, with that political philosophy's commitment to social engineering.[31]

The making of things, useful, functional things, was a primary goal of all polytechnic education. In the arts, this meant the emphasis on architecture, industrial design, and other forms of applied art. The Bauhaus in Germany's Weimar Republic (subsequently transplanted to the United States as Chicago's Institute of Design) was the archetype of the *école polytechnique* as a training ground for artists.[32] (Our best-known version of the latter, in photography, is the Rochester Institute of Technology — which, far from being a hotbed of socialism, is umbilically tied to the Eastman Kodak Corporation.)

•

These, then, are the three principal contexts in which photography today is taught to the putatively adult: the college or university, the art academy, and the polytechnic institute. To these we might add sev-

eral ancillary forms: the vocational training program — a diluted version of polytechnic education — offered by such institutions as the Germain School in New York and the Brooks Institute in California; the "community" or "junior" college, whose function is largely introductory; the "adult/continuing education" program, with its tendency toward the social, the entertaining, and the therapeutic; and the "alternative" workshop, which is prone to the problems endemic to community college and adult education.

(While, at its best, the alternative workshop represents an attempt to preserve/restore the master-apprentice experience, its effectiveness is reduced by its usually short-term nature, and its integrity often compromised by a liaison with the vacation impulse. A few photographers — Sid Grossman and Harold Feinstein, for example — have regularly offered private workshops, with no institutional superstructure; some have proven extremely influential. The option of apprenticeship remains widely available, of course; to some extent, it finds an institutional form in the sometimes voluntary, sometimes mandatory "internships" built into many accredited educational programs.)

After almost twenty years of observation of and involvement in various approaches to photography education, I think it is safe to say that there is no formal course of study of photography today that offers the experiential intensity and craft grounding of the long-term master-apprentice relation, as it was manifested in the Renaissance workshop and the academician's atelier, or the formal rigor and theoretical exploration of the fine-arts academy, or the intellectual breadth and scholarly depth of the university. Even institutions that can measure up to the stringent technicism of the polytechnic institute have become rare.

I will grant you, without argument, any single institution you care to name as an exception in any category; I will challenge you to name five more like it in that same category if you would disprove my contention — which is that we have grievously confused the function of these various forms of education, to the point where neither we nor our students are clear about their destinations. Are they en route to becoming amateur artists, professional artists, professional teaching artists, professional applied photographers, or professionals in other fields (the observational disciplines such as sociology and anthropology, for example) to which photography is somehow pertinent? What appropriate role(s), if any, do the particular educational institutions in which each of us is involved have to play in those processes?

As a result of this confusion, the state of photography education seems to me bad, and rapidly getting worse. This is not to say that none of today's young photographers are genuinely educated; rather, it's to suggest that — notwithstanding the much-celebrated spread of photo education — those few who are truly educated in photography actually *earned* their education by piecing it together themselves, achieving it not because of but despite the institutions they attended.

The shambles of the field is reflected, appropriately, in the rapid deterioration and imminent collapse, at least on the national level, of the Society for Photographic Education. The organization is so befuddled on even the most basic issues that it sponsored a national survey of MFA programs written and conducted by a graduate student — who, predictably, was so inexperienced that she didn't know what questions were essential to ask. (Such as: Do you accept your own undergraduates as graduates? And do you hire your own graduates as faculty? Both of these practices being infallible signs of terminally corrupt and inbred programs.) Next year's national conference, to be organized by the SPE's Board of Directors in their spare time, will be merely an adjunct of Houston FotoFest. The only hope for the organization, in my opinion, lies in its regional divisions, which fortunately have been gaining in strength and stability over the past few years.

As you have probably guessed by now, I am not optimistic about the immediate future of photography education. Most of the worst-case predictions that I made to my colleagues in the field in my 1978 keynote address to the National SPE Conference have either come to pass or are hard upon us.[33] Moreover, the demands of vocational training are increasingly being put upon university, art-academy, even junior-college and adult-education programs. This is to the benefit of none of those involved.

When such confusion reigns, the only possible path out of the welter is to re-examine the context and the operative definitions. If faculties and administrations were to scrutinize their institutions in light of the distinctions I've made above, they might be able to come to some clearer idea of the historical precedents and mandates of their institutional forms: where they came from, what they are, what they are not, and what they can't expect to become. As Dirty Harry is fond of saying, "Man's got to know his limitations."

A photographer I know who taught at one of the nation's oldest (and once most respected) art schools was barred by his administration

from attending departmental recruitment events a few years ago because, whenever asked by anxious parents whether their offspring would be assured of a job upon leaving the institute, he invariably responded, "Not as a direct result of anything they'll learn from me." That answer is both honest and appropriate; but, in that context, the question should never have occurred — and, if asked, should have received that very answer from the department chair himself.

So, even if it did not provide any immediate solution to the complex dilemmas in which the field of photography education is immersed, a reconsideration of the origins of our various educational institutions would at least spare a great many people a good deal of embarrassment. If such a reconsideration had begun a decade ago, my colleague's chairman would not be mortified by his faculty member's forthright articulation of what should be a given in a photography program in an art institute. The California Board of Higher Education would not look ridiculous for permitting an institution under its control to take on the self-contradictory title of "polytechnic university." And my former student would not feel foolish when he eventually realizes (as I hope he will) that his parents spent more than forty thousand dollars to buy him a degree from New York University but he never bothered to find out what a university was.

The best summation I can offer of the field at present is that none of these people who have thus embarrassed themselves feel any embarrassment whatsoever.

Now that's *dumb.*

(1987)

Victor Schrager, *Untitled*, *1979* (original in color).

POLAROID: TOWARD A DANGEROUS FUTURE

> "It is the business of the future to be dangerous."
> — *Alfred North Whitehead*

In her preface to *One of a Kind: Recent Polaroid Color Photography*, Belinda Rathbone offered a provocative formulation of the issues raised by this group of images. (Rathbone edited this superbly printed coffee-table book, which is also the catalogue of a currently traveling exhibition curated by her.) As she put it, the *One of a Kind* book and show provides "an occasion to question and explore the extent to which the medium affects the artist and the artist the medium, and what this reciprocal union might yield."[1]

Those are always important questions to ask and to ponder. But (perhaps because she was employed by Polaroid at the time) Rathbone omitted from her equation one major and essential factor. Without that factor the equation is incomplete, the resolution thereto necessarily unspecific and inaccurate, and the real lessons thereof unlearnable.

•

In the summer of 1980 I had the opportunity to observe the workings of the Polaroid 20x24 camera, set up in a studio at the Arles festival (officially called the Rencontres Internationales de la Photographie) in southern France. The studio was being made available at no cost to "art photographers" who were present at the festival. In return for the photographer's choice of a print to donate to the Polaroid "Europa" collection, each photographer who signed up was permitted several hours in which to experiment with the mammoth device, and was allowed to keep all other prints he or she produced. Use of this studio included materials, a sophisticated lighting system, and a full-time "technician" to operate the 20x24. The studio was booked solid for the entirety of its available time.

While watching, I overheard a discussion between one of the fortunate photographers and a Polaroid representative. The photographer — who had worked with Polaroid materials before, but never with the 20x24, and never with any camera format that large — was unsure of what subject matter to address with this device, and was thinking out loud about the possibilities. The man from Polaroid suggested that she

"bring in people off the streets — common citizens, everyday types — for formal portraits." He was willing to introduce her to some eminently picturesque local types — a colorful barfly, to mention just one. . . .

•

The missing factor in Rathbone's equation was the Polaroid Corporation itself. The corporation has long been a silent partner (and, as the above incident suggests, a sometimes less than silent one) in the development of an extensive body of "creative" Polaroid photography. The corporation's role in this cannot merely be subsumed into the category of "medium" (as can, say, Kodak's impact on imagery as exercised through the aesthetic and perceptual options and limitations built into its products). Polaroid's influence on the work created by those who use Polaroid systems to generate "art photography" is hardly limited to the consequences of the structure of the tools and materials alone.[2] Rather, it extends much further — it is now intertwined with the economics, production context, presentation and dissemination of the imagery itself.

This is a direct result of Polaroid's commitment to supporting creative experimentation with Polaroid equipment and film. By comparison with most other manufactures of photographic products, Polaroid's approach to this issue seems exemplary. Film has been given away in large quantities. The various SX-70 camera models have also been given outright to many artists, while more expensive equipment has been lent out for prolonged periods (or, in the case of the 20x24 camera, made available). A considerable amount of imagery has been purchased for both the Boston and the "Europa" collections. And that work has been circulated in numerous Polaroid-organized exhibitions, anthologized in at least two Polaroid-sponsored books to date, and otherwise disseminated, sometimes directly by the corporation and generally with its blessing and assistance.

I do not intend to suggest that this aggressive policy is insidious, or even wrong-headed, on Polaroid's part. The benefits that accrue to the corporation thereby, in public relations value alone, are enormous; and though I have yet to see an estimate of the financial value of the collections, their promotion by the corporation has surely not decreased their value in the marketplace. By the same token, photographers who could not otherwise afford to explore Polaroid equipment and materials have been given the opportunity to do so. They have thus been enabled

to create works that they can publish, exhibit, and sell independently, and in many cases have had their results purchased and/or disseminated (through exhibition and publication) by the sponsoring institution itself.

To complain about this situation *per se* is to step into the role of dog-in-the-manger. The corporation seems to have no regrets over its role in all this, and the only *consistent* criticism I've heard from photographers is that the selection of those chosen to receive Polaroid's *largesse* is "political" — *i.e.*, involving favoritism — and that Polaroid is "chintzy." Yet, short of providing unlimited access to the equipment and an endless supply of film to everyone who decides that he or she is an "art photographer," there's no way that Polaroid could avoid such accusations. Since that's patently impossible, those charges can be largely discounted.

Why, then, do I feel this lingering unease?

Its source is a critical perception: given what seems to me to be the revolutionary nature of Polaroid as an image-making process, the work being produced thereby *under the aegis of the Polaroid Corporation* is aesthetically and conceptually conservative.

My basis for this observation is the imagery collected in *One of a Kind* and in *SX-70 Art*.[3] The former is drawn primarily from the Boston collection, and functions explicitly as a catalogue of the exhibit as well as a printed anthology. The latter draws heavily on the "Europa" collection; an exhibit that closely parallels the book is currently touring Europe. (I saw it at the Beaubourg, in Paris.) Together, these two books and their exhibition versions comprise what might be called the public face of Polaroid's direct sponsorship of creative Polaroid photography. It is from those manifestations of Polaroid's attitudes toward work in the medium it controls that the following tentative conclusions have been drawn.

Most of the photographers represented in *One of a Kind*, and many of those included in *SX-70 Art*, seem fixated on the past — not *their* past, in a specifically personal sense, but history. How else to explain their urge toward preservation, their devotion to archaism, their elaborate fussing with antique knick-knacks? How else to interpret their continual references to other, already-existing images — a practice that reaches an apogee of sorts in Victor Shrager's repetitive Sears, Roebuck catalogue-style arrangements of art reproductions?

In her introduction to *One of a Kind* ("A Still Life Instinct: The Color Photographer as Epicurean"), historian Eugenia Parry Janis attributes this to the medium itself, citing a "hermeticism" that she believes is virtually built into the "color chemistry" of Polaroid materials.[4] Rathbone, in an article published after her departure from the Polaroid fold, notes the same phenomenon: ". . . Polaroid photographers can be generally noted for their isolation from prevailing photographic trends, with which Polaroid materials are not necessarily compatible. Instead, they have had to adopt (more or less) the conceptual position of their ancestors. . . ."[5]

Either (or both) of them may be right. But let us at least consider another possibility — that the Polaroid imagery being supported by the Polaroid Corporation is shaped to a great extent by that very sponsorial process. If this is true, then generalizations about "Polaroid photographers" based on such biased data are highly questionable. (Indeed, when they come from someone currently or previously involved in Polaroid's sponsorial network, they may be little more than self-fulfilling prophecies.)

Is it coincidental that the imagery in *One of a Kind* and *SX-70 Art* is, by and large, emotionally tame, thematically and stylistically classical (with some exceptions, notably in the SX-70 work), and often academic in its reference points? Might one ask why Les Krims — who has created, published, and exhibited a large body of disturbing SX-70 fantasies that are highly controversial — is represented in both these books by only a single untypical image that is not readily identifiable as his and contains none of his characteristic emotional charge? Could that be related to the story told to me by another artist — known for his inquiry into the connections between sexuality and American culture — who was unable to complete his project with the 20x24 because the Polaroid technician assigned to work with him objected to the content of his imagery and refused to assist in its making? And is that in any way linked to the previously mentioned Polaroid representative's attempt to insinuate his own aesthetic into a photographer's decision-making process?

•

It is perhaps inevitable that a major corporation — even one built around a revolutionary imaging system — would, consciously or not, tend to favor safe, likable, non-controversial and unthreatening "cre-

ative" applications of their products. One can add the argument that, historically, the first uses of new communication technologies tend to mimic and recapitulate their predecessors: the first films aped then-current theatrical styles, early television was a visual version of radio, and so on.

Still, without casting aspersions on anyone, we might conclude that, on the evidence provided by these books and exhibits, Polaroid's impact on creative Polaroid photography to date is a paradigm of the problems inherent in corporate sponsorship of art. Then, rather than accusations, all involved might glean from this some valuable lessons.

Polaroid might well look carefully at the work that has resulted from its direct patronage and ask why so little of that work suggests that Polaroid processes were essential to its production. The corporation might also ask why so much of this work is merely quaint, clever, fey, and decorative, and why so much of it is conceptually bland, socially disengaged, and emotionally neutral. Has Polaroid truly been sponsoring artists who embrace the visual challenges inherent in Dr. Land's visionary invention? Should there not be risk-taking on the sponsorial end to match the radicalism of Polaroid as an image-making tool? (After all, it was Dr. Land himself who, at Polaroid's annual stockholders' meeting in 1977, declared to an economically timid questioner that "The bottom line is in Heaven."[6])

The artists receiving Polaroid sponsorship, in one or more of its many forms, might ask themselves similar questions from their own standpoints. Are they shaping their work — consciously or not — to please Polaroid executives and satisfy a corporate vision of what Polaroid photography should be? Are they in fact exploring the structure, the syntax, of the various Polaroid processes in order to locate what is unique to these materials and this technology, or are they letting themselves be cowed by it into a formulaic aestheticism?

The critics and historians might ask these questions too, examining their own roles in this nexus of activity. Is it possible that evaluations of recent Polaroid work have been hasty, even premature? What constitutes a body of work in Polaroid? Which if any of the existing ones are exemplary, and why? In their analyses of books like *One of a Kind* and *SX-70 Art*, are they ignoring the corporate component and its shaping influence? Are they assuming that these books represent both a true cross-section of everything significant that *is* being done with

Polaroid, and a fair representation of what *can be* done with it? In short, are they — are we — tailoring our understandings of Polaroid's potentials as a medium to fit the limitations that this sponsorial system has (no matter how benignly) imposed?

The various Polaroid systems have unique qualities of their own, which seem to me to have remained largely unexplored. The immediacy of the image's appearance is certainly the primary one — and, as an aspect thereof, the emergence of the visible image within the original context of its making. This is a phenomenon that has significant consequences when the subject of the imagery is one or more human beings. Though common to all the Polaroid processes, this phenomenon is an issue in only a few bodies of Polaroid work.

There are also aspects of the individual Polaroid processes that merit investigation. With the 20x24, for example, scale, virtual grainlessness, shallow depth of field, and studio conditions are all givens. Few photographers have used these as springboards; the latter two have most often been taken as constraints.

With the SX-70, the rapidity of print ejection encourages a kind of gestural drawing and the creation of multiples, variations on themes, and sequences. The symmetricality of the prints, as well as their small size, lends itself to the piecing together or "quilting" of larger works. The system's effects on the dynamics of portraiture and group interaction are unprecedented. Yet none of these qualities is explored at length in either book. (The inherent miniaturizing effect of the SX-70 print, and the malleability of its emulsion, are annotated somewhat more thoroughly.)

Looked at from another vantage point, one can note themes and issues that — if one takes these books as comprehensive — have yet to be addressed. Among them are the family, human labor, social situations, the male nude, motion, multiple exposure, politics, autobiography . . .

This begins to should like a shopping list, so I will end it here. There is work I have seen — some of it represented (always too briefly to be really useful) in these two books, some not — that I think points toward the future of Polaroid photography. Nathan Farb, Doug Holleley, Robert Heinecken, Sharon Smith, Les Krims, Lucas Samaras, Kelly Wise, Chris Enos, Robert Delford Brown, John Reuter, Joyce Neimanas, Benno Friedman, and Rosamund Wolff Purcell are among those who

have produced it. But most of what I've seen that has resulted directly from the interaction between the artist, the medium, and the Polaroid Corporation looks not forward but longingly backward, toward the past.

(1980)

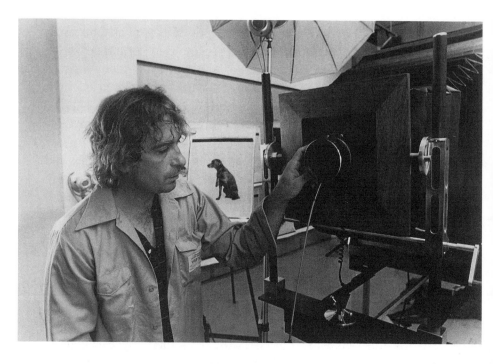

William Wegman with 20 x 24 camera, (photographer unknown); courtesy Polaroid Corporation.

PHOTOGRAPHY CRITICISM:
A STATE-OF-THE-CRAFT REPORT

Shortly before his recent death, art critic Thomas Hess called for "twenty years of cold, boring formalist criticism of photography, beginning with this question: If the lens is round, and the image is square, what happens in the corners?" Unfortunately, Hess did not live long enough to answer his own burning query, though I'm sure that somewhere out there some eager beaver is plotting it all out with charts and graphs.

From an almost diametrically opposite standpoint, another critic recently gave us this reading of Robert Frank's photograph, *Sagamore Cafeteria*, which shows a group of smiling female office workers: "The picture reveals the quiet optimism, the self-confidence of working people (which I believe stems from their intuitive belief that they will eventually triumph as a class)."

To envision these two gentleman together in a room, each attempting to persuade the other of the overriding importance of his own stance, is to conjure up a futile, eternal, hellish wrangling worthy of Jean-Paul Sartre himself.

•

Back in 1974, I described the state of photography criticism as "pre-critical mass." I felt, at that time, that the crucial problems in the field of photo criticism included the minuscule number of practitioners of the craft and the lack of sufficient forums and outlets for critical writing on photography.

This no longer holds true. The ranks of photography critics have swelled considerably in the interim. And although regrettably few major newspapers and magazines have opened their pages to photography criticism, the number of smaller, more specialized publications has grown rapidly. They are hungry for intelligent writing, and there are enough of them that anyone entering the critical arena in a committed way is not likely to go unpublished — though he or she is likely to go unpaid.

So I'd revise my estimate at his point. The stage of critical mass has been reached. Yet I am not convinced that we have come any closer to achieving the goal that purportedly underlies all this activity: the creation of a meaningful critical dialogue in photography. By this I

mean neither the unilateral pronunciamentos of camp followers nor the internecine warfare within one or another critical mode, but rather a wide-open, ongoing, interconnected discussion of current issues and contemporary work, a discussion in which all members of the critical circuit — critics, image-makers, and audience — are actively engaged.

This strikes me as the obvious next stage in the development of photography criticism. Yet it seems to me that photography criticism at present is — or is felt to be by its practitioners — caught between the Scylla of academic writing addressed to an elite and the Charybdis of a more practical, colloquial stance intended to engage a wider audience.

One could give these tendencies other names — *theoretical* instead of *academic*, *applied* in place of *practical* — but the principles and issues would remain the same. On the one hand, there are factors such as the increasing interconnection between photography and other media, the dramatic and continuing expansion of the cumulative body of imagery subsumed under the rubric of "photography's history," and the current burst of infrastructural inquiry on the part of photographers and other image-makers involved with the medium. All these seem to direct the practitioner of that ancillary form known as criticism toward a formalist, hermeneutic frame of reference aimed at those most single-mindedly engrossed with the photographic image: scholars, historians, photographers, artists, and other critics.

On the other hand, the small size of the current audience for photography — small in relation to the volume of imagery now being generated, and small in contrast to what appears to be the potential size of that audience — makes it painfully clear that the medium is reaching neither the maximum nor the optimum number of people. The critic-as-aesthete can disregard this situation and disclaim responsibility for it; the critic-as-intermediary cannot.

This may seem to be much too mundane an issue to broach. But the longer I remain in the field of photography criticism, the clearer it becomes that one central question is, "To whom is my/your/our work addressed?"

Based on what I've been reading (and where I've been reading it) over the past several years, I'm of the opinion that we're tending more and more to talk to ourselves. Rather than working to build and educate an ever-growing audience for the medium, our writing in aggregate seems directed principally to those who don't really need it: the existing cadre of the visually sophisticated.

This signals something askew in our priorities. The medium at present is undergoing not only a period of tremendous, energizing redefinition from within, but also a time of concentrated attention from without. It is a juncture that contains the potential for rapid expansion of the engaged audience for photography.

The purpose of such expansion would not be critics' self-aggrandizement, but the broadening of the medium's base of knowledgeable support. Such growth will be necessary for the medium's continued health. Indeed, the development of such an increasingly alert audience is presumably one of the primary reasons why photographers — and critics — put their work out in the public eye in the first place.

So it seems ironic to me that with more photographic imagery than ever before being published, exhibited, and collected, and with an audience more primed for the medium than any we've had for a long time, I'm finding proportionately less to read about this ferment and the specific works contributing to it in publications directed at that audience — less than we had even five or six years ago.

I'm not speaking here of the specialized publications — the large-circulation camera magazines (the quality and volume of whose critical coverage has increased significantly in recent years), the art-critical journals finally paying some heed to photography, or the "little magazines" of the medium, whose number has continued to rise. I'm speaking of general-interest newspapers and magazines.

New York being our own locale, let me use it as an example. Six years ago there might have been an average of 100-150 significant photography books published each year. Roughly one-third of those would receive some critical attention — and thus some exposure to readers — in the *Village Voice* and/or in one or another section of the *New York Times*. Today, with perhaps four times as many photo books coming out per annum, there are numerically fewer critical discussions of them in those periodicals.

Similarly, while the number of galleries, museums, and other institutions exhibiting photographs has multiplied a hundredfold since the late 1960s, the number of exhibitions reviewed in the *Voice* and the *Times* has decreased steadily during this period. And it is only at the *SoHo Weekly News* and — to a much lesser extent — at the *New Yorker* that space for photography criticism can be said to have opened up in any of this city's general-interest publications.

Surely the cause of this is not the lack of an interested reader-

ship. To some extent we can attribute it to benighted editors. And, without blameful intent, we might trace some of it to an understandable inclination on the part of those critics with access to such forums to write extended considerations of a few exhibits rather than capsule reviews of many.

Yet, whatever the cause, the fact remains that it's a rare book or exhibit that will receive critical attention in more than one New York-based general-interest publication. And though a great deal of the current volume of photography criticism emanates from New York, I find it's a rare critic of the medium who's writing in a language designed to be accessible to such readers. Consequently, should the benighted editors I've just mentioned suddenly see the light, I for one would be hard-pressed to tell more than one or two of them where to look for substantial yet accessible writing.

Without meaning to negate the potential usefulness of formalist criticism at one extreme and politically programmatic criticism at the other, I do want to suggest that with these as the dominant modes of critical discourse in photography we are more likely to alienate the public from the medium than to encourage that public to engage actively with either the criticism or — dare I even mention them? — *the primary works themselves.*

What we need, it seems to me, is a group of critics less interested in equating themselves with photographers or aligning themselves with curators, gallery owners, and other critics, and more actively committed to functioning as articulate intermediaries between the work of photographers and the largest potential audience for that work. Such positioning is another form of "knowing where to stand," and is no less important in photography criticism than in photography.

•

Finally, a brief afterthought.

In assessing the Second Conference on Photography Criticism, which took place at the Visual Studies Workshop in April of 1977, I suggested that we needed a greater willingness to be brutal on the part of photography critics.[1] I wasn't thinking of the brand of *thuggee* being practiced by at least one local critic, but rather of the general absence of clear, high, difficult-to-meet standards for work done in all the various modes of photography. As critics, I think we've come to accept a shockingly low level of research, fieldwork, articulacy, fore- and afterthought, and commitment from photographers. For example, we're prone to con-

sider any image of any urban situation as constituting a "social comment," and any body of such images as a social critique. We tolerate photographers' one- and two-week junkets into other cultures or subcultures, and the presentation of their uninformed snap judgments, as "in-depth studies." An attention to one or another subject so fleeting that it would be considered scandalous in any other discipline is accepted without question in photography.

Perhaps photography critics tend to be generous in this regard in the hope that others will be equally generous to them in their pretensions. I think there may be value to psychoanalytic, structuralist, and political analysis of photographs specifically and photography in general. But we degrade not only our profession but its basic tool, the language, when we tolerate "Marxist" critiques from writers who do not appear to have read *Kapital*, psychoanalytic interpretations from people who've browsed through a bit of Jung and Freud, and semiological exegeses from those whose credentials consist of occasional epigrams from Barthes and Levi-Strauss. (Everybody talkin' semiotics ain't a-doin' it; indeed, I suspect that much of what's passing for "semiotic" criticism in photography and the other media would be considered sophomoric at best by trained semioticians.)

So, in suggesting that we need more critical brutality, let me conclude by proposing that some of it be directed toward ourselves; like charity, such brutality properly begins at home.

(1979)

THE HAND WITH FIVE FINGERS;
OR, PHOTOGRAPHY MADE UNEASY

Several years ago, my son, my (then) wife, and I were discussing new technologies, when the conversation came around to the recent appearance of machines and appliances that talk to you. Inevitably, we got to the camera that, through the magic of the microchip, lets you know in no uncertain terms when — in its opinion — you're too close to your subject, are working in insufficient light, and so on.

Suddenly, Ed — who was then seventeen years old and who, having lived in the art-photography world *all* his life, views it with an eye even more jaundiced than mine — went into a spontaneous skit featuring an imaginary camera that could be programmed to take only a certain kind of picture, would offer a running critique of your seeing, and would refuse to register any negative that didn't meet its standards. For example, he improvised, you could have the NEA camera, guaranteed to produce a portfolio that would win a grant from the National Endowment for the Arts.

In a flash, Ed was bobbing and weaving around the room in a cutting parody of the avid small-camera user on the prowl — except that the invisible camera he held, having a mind of its own, kept pulling itself away from his eye to other, presumably better vantage points, all the while chastising him for his choice of shutter speed and aperture. He soon had Theresa and myself rolling on the floor.

Thinking about this afterwards, I realized that this conceit could be connected to what my colleague, the Baltimore Oriole, refers to as "cryogenic imagery." The Oriole argues that, by now, photographers have established a sizeable, steadily growing repertoire of archetypal images, any variation of which is recognized by all and sundry as a "good shot." It's the Oriole's theory that *these images now come in the camera, cryogenically frozen.* The camera user needs only to scan the field of vision until the lens comes across a new instance of one of these archetypes; the frozen image is instantly awakened from its sleep and registered on the negative.

Now that would suggest that Howard Smith's theory was outdated. Smith, writing about the work of the midwestern studio photographer Michael Disfarmer in the *Village Voice* back in May of 1982,

suggested that "the secret of taking a great portrait is actually quite simple to understand: the photographer just looks through the lens with intense magic until the person posing is transformed into a timeless work of art. At that exact moment the shutter is released." Smith, obviously, is still committed to the antiquated notion that it's the photographer who makes the picture, not the camera.

I realize that you may be getting a little skeptical here, wondering if these folks don't have their tongues in their cheeks. You may even be questioning my sincerity. Let me assure you not only that my aim is true, but also that what I'm describing represents accurately the openly announced long-term agenda of the photography industry — which, in a nutshell, is to get people out from behind their cameras so that they'll have more time available to be the subjects of photographs and to consume photographic film and prints.

You'll have to follow me closely on this one.

•

Up until 1888 — that is, for the first half-century of the medium's existence — anyone who wanted to make photographs had to practice photography. If you worked with the direct-positive processes (such as the daguerreotype or the tintype) you developed your exposed plates immediately. This was true also of the positive-negative processes that prevailed through the 1860s — the so-called wet-plate methods, which utilized glass sheets on which the emulsion had been freshly coated. Even the introduction of dry plates did not significantly reduce the photographer's involvement with the craft; it only provided some breathing room between exposure of the negative and production of the print. Short of hiring a personal assistant to handle darkroom work, the person who wanted to make photographs had no choice but to become knowledgeable in all areas of the craft, to think his or her work through from exposure to print.

George Eastman changed all that, permanently, when he introduced the first Kodak camera in 1888. "You press the button, we do the rest," read the slogan under which it was advertised. The camera user received the loaded camera, ready to go; after making 100 exposures he or she shipped the film, still in the camera, back to the company for processing and printing.

Not only did this make it unnecessary for the camera user to process his or her own film and make his or her own prints, it actually made that impossible, at least at first: the film for this camera initially

was such that amateur processing was impracticable.

Historians of photography are prone to celebrating this as a triumph. I'd suggest that, in fact, it was in another sense a setback of major proportions. This was a time when a continually widening segment of the public was acquiring craft expertise in the first democratically accessible visual communications system. The Kodak No. 1 — by appealing to people's capacity for laziness — allowed the "luxury" of foregoing any study of that craft. In separating the act of negative exposure from development and printing, Eastman's system effectively undermined the impulse to learn the process of photography, by rendering such knowledge unnecessary.

A year later, Kodak introduced a new film, on a plastic base, that gave amateurs the option of either developing and printing their own images or letting Kodak "do the rest." But the die had already been cast. By permitting camera users to remain ignorant of the processes they were employing, this approach to photography remystified the medium — made of it a prototypical "black box" — right at the juncture when its demystification was underway among the population at large.

Why do I consider this a setback? Because the camera is, on at least two levels, an instrument for the control of perception. Not only does the user employ it to tame and organize visual perception, but through its structure the originators of the camera and their descendants — those who design the cameras, films, and papers of our time — dictate how we will see.

The only truly effective way to come to an understanding of the degree to which "the medium is the message" in photography is to study the medium itself — that is, the process of production. Only in that fashion can one discover the medium's inherent biases — the kinds of ideas and information whose transmission it facilitates, the kinds that it inhibits or obstructs. Only through the direct experience of craft can one encounter first-hand the limitations, the controls and the range of variables at the disposal of the practitioner. (While still photography is the model I'm using, the same obviously applies to the other lens-based media — video and film.)

Globally, there is now an enormous population of camera users, only a tiny fraction of which actually practices photography. The two functions, initially integral to each other, have been severed in what I can only suggest is the equivalent, for photography, of pre-frontal lo-

botomy. Social historians of the far future will find it astonishing that, in a culture producing billions of photographs annually, much of the population still believed that cameras take pictures, that photographs don't lie, that seeing is believing. These are ideas of which photo students are effectively disabused by their second semester of coursework. They're ideas of which an entire culture could be disabused by a widespread emphasis on media education.

Unfortunately, what we get instead is an endless series of variations on the theme that, in the 1940s, was summed up in manuals and courses promising "Photography Made Easy." To counteract this, the late photojournalist W. Eugene Smith taught a course at the New School for Social Research in New York City that he titled "Photography Made Difficult." But the tide was against him then, brave dinosaur that he was, as it is now against anyone who would seek to make photography difficult, or even uneasy — anyone who would argue in favor of a more thoughtful, complex, problematicized relationship to the creation of photographic images.

Certainly the photography industry is not about to encourage such an approach among the citizenry. The relationship to photography that this industry promotes is one of rampant, even literal mindlessness. How else can one interpret the symbolism of the dreaded, disembodied "Hand with Five Fingers" that one camera company uses to promote its newest, most automated model? How else can one explain the fact that at least two major manufacturers are advertising their wares with slogans promising "decision-free photography"?

Decision-free information? Decision-free perception? Decision-free self-expression? Decision-free communication? By their nature, such acts cannot be decision-free — at best, the decisions they involve can be deferred, left in the hands of others.

The phrase "at best" assumes, of course, that the avoidance of decision-making is a positive goal in life. If that is so (have no doubt that I hold an opposite opinion), when did it become so? When did the premise of our public discourse change so drastically that "freedom from decision" ceased to be a totalitarian threat? When did the ability to "slip effortlessly through life" that is offered to us by the makers of an instant camera lose its sting as an insulting description of the con artist or the uncommitted dilettante?

Media education, including the study of photography — in almost any form it takes in an environment whose keynote is sounded by

the above slogans — is an oppositional force, an embrace of decision-making, difficulty, uneasiness. Let us keep that in mind as we proceed; after all, the real threat of "the hand with five fingers" comes not from outside ourselves, but from within.

(1985)

Memoirs of a Circuit Rider

One of the less-publicized aspects of the free-lance life (which affects writers like myself no less than photographers) is this hard truth: not only is there no free lunch, but there are no paid vacations.

With no employer obligated to fund one's rest and recuperation, a free-lancer has to seize his or her opportunities to unwind when and where they occur. Usually this results in situations that — contrary to the old dictum — mix business and pleasure, along the lines of what used to be called a busman's holiday.

In photography, what's evolved over the past decade is a circuit of sorts: a loose network of institutions and events that provide photographers, critics, photo students and other interested parties with opportunities to explore one or another aspect of the medium in a relaxed atmosphere. The settings are usually informal, even resort-like; proximity to the beach tends to be as much a concern as quality of presentation.

I spent the summer on this circuit — late June through mid-July in Europe, August in the northeast U.S.A. What follows is a series of impressions collected in my European transit.

•

Vienna, June 22 — I'm here to participate in a symposium on the criticism of photography put together by Anna Auer, a dynamic woman who is working with the Staatliches Länderbank of Austria to energize the photography scene in her country. This is the fifth symposium on photography that she has organized and the bank has sponsored; the bank also supports a collection and an exhibition program, and is about to open a photographic-print study center and reading room.

I appear to be one of only two working critics in a line-up of six people; the other is Otto Breicha of Vienna. The remaining participants include Marco Misani, editor and publisher of *Print Letter*, a magazine directed at collectors; André Jammes, French historian and collector; Vilém Flüsser, professor in the theory of communication; and Bazon Brock, an aesthetician with a background in literature, philosophy, and sociology.

With the exception of Jammes and myself, everyone speaks in German — a language I bumbled my way through in college and still grasp only dimly. My translator is from the city university. She is remarkable — able to translate complex ideas on a subject in which she

has no extensive background, grammatically and rapidly. She spends most of the day acting the role of my ears — whispering an English version of the proceedings to me.

From what I gather in this fashion, very little of what transpires has much to do with the specific issues of photography criticism. Jammes does devote his talk to a consideration of the ways in which French art critics of the nineteenth century responded to photography. Misani traces the history of *Print Letter* — a periodical that, by design, concerns itself with information, not criticism.[1] Flüsser and Brock offer general thoughts on structural analysis of communicative media, and abstract yet overly simplistic analyses of "the apparatus of photography itself" — warmed-over Walter Benjamin, with a dash of Sontag.

Using a prepared text, I speak (as I've been asked to) on the recent history and current state of photography criticism in the U.S., and on the development of a critical vocabulary specifically pertinent to photography.[2] I have no notion of what reference points I share with this audience, and find it unnerving to make a paragraph-long statement in English and then stand by silently as a German version thereof unfolds. I am only slightly reassured to find that the audience seems to be laughing in the right places during the translation.

Unfortunately, shortage of time requires that the talk by Otto Breicha — the only other critic in the group, and the one I most wanted to hear — be cut short. During the brief concluding question-and-answer period, in which the audience is allowed to engage, Prof. Flüsser expresses his concern that I am "not being theoretical enough."[3] I try to explain that I believe theory should be grounded in practice — and that practice, for a critic in the visual arts, consists in looking at, responding to, thinking about, and writing about concrete works. I'm not sure how this goes down — the translated version engenders a roomful of mixed nods and grumbles.

Those responsible for the symposium seem quite satisfied with the event, however, and speak of a second session in the near future. I am delighted to be informed that Manfred Willmann, another Austrian photo-activist, will shortly be publishing the premiere issue of an Austrian photography magazine that will emphasize criticism and imagery; it is obviously much needed.[4] I find myself recalling one of Les Krims's image titles — *I Get a Headache from Listening to German Sounds* — as we head for dinner in a futile attempt to avoid that constant presence in Viennese life: sausage.

•

Paris, July 1 — Paris has been unseasonably gray, cold, and rainy since we arrived a week ago. They are blaming it on Mt. St. Helens. This is part of a consistent pattern; the U.S. is also held responsible for the Soviet Union.

In this sleazy, sneezy weather we have come to the Centre Pompidou — generally referred to as "the Beaubourg." This new culture warehouse, built on the former site of an historic open-air market, is a curious combination architecturally: part guano processing plant, part shopping mall, part space-colony *moderne*. I still don't know what I feel about it as an object and as a functional structure; I think I will have to be there a number of times to find out.

We are here for the press preview of a group show. France is currently celebrating *"l'année du patrimoine"* — which translates roughly as "the year of the national heritage." Cathedrals, historic buildings, and other landmarks are being refurbished; the French are being urged to appreciate (and vacation in) their own cultural history.

As part of this, ten photographers have been given hefty stipends and asked to photograph something that they feel is quintessentially French. Those chosen are all male: Edouard Boubat, Bernard Descamps, Jean Dieuzaide, Gilles Ehrmann, Michel Kempf, Roland Laboye, Jean Lattes, Willy Ronis, Michel Thersiquel, and Gilles Walusinski. Each has contributed fifteen images to this show, titled "Dix Photographes Pour Le Patrimoine," which will tour France and then travel abroad.

The opening is hectic. Last-minute details — like painting the sign which hangs over the entrance — are still being attended to, while press secretaries, ministers of culture, TV crews, and assorted others crush against each other. It is a less than ideal situation in which to view photographs, but then that's true of any opening. What is noteworthy is the amount of government support (in money and in public relations) for this project, the virtually complete freedom of choice of subject and point of view granted to the photographers, and the obvious interest of the press and the other news media in the event.

A quick tour of the show yields the overall impression of an amiable collection of moderately interesting but undistinguished small-camera reportage. Certainly I might well be unable to pick up many of the nuances of cultural expression that these images may encode, so I am wary of my own ethnocentrism. Still, it's hard for me to imagine that you couldn't go into the files of any French stock photo agency and pull out equivalent groups of images.

Amidst all this uproar I find three sequences that I hope to encounter again, for contemplation in quieter circumstances. These are Jean Dieuzaide's elegant studies of church organs; Bernard Descamps's ironic, slightly skewed response to the battlefields and monuments of Verdun; and Michel Kempf's cheerless survey of the industrial mining region of northern France. Later, reading through the exhibition catalogue, I discover that these three (and one other) are the only photographers in the exhibit who make their own prints. I am not sure how to interpret this information, but it does not strike me as coincidental.

•

Late that afternoon we stop by the Bibliothèque Nationale to visit with Jean-Claude Lemagny, one of the two photography curators in the Bureau of Prints and Photographs. Lemagny's purview is twentieth-century work; his colleague, Bernard Rambot, specializes in nineteenth-century photography. Together they supervise an archive at whose true extent they can only guess. Lemagny cheerfully admits that he has no precise idea of the size of the Bibliothèque's photography holdings: "Indexing is not counting," he states, offering a rough estimate of "hundreds of thousands of nineteenth-century photos, tens of thousands of twentieth-century ones."

Lemagny is affable and informative, inquisitive and acquisitive. The last-named quality is certainly nourished by the system underpinning the Bibliothèque, whose scope and powers go well beyond those of our own Library of Congress. A fifteenth-century law, called the *dépot legal*, obligates every artist to give one copy of every print he or she produces to the Bibliothèque. In 1943, this rule was extended (under Marshal Petain) to cover photographs as well.

Consequently, Lemagny is in a position to requisition a print of every photograph made by a French photographer, should he so desire. Mercifully, for the sake of photographers and the library's overworked conservation staff, he is selective; about 4,000 photographic prints per year enter the collection. Much of that is straightforwardly donated; some is purchased, at an average price of 30 francs ($7.50) per print. "I don't know if I should be very proud of that, or very ashamed — to take so much work, so cheaply, from poor photographers," Lemagny says.

There is a flip side to this coin, however: any French citizen can donate his or her work to the Bibliothèque, and the institution cannot refuse to accept, accession, index, and conserve it. This is no small matter, for the library takes conservation very seriously. All prints are mounted on all-rag, acid-free mount board, overmatted and protected with spe-

cial tissues made exclusively for the Bibliothèque. Each print is blind-stamped (with part of the embossing appearing, obligatorily, on the image itself, not just the border). It costs 60-100 francs per image ($15-25) for this phase of conservation alone.

As Lemagny leads us through several of the vaults, pausing here and there to haul out some item of interest, I ask what he would do if he were forced to cope with all the images that the *dépot legal* and that mandatory acceptance rule could leave on his doorstep. He smiles, puts his index finger to his temple, cocks his thumb, and commits mock suicide. But then he leads us to a shelf of prints donated by French camera clubs, which he's delighted to have because, for researchers in the future, "it will be important for the Bibliothèque to be able to show the state of amateur photography at this time." With a sad sigh over what he considers to be the lamentable state of photography education in France at present, our visit with M. Lemagny concludes.

•

Arles, July 9 — Though it is generally referred to as the "Arles festival," the Rencontres Internationales de la Photographie more strongly evokes the carnival. It is a monumental undertaking — a month of workshops, a dozen large exhibits, and, in the middle, an intensive week of afternoon panel discussions and evening lectures. All of which is interspersed with socializing, gossip, press conferences, and the like, involving photographers, editors, publishers, gallery owners, curators, critics, and students. If you cross-bred Photokina [in Cologne] with the national conference of the Society of Photographic Education, the offspring might look something like Arles. It is the European photography community's central meeting place.

Pre-festival reports and estimates by festival regulars have pegged this as the dullest session in Rencontres history. It is hard not to agree, even though this is our first visit to Arles. Last year — the tenth-anniversary celebration — was, by all accounts, controversial and energized. Now it feels stale. The evening lectures take place in a marvelous setting — an ancient Roman amphitheater with a huge screen and excellent audio-visual system — but the offerings are dull: a photobiography of Coco Chanel; a hodgepodge of portfolios, few of them funny, surveying "humor in photography"; endless, self-indulgent displays of the "personal work" of commercial photographers Jay Maisel and Francisco Hidalgo.

The audience, to its credit, does not tolerate trivia. Visually, in-

tellectually, and politically, those who attend these *soirées* appear to be much more sophisticated than the pap they're offered, and they make no bones about it. The opening-night presentation — a promotional film on the Rencontres, which we missed — evoked continual laughter. The next night's feature, "Arles Then and Now" — an unconsciously self-parodying "rephotographic" project — precipitated so much catcalling that it was abruptly stopped halfway through.

Tonight we have Jay Maisel, who takes us through an interminable display of banal stock shots — pigeons, sunsets, every cliché in the book — accompanied by his own pretentious monologue on the "poetry of light." Alain Desvergnes, festival director and chief translator, cannot contain his laughter on many occasions as he renders Maisel's pomposities into French. The audience responds similarly — riotous, sarcastic cheering erupts as the umpteenth sunset flashes on the screen.

There is a brief intermission, during which I speak with picture editor John Morris. John is sporting a broken right hand, rumored to be the result of a falling-out with the Museum of Modern Art.

Then the lights dim and — this is bad planning, surely — Francisco Hidalgo's presentation commences. Aside from the fact that Hidalgo uses a cross-star filter so that everything you see is quadruplicated, there is no distinguishing his work from Maisel's, and his monologue is virtually a repeat of Maisel's. The audience begins to hoot and holler; Hidalgo's voice falters. And then an epiphany (I have witnesses to this): a blind man, holding a cane, is led past us and out of the amphitheater by a group of people. A few minutes later, we follow his example.

•

The next day I have the opportunity to visit a number of the shows. The exhibition spaces (many of them in civic government buildings) are adequate, and Donna Stein, who organized the entire exhibition installation program, has done a remarkable job of utilizing the facilities to the best advantage of the images. Much of the work is familiar: a selection from the Lustrum book *Nude: Theory*; a group of Arnold Newman portraits; more Jay Maisel sunsets. Two of the shows are extraordinary. One is a survey of the work of Charles Nègre, the nineteenth-century French photographer. It's a large group of original salt and albumen prints — many of them studies of Arles, which Nègre photographed for a book project — accompanied by letters and related material, all from the Nègre family's archives. A rare treat.

The other is an exhibit of the work of Julia Pirotte, a Polish photographer who served with the French resistance forces during World War II. This is photography that is not just "concerned," but committed — imagery that, if found by the Nazis, could have cost Pirotte and those she photographed their lives. It is a unique document — particularly a series on the uprising in Marseille during 1944.

The negatives are old and worn, but the show is charged with vitality, a sense of life being lived on the edge, amplified by the reportorial quality of the imagery. Pirotte — now in her seventies, but very forceful — is in the room. From where she sits, she can look down the length of the gallery at her dark and tender portrait of her younger sister, Marie Dirivaux, made not long before her decapitation by the Nazis thirty-six years ago. And, on an adjacent wall, she can see her own self-portrait made around the same time: thoughtful, sad-eyed, reflected in a mirror with her Rolleiflex. There is something terribly, painfully poignant in this triangulation of past and present — and something quintessentially photographic.

We leave Arles the next day. Coming into Avignon on our way north, we are trailed by the Goodyear blimp. Paris continues to be unseasonably cold, gray, and rainy; and New York, when we return, is in the midst of a record-breaking heat wave.

(1980)

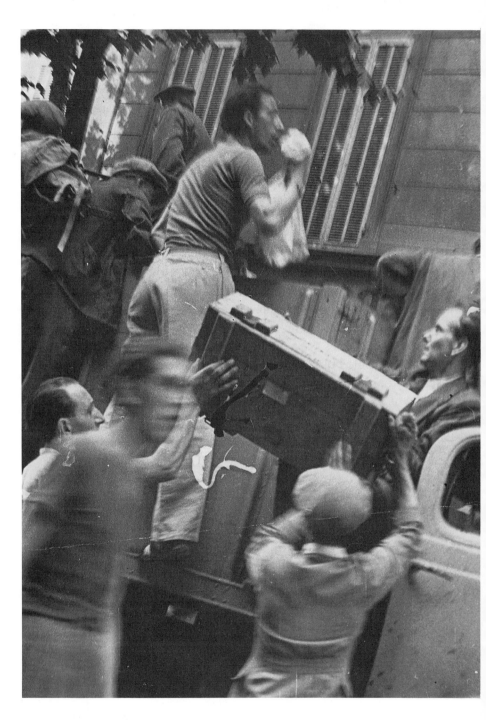

Julia Pirotte, *Marseille Uprising*, August 20th, 1944, 2:30 pm;
courtesy of the photographer.

III
Paradigm Shift

SILVERPLATING THE DANDELION:
THE CANONIZATION OF FATHER FLYE'S SNAPSHOTS

Photography is, in its relation to the casual camera user, an inordinately generous medium. Most anyone who exposes a goodly amount of film (or even a small amount, regularly, over a long period of time) ends up with a certain proportion of negatives that, appropriately rendered in print form, could provide images of at least passing interest.

Most people, also, are potentially more creative than is generally acknowledged. Moments of insight, clarity, and grace are not rationed only (or even predominantly) to professional artists, though the latter may be more consistently alert to them and better prepared to take advantage of their arrival.

"Time," as Susan Sontag put it in her erratic polemic, *On Photography*, "eventually positions all photographs at the level of art." As she herself later admitted, the true subject of her book was not really photography at all;[1] thus a more useful formulation of the idea just quoted might be, *Time eventually positions all human artifacts, including photographs, at the level of art.* But the point she makes is that a sentimental fondness, a nostalgia, eventually accrues to any artifact once it becomes sufficiently time-displaced, and that this poignancy attaches inexorably to human-made things with little regard to the quality of thought/craft/art that originally went into their making. (I recall, for example, the reverential, security-guarded display of a petrified wonton in an exhibit of "priceless treasures from recent Chinese archaeological expeditions" held several years ago in Washington, D. C.)

Because there's a quintessentially human, heroic futility inherent in photography and its products — a brave, hopeless attempt to secure slivers of the present against the suction of the past and the onrush of the future — that intrinsic nostalgia is especially apparent in photographs, even those of fairly recent vintage. It can be found in photographs of all kinds, but is perhaps most endemic to the true snapshot, whose fundamental impulse is preservation rather than aestheticism.

Many snapshots do not transcend the closed network of private reference points for which they're made. Yet if their subjects are clearly stated, and if the equipment employed in their making is not so "hopelessly sophisticated" (Minor White's wonderful phrase) that it confounds

the user, then images that articulate the commonness — the mutuality — of some fundamental human experiences sometimes result. Virtually everyone who makes snapshots will have a few. Think of them as dandelions: nice, bright little things, easily propagated, hard to distinguish from each other, plentiful, growing everywhere.

•

So it is with the snapshots of Father James Harold Flye. Flye, long a teacher at St. Andrew's School in Tennessee, is known primarily for his published correspondence with the late novelist James Agee. It turns out that he also took photographs on occasion during the late '30s and early '40s: mostly pictures of the students and staff of St. Andrew's, a few out-of-focus grab shots of Agee, a handful of Harlem street scenes made during a visit to New York.

I used the word "took" deliberately. Flye, in his own words, photographed only "sporadically" and "casually." He did not make his own prints, nor process his own film; these tasks he happily turned over to some equivalent of the local drugstore. According to the authors of his just-published monograph,[2] "He never worked at making pictures, nor did he ever master the technique required by his camera, which, it's true, was easy enough to operate . . . even so, he never learned sure control of the focus or exposure."

It shows, of course. Working thus without commitment to craft or deep interest in the process, Flye functioned like any casual snapshooter. And photography, in its generosity, rewarded him as it does most snapshooters — by not interfering with the laws of statistical probability. Like every "sporadic" photographer, Flye lucked into an occasional image of mild attractiveness. And — time and nostalgia operating as is their wont — four decades later some of those pictures have acquired a faintly enjoyable patina as relics of another era.

They do not, however, constitute a "body of work," an *oeuvre*. Erratic, technically inept, lacking any true hermeneutic underpinnings, addressing no photographic issue at length, they are only what they are — a random assortment of occasionally charming snapshots by a dilettante. In short, a small handful of dandelions.

I do not say this to insult their maker, and I doubt that he will take offense at these words. Flye seems to have an intelligent assessment of his own role in these images, and of their importance — or, at least, he *had* such an assessment until the authors of this book got hold of him. "That's a beautiful picture, yes, . . . But the camera, not me,"

he's quoted as saying in David Herwaldt's introductory essay. Having accurately appraised it as insignificant, Flye had little interest in and no ambitions for his photography.

That was not true of Donald Dietz and David Herwaldt, the two young photographers responsible for this book and the traveling exhibit[3] for which it is the catalogue. After making the acquaintance of Flye, they were at one point shown these snapshots. "We were . . . unprepared for the wonders we saw," Herwaldt writes in his introduction. "It was immediately clear that these pictures deserved — and more than deserved, demanded — attention and care."

Flye disagreed. According to Herwaldt, Flye "prefer[red] to let luck and the mysteries of photography claim the credit. *Not about to let that happen* [emphasis mine], we asked him if there could be, as this essay has in part argued, an instinct for making pictures, and he replied, 'Maybe so. But I don't want to have things attributed to me that I don't deserve.' Pressing the issue, we asserted that he had all along possessed, without knowing it, a marvelous instinct — or talent — for making pictures, and that, having this talent, he deserved credit for it."

That theme — of Dietz and Herwaldt validating the importance of these images over Flye's persistent demurrer — runs throughout Herwaldt's text. To override the image-maker's own judgment, Herwaldt has to persuade himself — and attempt to persuade us — that Flye "knew, without knowing he knew" exactly what he was doing all along. That phrase recurs four times in the text; variations on it abound. Unfortunately, it's to no avail; the images themselves cannot sustain Herwaldt's premise of deep currents of intuition.

A further red herring dragged across the trail of "the work of Father Flye" was the decision on the part of Dietz and Herwaldt to disregard the original prints that had satisfied Flye, take his negatives, and make exhibition prints of them according to their own craft standards. That act in itself indicates that Herwaldt and Dietz had ambitions for these images — ambitions that, I suspect, had much less to do with the images than with the intellectual cachet attached to the name of Father Flye and, through him, to the Agee/Walker Evans/Helen Levitt myth. (All three of them are evoked in Herwaldt's text.)

To annotate and celebrate the work of a *naïf* artist like Flye, it is essential — indeed, mandatory — not to tamper with his or her means of production. You don't falsify the evidence by upgrading it with sophisticated craft techniques that the maker never employed. You don't

orchestrate Woody Guthrie, and you don't touch up Grandma Moses. The only way this project could have retained its integrity would have been through a straightforward presentation of the original commercially processed prints — the form in which Flye conceived and produced his work, the form that satisfied him for forty years. Then we would have an authentic encounter with the man's photographic vision. (And, after all, drugstore prints from Brownie-camera negatives were enough to get William Christenberry a Guggenheim, an NEA, and a dozen major museum shows and catalogues. Walker Evans even put his *imprimatur* on Christenberry and declared him "a poet" on the basis of those prints. If they're good enough for Evans and Christenberry, surely they're good enough for Flye.)

But the book provides us with not even a single example of Flye's work in the original. I take this disrespect for Flye's chosen working method as a sign that Herwaldt and Dietz knew (without knowing they knew) that the work was trivial and needed exaggeration in order to sustain the project they decided to construct around it.

So we have, instead, exhibition-quality prints (and duotone reproductions thereof) of poorly-made small-camera snapshot negatives four decades old. And we have Herwaldt's ecstatic praise of the quality of light in these images — a quality for which he and Dietz are in large part responsible. This self-flattery is uncalled for. Any competent and well-educated young photographer should be able to take any readable negative and render therefrom a tonally attractive and visually structured print. Certainly any photographer with a grounding in current modes of photographic practice could go through anyone's negative file and find a selection that, strategically printed, might appear to be at least tangentially relevant to some of the serious work done in photography over the past half-century.

This Dietz and Herwaldt have done — but the visual qualities of the resulting photographs are consequently attributable at least as much to their darkroom skills as to Flye's abilities as a camera operator. Dietz and Herwaldt have muddied the waters grievously with this act, and have made serious consideration of "the work of Father Flye" impossible by interfering thus with his way of working.

Nonetheless, when these prints are converted back into reproductions on the page (even such excellent ones as these, by the Thomas Todd Company) their triviality reasserts itself stubbornly. Out of focus, haphazardly framed, tonally murky, and generally banal, they have no

distinguishing characteristics whatsoever. They are, essentially, what any teacher of photography would classify as "student work." They are no better than — and not significantly different from — the work produced by beginning students in the Photo League's classes during the era in which they were made. They are no better than the average run of present-day student work, and different only in that they encode a time long past. There's nothing here that is either seminal or virtuoso — nothing that makes even a minor contribution to the medium's evolution or to our understanding of its history.

Obviously, though Flye would seem to agree with me, Herwaldt and Dietz do not. In an essay that is a paradigm of fawning patronization, Herwaldt claims that these "wonders" are "keenly observed and well formed. They are, in a word, accomplished photographs — projecting a consistency that has to be called style and which defies any explanation by luck. . . . [Flye had] incredible photographic instinct." Herwaldt buries these images under such an avalanche of embarrassingly unearned praise — "inspired in its startling and compelling eccentricity of vision," "fine, perceptive, lively, and moving," "rare virtue" — that the sheer weight of his hyperbole is more than they can bear. Flye himself "felt the pictures were of personal value and would only bore those asked to look at them." He was, with only one or two minor exceptions, right.

Let me make it clear that my objection is not to Flye's having made these images, nor to their continued existence, nor even to their public presentation. Had the project originated with some Tennessee historical society, emphasizing the slight informational value of the images, preserving them as mementos for the school's population and the region's residents, showing them in their original form and reproducing them adequately (good single-run halftone would have done just fine), I might even have found it well-conceived.

But to blow them up into exhibition prints for a widely-traveling show (fifteen stops arranged so far, according to Dietz) accompanied by a duotone-printed catalogue designed by Katy Homans is, if I may coin a phrase, silverplating the dandelion. And to have this work presented to the photography community as exemplary is, frankly, offensive — especially when those responsible are aware enough of their own medium to know better.

By puffing this work up into something it's not, Herwaldt and Dietz have done neither Flye nor his snapshots any service. However,

by providing such unwarranted attention to the mediocre work of an unexceptional snapshooter, they have done the medium of photography a disservice. There are in photography numerous noteworthy but overlooked bodies of work: patiently constructed, superbly crafted, carefully thought-out, organically felt *oeuvres* created by men and women who have given their lives to the medium. Surely Herwaldt and Dietz know of some of these. To ignore them, their achievements, and their contributions in order to seduce with flattery the ego of a dabbling amateur strikes me as not only an act of grossly misplaced reverence but a willful refusal to pay due homage to those in their own profession who have truly accomplished something worth celebrating.

(1981)

SLIM PICKINGS IN HOG HEAVEN:
GARRY WINOGRAND'S *STOCK PHOTOGRAPHS*

An acquaintance of mine with extensive experience in both commercial and fine-art photography is fond of saying, "The main difference between commercial photography and art photography today is that the commercial photography has to be well done." Those who think him cynical would do well to contemplate the latest opus by Garry Winogrand, the man John Szarkowski has anointed as "perhaps the central photographer of his generation" — *Stock Photographs: The Fort Worth Fat Stock Show and Rodeo.*[1]

In point of fact, the pun in the book's title — referring both to images of livestock and to photographs usable by a stock photo agency — is valid only literarily. Whether taken collectively or (with rare exceptions) individually, these images have neither the impact and durability of significant creative work nor the utilitarian functionality of effective stock shots. The bankruptcy of Winogrand's approach is inescapably obvious in this book, and even Szarkowski should beware of continued attempts to make silk purses from these sow's ears.

"You respond to something you see," Winogrand's been quoted as saying, "'bang away at it,' and either it happens or something else happens, and whichever is better you blow up."[2] Since most of these photos are of human and animal figures that were in motion in dark places, and Winogrand lit them with flash (and open flash at that, frequently), he certainly could not have "gotten what he saw." The "something else" that he printed instead is a jumble of haphazard images — and the sad fact that most of them are inept and uninteresting demonstrates in the clearest way that luck has very little to with Winogrand's work.

After all, statistical probability is on the side of the small-camera photographer who "bangs away at it" — this is a very generous medium insofar as accident is concerned, surely the most generous of all the visual arts in that regard. And working a livestock show and rodeo is — for a grab-shooter like Winogrand — hog heaven; in such territory, potential "art photographs" are as plentiful as flies. Anyone who exposes as much film under such circumstances as has Winogrand,

only to come up with such slim pickings, is hardly dependent on (or even touched by) luck.

Editing and sequencing are the only means by which Winogrand could give meaningful shape to the amorphous by-product of his omnivorous image-mongering, but he has cheerfully abdicated any control over those procedures. Tod Papageorge edited, sequenced, and wrote the introduction to Winogrand's last book, *Public Relations*, published by the Museum of Modern Art; he edited and sequenced this one. No one but an indefatigable acolyte would revel in such a fruitless task; here, as in *Public Relations* (and, for that matter, the volume that preceded it, *Women Are Beautiful*), the images are basically indistinguishable from each other and the sequencing makes no conceivable difference whatsoever.

Papageorge would have better served these images and their maker by editing them more stringently. Even so, of course, it would be difficult if not impossible to build a strong book around a mere dozen interesting images — and there are no more than that here which merit prolonged attention. Another approach to the problem would have been to emphasize the few strong images by printing them full-page, reducing the others in size and organizing them in supportive layouts. (Here they have all been printed the same size, one to a page.)

That smacks of photojournalism, of course, a context in which Winogrand is loath to be considered. So, instead, Papageorge equates all the images and gives them the same weight in his arrangement. The intent, I suspect, is to imply that they are all equally good, equally important (the apostle, in his devotion, assuming that his mentor can do no wrong). The effect, however, is to make Winogrand seem almost incompetent at his own specialty and to make the book appear to be a desperately overinflated attempt to bulk up a handful of moderately effective images into a statement of epic length that they cannot possibly sustain. Blind devotion such as Papageorge's can do its victim as much harm as good.

Papageorge has also taken onto himself the chore of amplifying Winogrand's posture of inscrutability. Thus, while Winogrand declares that "the photograph has no narrative capacity whatsoever," Papageorge informs us that behind Winogrand's photos there is "always a narrative voice." Yet all this coy verbal maneuvering cannot perpetually disguise the increasing mediocrity of the work itself. This book's jacket blurb

describes its maker as one of the world's "most imitated contemporary photographers." It fails to mention that his most prominent and frequent imitator is himself.

The self-mimicry that has taken over Winogrand's work is the inevitable consequence of his tautological relationship to the medium. "I photograph to see how things look photographed," he's said. But that attitude assumes a personal transparency no photographer has ever achieved — a neutrality and lack of inflection that are forever out of the reach of human beings. What photographs have to show us is not "how things look photographed," but how things look when photographed by the individual responsible for the images. What Winogrand's pictures reveal is how things look photographed *by him.*

And how do they look under those circumstances? Characteristically, the world of Winogrand's photographs is disjointed, awkward, and somehow skewed or out of kilter. These effects are achieved by such basic devices as tilting the camera to throw the frame out of alignment with the horizon line, and freezing conversational gestures with on-camera flash. The hard frontal light of the flash makes virtually any interior look glitzy and cheesy and alienating; as a result, anyone occupying those interiors without obvious distaste for his or her surroundings seems *declassé* and tasteless. They are themselves blasted with the same intense, unnatural light, of course; and this produces harsh tonal contrasts in their face and clothing, and a stilted, arrested quality to their poses and motions. In short, everyone is made to look tacky and graceless, their trivial gestures trivialized even further by random framing and the clutter of irrelevant detail with which Winogrand distracts himself and the viewer.

There's nothing wrong with any of this *per se.* But the strategies are too simplistic, their use too ham-handed, and the repertory too restricted to qualify as major work. The argument that they represent some formalist investigation simply does not hold water; there are no essential lessons in craft or image infrastructure to be learned here. Furthermore, there is no evidence of the rigorous selectivity that any meaningful formalist inquiry necessitates. And the choice of subject matter — Winogrand invariably photographs human beings interacting in urbanized public settings — is so consistent, and so antithetical to formalist purposes, that his intent can hardly be abstract or emotionally disengaged.

The alternative argument often presented by Winogrand's devotees is that he is a social commentator whose work constitutes a social

critique. This is closer to the truth. Yet there is no attempt at social analysis in Winogrand's work; such an analysis requires an articulated personal politics, and both Winogrand and his work are too compromised to permit such articulation. Clearly, his professional and economic allegiance is to the upper class; he's received an enormous amount of support from the corporate/governmental sector and the museum/gallery network that is its right arm. He cannot afford to bite the hand that feeds him — at least not too hard. He is, however, permitted to nip at the fingertips. Basically, that's what he did in *Public Relations,* a book in which the wealthy, famous, and powerful are revealed as having their own moments of foolishness. In a facsimile of egalitarianism, he does the same in this book to the southwestern middle class.

But this does not constitute a social critique; it is simply the sniping of the court jester, whose jibes are permitted, encouraged, and funded by those in power because (to use Lyndon Johnson's pithy explanation) his balls are in their pocket. Fundamentally, Winogrand is a misanthrope with a soft spot for young women. His stance is that of an artsified *paparazzo*, at once ironically detached and in the thick of the action. The detachment, however, is feigned, for his disdain for most of his subjects is manifest. The images are judgmental, often harshly so; but his evidence-gathering methodology is biased in the extreme and, ultimately, undermines its own credibility. What poses as scathing indictment is reduced to mere repetitive mockery.

At this late stage in his development, Winogrand's proclivities are clear and, in all likelihood, permanent. It would be naïve to expect him to put in the intellectual labor necessary to evolve a coherent politics; the conceptual laziness of the imagery suggests that he has reached his own level of incompetence. Furthermore, such an undertaking runs counter to the best interests of his career. At present, Winogrand enjoys the best of both worlds. Through adroit tactical positioning — "knowing where to stand" is how he puts it, I gather — he is presented to the world simultaneously as an incisive observer of human affairs with much to say about society and as the ultimate photo-theoretician of our time. This is achieved by avoiding commitment to a position, but that is not the hallmark of true objectivity. It is simply the predilection of one who has been effectively neutered — in this case, so far as I can tell, by his own hand.

(1981)

PHOTOGRAPHY AT MoMA:
A BRIEF HISTORY

Some time ago, I found myself writing the following sentence about the Museum of Modern Art's Department of Photography: "The directorship of that department is unquestionably the single most influential sponsorial position in contemporary creative photography."[1]

As it emerged on the page, that struck me as an extraordinary statement — extraordinary not only because I believed it to be true, but also because I knew no one, here or abroad, would argue the point. There is no other institution that even comes close. How — in slightly over four decades — could that have come about?

According to Beaumont Newhall, "Photography at MoMA was founded by myself — myself means Nancy [his late wife] and I — Ansel Adams, and David McAlpin. We founded a department of photography and I was appointed curator. This was the first time that a major museum had founded a department of photography equal to other departments. . . ."[2]

That event — which marks a turning point in the institutional history of the medium — took place in 1940. But in many ways the die had already been cast. In 1936, Alfred Barr, the museum's first director, offered Newhall (at that time the Modern's librarian) the opportunity to put together a photography exhibit. The result was the survey exhibition "Photography 1839-1937," the catalogue for which subsequently became the infrastructure of Newhall's *History of Photography*. Thus Newhall's career as the most influential American photo historian was launched. He was twenty-seven years old at the time.

One year later, in 1938, came the exhibit "Walker Evans: American Photographs." This was the second show at MoMA for Evans; the first — "Photographs of 19th-Century Houses" (1933) — was MoMA's first one-person photography show. "American Photographs" was organized not by Newhall, but by Thomas Dabney Mabry and Lincoln Kirstein. This exhibit — and, perhaps even more, its accompanying catalogue — was a seminal presentation; in the late Garry Winogrand's words, it "state[d] that America was a place to photograph in."[3]

The influence wielded by these two works — Newhall's survey (and its subsequent elaborations) as the standard U.S. history of pho-

tography, Evans's sequence as a model of "straight" photographic seeing and book-making — is so vast as to be immeasurable. With its bias toward the purist posture generally and the f.64/F.S.A. groups specifically, Newhall's movie version of the history of photography (its final draft was prepared under the guidance of a Hollywood scriptwriter) at once created the American photo-historical establishment and defined its taste patterns.[4] And one can trace a direct lineage from Newhall's emphases to those of John Szarkowski, the current director of the department, for whose aesthetic Walker Evans has ever been the linchpin.

Thus the overview of photography promulgated by MoMA today can be said to have changed little from that which it offered forty years ago. There have been some digressions in between, however, most notably during the flamboyant tenure of Edward Steichen (1947-1962).[5]

Steichen had been represented in the very first MoMA exhibit to include photographs — "Murals by American Painters and Photographers" (1932) — and had already directed two exhibits there: the highly effective wartime propaganda pieces "Road to Victory" (1942) and "Power in the Pacific" (1945). He returned from the war a much-celebrated hero, apparently with his eye on the directorship of MoMA's photography department. During the leave of absence of Beaumont Newhall, who was also serving in the armed forces, that position had been occupied by Newhall's wife Nancy; at war's end, Alfred Stieglitz warned her that Steichen had plans for it. Those plans included the raising of $100,000 from ten manufacturers of photography equipment to subsidize Steichen's salary — the first time that commercial/corporate monies had entered the museum in such a fashion.

After much maneuvering, Steichen got his way. His appointment to the directorship was viewed by many, both within and without the museum, as the "firing" of Beaumont Newhall; in any event, it forced Newhall's resignation.[6] Moreover, it created a considerable scandal in museum circles and within the photography community; Ansel Adams, the Newhalls' compatriot, went so far as to label Steichen "the anti-Christ of photography: clever, sharp, self-promoting and materialistic."[7] At the same time, Steichen's appointment was certainly a public-relations coup of the first order, bringing the medium's one household-word celebrity and high-profile war hero to the helm of MoMA's department of photography.

The differences between Newhall's vision of the medium and Steichen's were not enormous, judging by the work they chose to spon-

sor: Alfred Stieglitz, Paul Strand, Edward Weston, Helen Levitt, Ansel Adams, Eliot Porter, Gjon Mili and Eugene Atget were spotlighted by both men. Indeed, the main distinctions between the curatorial approaches of the two seem to come down to matters of scale (both physical and economic) and style.

Newhall's exhibits tended to be on the small side; aside from the 1937 survey exhibit and the two shows directed by Steichen during Newhall's tenure, the largest exhibits presented between 1940 and 1947 were retrospectives: "Paul Strand: Photographs 1915-1945" and "The Photographs of Edward Weston" (1946), both accompanied by small but influential catalog-monographs prepared by Nancy Newhall.

Beaumont Newhall was responsible for 30 exhibits during his seven-year tenure; Steichen presented some 54 during his fifteen-year reign. Many of the latter were large shows geared for the widest possible audience. Examples of these would include "Korea: The Impact of War in Photographs" and "Memorable *LIFE* Photographs" (both 1951); "Seventy Photographers Look at New York" (1957);[8] "Photographs from the Museum Collection" (a 500-print extravaganza, 1958); and, of course, the blockbuster "The Family of Man," the most popular and influential photography exhibit and book of all time, which opened in 1955.

The museum was naturally wealthier during Steichen's tenure in the post-war boom than it had been during Newhall's time, and Steichen's own impulses toward acting the part of the folk hero and the public figure were much more pronounced than Newhall's. In any case, Steichen's imprimatur certainly carried more weight than his predecessor's, so that even the smaller shows he presented by lesser-known photographers (such as the "Diogenes with a Camera" series, 1952-1961) drew considerable attention. Certainly, during his tenure, photography's potential as a major museum attraction was firmly established, even if its aesthetic credentials were still in question.

•

The Modern's photographic-print collection also grew by leaps and bounds during Steichen's time. The collection's first acquisitions occurred in 1933, well before the department was founded. In 1943 the MoMA Photography Center was established at 9 West 54th Street, under the directorship of Willard D. Morgan; part of its function was to house the print collection, which had grown to 2,000. By 1958 there were 5,800 prints in MoMA's archives. (At last report — 1983 — there were over 15,000 prints, plus an extensive collection of rare books, let-

ters, and other archival material.) A considerable portion of the museum's holdings in photography is still warehoused — uncatalogued, inaccessible, and mysterious even to the Department of Photography itself. But it seems safe to assume that at least 5,000 prints entered the collection during Steichen's directorship.

Most of these Steichen acquired by asking photographers to donate them to MoMA free of charge. As a rule, they acquiesced; it must be remembered that this was a time when few museums even considered original photographic prints to be works of art, and virtually none would purchase them. So most photographers considered themselves inordinately lucky to be invited by Steichen to give their work away.

This was an expedient way to build a museum collection, but as a curatorial policy it was a two-edged sword. The existence of the MoMA photography department and collection did much to increase public acceptance of photography as a creative vehicle, and to establish it among curators, art critics and art historians as museum-worthy material. In addition, the Department of Photography's concern for the physical care and preservation of its accessioned holdings has been exemplary; most institutions at that time kept such photographs as they had collected in boxes in the basement. At the same time, Steichen's approach established a precedent of treating original photographs as so economically insignificant in value that photographers could be expected to give them away *en masse*, in grateful return for the cachet of their presence in a museum's collection. (It was not uncommon for Steichen to commandeer literally *dozens* of images from a single photographer, or to purchase a handful for five dollars apiece.) This precedent has done as much damage to the economic structure of creative photography as the existence of the MoMA collection has done good in that regard, for Steichen's example has long been accepted and followed by curators around the world. Consequently, the establishment of a coherent pricing and evaluating system for original photographic prints was severely retarded; the current turmoil in the market for photography is a clear if belated indicator that this issue is still far from resolved.[9]

•

Steichen's retirement in 1962 — on the heels of his own major retrospective, "Steichen the Photographer" (1961) — led to the eventual appointment of John Szarkowski as his replacement. Szarkowski was a dark horse among the candidates for this job. He had a budding

reputation as both a writer and a photographer, having published two books, *The Face of Minnesota* and *The Idea of Louis Sullivan*. Apparently he was as surprised to be offered the job as the photography community was when Szarkowski's acceptance was announced.

Szarkowski's twenty-three-year tenure has encompassed more than one hundred MoMA exhibits and numerous important publications. Some of these presented major figures for the first time: "The Photographs of Jacques-Henri Lartigue" (1963); "New Documents," with work by Diane Arbus, Lee Friedlander, and Garry Winogrand (1967); "E.J. Bellocq: Storyville Portraits" (1970). Others surveyed the medium in valuable and provocative ways: "The Photographer and the American Landscape" (1963); "The Photographer's Eye" (1964), followed by an influential book version in 1965; "From the Picture Press" (1973), a major survey of news photographs. And there have been retrospectives devoted to the work of Arbus, Harry Callahan, Bill Brandt, Henri Cartier-Bresson, and a host of others.

Many of these have been big shows — big both in scale and in public response. The Arbus retrospective, though atypical in some ways, nevertheless became the only photography exhibit to rival "The Family of Man" in attendance and publicity, and there have been other shows presented under Szarkowski's aegis that have drawn a large audience.

However, Szarkowski's vision of the medium — and of his role as a sponsor and tastemaker within it — could hardly be described as populist. The overall pattern of his curatorial work has emphasized rigorous formalism and the self-referentialism of "photographs about photography." He is open to both small-camera work and large-format imagery, but in general it could be said that he favors black-and-white photographs of urban vistas, building facades, and street scenes — the genre known as "social landscape." Multiple exposure, post-exposure darkroom exploration, image-text works, serial and directorial imagery, color imagery[10] — these and other forms of contemporary work in photography have received short shrift from MoMA during his tenure.

Since those are areas in which extensive experimentation has been taking place over the past two decades, one can safely say that Szarkowski is in no way committed to providing the public with a broad overview of current activity in the medium. Indeed, "Mirrors and Windows," 1978's attempt at such an overview, failed dismally — largely because Szarkowski's sympathies lay so obviously with what he considers to be the "window" stance.

For a time, Szarkowski's tendencies were balanced by the presence in the department of Peter Bunnell as curator and second-in-command. Bunnell has limitations of his own, but his aesthetic is much looser than Szarkowski's, and during his time at MoMA (1966-1972) he served as a counterbalance to Szarkowski's single-mindedness, curating such shows as "Photography as Printmaking" (1968) and "Photography Into Sculpture" (1970), along with smaller one-person exhibits by Duane Michals and Jerry Uelsmann, among others.

Apparently, however, Szarkowski and Bunnell did not get along. It would appear that David McAlpin, who has remained a major private donor to the department's collection, was instrumental in resolving the situation: he endowed a chair at Princeton in the history of photography, in which Bunnell promptly sat, and Szarkowski was left in peace once again. Since Bunnell's departure, there have been a string of short-term residencies by "curatorial interns," but no strong second voice has been permitted to develop within the Department of Photography.

My own opinion, which I've elaborated elsewhere,[11] is that the department needs such a voice. Scanning the exhibitions list of the last decade, it is clear that the department is wide open to charges of racism, sexism and cronyism. Influence-peddling abounds, and the increasing amount of corporate money over which the department exercises control is being devoted to the support of one area of activity rather than to the entire spectrum of contemporary work.

Since the department does exercise such enormous influence, both here and abroad, it seems essential that it accept as its primary responsibility the presentation of work representative of all aspects of creative photography. The lack of attention to such older masters as Lotte Jacobi, Roy DeCarava, Minor White and Imogen Cunningham, and to such established younger figures as Les Krims, Linda Conner, Ralph Gibson and Abigail Heyman is deplorable. And there have been other oversights and gaps in the department's coverage of the medium's recent evolution.

The effect of the Department of Photography's present policies is the miseducation of the audience for photography — including photographers themselves. The best time to begin rectifying this state of affairs would be now, if the department is still committed to earning the influence it has wielded for so long.

(1979)

•

POSTSCRIPT

Much has happened to the Department of Photography since the above chronicle was written, and certain aspects of its recent history initially left undiscussed merit some annotation here.

On February 20, 1977, at Ansel Adams's 75th birthday party in Carmel, California, it was announced that Ansel and Virginia Adams were endowing a permanent staff position in the department, known as the Beaumont and Nancy Newhall Curatorial Fellowship, for $250,000. "One need only turn to an Adams bibliography to know something of the rich personal history in their gift," Anita V. Mozley noted obliquely about this occasion.[12]

Indeed, for those familiar with the public history of the relations between the Newhalls, Adams, and MoMA, as outlined above, there was considerable irony in this symbolic reinstatement of Beaumont Newhall, by proxy and in perpetuity, as second-in-command to the department's Director. Coincidentally, John Szarkowski, in attendance to accept the ceremonial check for the endowment's first installment as well as to join in the general celebration, announced at that time that Adams would shortly have a major retrospective at MoMA — as indeed he did: "Yosemite and the Range of Light."

Well underway is the monumental four-exhibition/four-volume survey of the department's Eugene Atget collection — the first such project ever undertaken in scrutiny of a single photographer's work. This epic endeavor has been the main thrust of the department's activities during the recently completed expansion and remodeling of the entire museum. Maria Morris Hambourg, who has since become the Curator of Prints, Drawings, and Photographs at the Metropolitan Museum of Art, was Szarkowski's assistant on the Atget project. The first beneficiary of the Adams endowment was Betsy Jablow.

The expansion has left the Department of Photography with new quarters, on the second floor, that — in six modularly designed small galleries — provide almost three times as much wall space as was previously available, some 4,800 square feet altogether. The Photography Study Room, now on the fifth floor, has also been expanded and renovated.

The new display space is a pleasure. The lighting, all artificial, is more easily controlled; the lower ceilings scale the space more appropriately to photographic work; and the inclusion of longer viewing distances across and through several of the galleries makes possible the

Lee Friedlander, *Untitled*, from the series "Gatherings,"
ca. 1971; courtesy of the Museum of Modern Art, New York.

effective presentation of large-scale work, which was virtually prohib-
ited by the size and design of the previous galleries.

Yet a sense of enervation rather than excitement pervades the
place. The "permanent" display — which, Szarkowski has promised,
will be rotated more frequently than before — establishes no sense of
coherence or relationship. Documentary formalism has been reinvested,
even amplified, but now eccentrically interspersed with smatterings of
technically experimental work by Man Ray, Moholy-Nagy, and others.
The result is that the development of the former is periodically inter-
rupted by the latter; conversely, no sense of the continuum of the latter
form is generated. Prevailing instead is a vision of history as hodge-
podge, elegantly entombed. Only in the room devoted to recent work
does there seem to be any energy and spirit, though nothing resembling
a reasoned argument.

Perhaps, now that Szarkowski has completed the Atget enter-
prise, he will be able to turn his attention once again to the smaller
gallery activities — even if only to rethink and extend his earlier ver-
sion of the medium's history. Perhaps that will have to await his succes-
sor, whoever that will be. Or perhaps the vital energy for provocative
curating of photography has gone west, with the Getty Museum's new
collection, the San Francisco Museum of Modern Art's aggressive ad-
dress to contemporary photography, the Museum of Photographic Arts
in San Diego, and various other new venues.

Bringing the Modern's Department of Photography back to some
essential relation to the cutting edge of the medium is an unenviable, if
not an impossible, task. The only advice I would offer to anyone under-
taking it would be to heed the words of Samuel Cauman, paraphrasing
that great theorist of museumology, Alexander Dorner:

> A philosophy, if it narrows the frontiers of knowledge, turning the
> mind to contemplation of old material, is retrogressive. If it is also
> rich, bringing many insights and vistas, its discouragement of new
> thinking and new research can almost escape our notice, for this is
> always relative to what might be accomplished otherwise.[13]

(1987)

IV
Revisionism and Gap-Plugging

MAKING HISTORY

The history of the history of photography continues to offer an object lesson in the essential subjectivity of the discipline of historianship.

Currently the history of photography is in a state of extreme revision. Partly this is due to the constant rediscovery of neglected bodies of vital work. Some examples of photographers whose names appear in none of the standard histories of the medium: Edward S. Curtis, E. J. Bellocq, Michael Disfarmer, Alice Austen. It is unlikely that any future history of the medium will omit their names, but there are dozens like them being uncovered each year, and one can sympathize with the historian's plight in this regard. Imagine trying — at this late date — to integrate five major but previously unheard-of Impressionists into a history of turn-of-the-century painting, and you will have some inkling of the problems historians face when dealing with what Martha Chahroudi has termed "the time-displaced photograph."[1]

At the same time, the work and stature of photographers who have long been established in the pantheon of photography's history is undergoing revaluation. For instance, the record prices recently paid at auction in New York for two albums of prints by Carleton E. Watkins (which fetched roughly $100,000 apiece!) surely place him at the forefront of those American photographers who portrayed the Old West. Yet W.H. Jackson, Timothy O'Sullivan, and John Hillers are far more prominently featured in the available histories — a situation that will doubtless change as a result of that auction.

A symposium held under the auspices of the School of the Art Institute of Chicago in the spring of 1979, "Toward the New Histories of Photography," was indicative of widespread feeling that it is time to remake the history of photography. Organized by Alex Sweetman and Candida Finkel, the symposium brought together historians, critics, and specialists in a variety of relevant disciplines, joined for the purpose of publicly pondering the question, "Whither photo history?" (A publication based on the symposium has been promised.)[2]

Anyone wondering whether all this activity is really necessary — and, for that matter, anyone interested in the past/present/future of photography historianship — would do well to read the interviews with photo historians Beaumont Newhall and Helmut Gernsheim in the book

Dialogue With Photography by Paul Hill and Thomas Cooper.[3]

The book as a whole is erratic, often dull, and only by default the "oral history of photography" its dust jacket claims it to be. But several of the interviews — especially, at least for me, the one with W. Eugene Smith — are joys. And the Newhall and Gernsheim sessions are eye-openers.

It must be kept in mind that for all intents and purposes these two men were in complete control of the history of photography in the English language for a period of approximately thirty years — the first version of Newhall's history, an exhibition catalogue titled *Photography 1839-1937*, was published in March of 1937, while Gernsheim's history first appeared in 1955. Both men were aided and abetted by their now-deceased spouses, Nancy Newhall and Alison Gernsheim, to whom each pays extensive credit (Alison Gernsheim was listed as co-author on that team's second edition). Nonetheless, however we wish to count them, for three decades the medium's history was in their hands so far as the English-speaking world was concerned.

One could hardly imagine two more different men. Newhall is a Boston Brahmin; Gernsheim is a half-Jewish German who fled Hitler's terrors to become a naturalized British citizen. Gernsheim's history emphasizes the European contribution to the medium, and stops at 1914; Newhall's orientation is American, and ends around 1960. Gernsheim comes across as pugnacious and egocentric, while Newhall seems naïve and tolerant. Certainly it is a long and winding road that has led them to the U.S. southwest, that hotbed of photo historianship where both are presently located — Gernsheim at the University of Texas, Newhall at the University of New Mexico.

Yet there are many connections between them. Some of these are direct: as Gernsheim recounts, it was Newhall who started him off as a collector of photography, an activity that led directly to the writing of his history. Their relationship has been long, apparently amicable, and unquestionably mutually influential.

One of the most intriguing facets of these interviews is the constant revelation therein of the extent to which these men made their value judgments into definitions and turned their taste patterns into historical standards. Here are some samples from Gernsheim:

> "I had been brought up in the spirit of the *Neue Sachlichkeit* [New Realism] and had a distaste for the manipulated print."

"I think only a superb news or reportage picture could move me. Other photographs may leave a strong impression on me, but they don't move me."

"The college [the Bavarian State School of Photography, where he studied] was very progressive and modern. There were no restrictions on personal expression and creative ideas in pictures. The surface texture of an object had to be brought out, and a clear, sharp, glossy bromide print was the accepted standard."

"America was rich in great photographers between 1925 and 1965, but much of what parades at the moment under creative photography is not worth serious consideration."[4]

Gernsheim offers instead a list of European photographers who he claims "beat hollow" most recent American work: Lucien Clergue, Pierre Cordier, Erwin Feiger, and Raymond Moore are (to me) the most recognizable names in the bunch.

Newhall, for his part, concedes that his history "may appear chauvinistic, because, as far as I can see, the strongest photographers have come from this country. Or let us put it another way: more strong photographers have come from the United States than from any other part of the world, though I would like to disprove that. . . ."

Newhall's specific prejudices are less easily excerptable than are Gernsheim's. Still, they are quite apparent. When, for example, he speaks of his and Nancy's first meeting with Edward Weston as "an experience that shaped our lives," or when their personal and professional involvement with Ansel Adams is detailed, Newhall's bias toward purism in general and the f.64 movement in particular has its roots exposed.

Perhaps because it was the first history of photography I ever read, or because I too am American, Newhall's work is more of a reference point to me than Gernsheim's. Thus I'm fascinated to learn that Newhall once wrote to Gernsheim that "it is a real pleasure to make the acquaintance of a fellow critic." The role of critic is quite different from, and not readily compatible with, that of historian; a lifelong confusion over the distinction between these two functions would go a long way toward explaining some of Newhall's excesses as a historian, perhaps most notably his purging of William Mortensen from the medium's history.[5]

However, the most astonishing passage in these two interviews,

for me, is Newhall's description of his friendship with Ferdinand Reyher, "a Hollywood scriptwriter and novelist." As part of their friendship, Reyher served as Newhall's advisor on the first edition of *The History of Photography: from 1839 to the present day*, which was published in 1949. Here's Newhall on this subject:

> I went down to the Hotel Chelsea, where he lived, every morning for two weeks while he studied the first chapter only. I had to bring every single book from which I had quoted and we discussed why I had used this quotation and not that, why I had editorialized — opened my big mouth — when my hero spoke better than I did. We worked over that thing a solid two weeks and he said: "Now you've got the idea, rewrite the whole book!" So I spent all summer rewriting the book. *The History of Photography* was deliberately planned with the help of a storyteller. . . .[6]

That Newhall's history is highly readable — more so than Gernsheim's, which tends toward the turgid and pedantic — is undeniable. But, as this passage makes clear, it is essentially the movie version of the history of photography, revised according to the instructions of a man Newhall himself called a "play doctor" — someone whose job it is to patch gaps, eliminate minor characters, heighten the drama, make the "heroes" more pronounced.

The disregard of Hollywood scriptwriters for the nuances, complexities, and frequent dead ends of historianship is legendary. Novelist and screenwriter Budd Schulberg pointed to the inevitability of this situation in an essay contrasting the film and the novel:

> The film is an art of high points. I think of it as embracing five or six sequences, each one mounting to a climax that rushes the action onward. The novel is an art of high, middle, and low points. . . . [The film] has no time for what I call the essential digressions. The "digression" of complicated, contradictory character. The "digression" of social background. The film must go from significant episode to more significant episode in a constantly mounting pattern. It's an exciting form. But it pays a price for this excitement. It cannot wander as life wanders, or pause as life always pauses, to contemplate the incidental or the unexpected.[7]

The gulf between the film and the novel is no wider than that between the novel and the historical essay. Yet it was to a scriptwriter that Newhall submitted his narrative for editing. There's an additional

irony lurking in there, which didn't strike me until after I'd thought long about the interview. Assuming that there was validity to Newhall's seeking out a cinematic point of view, he could have approached any of several kinds of film workers for consultation. Suppose he had chosen a cinematographer instead of a scriptwriter?

Ah, well; of such strange, inexplicable decisions is "history" often made. And, since both Newhall and Gernsheim are currently engrossed in revising their histories, these gentlemen will offer us in the near future other opportunities to scrutinize the process of making history. Fortunately, for all that they (or Susan Sontag, or I, or any of us), can do, the living medium of photography will go on.[8]

(1979)

Some Notes on the Photography Book

When William Henry Fox Talbot published *The Pencil of Nature* — an account of his successful experiments with "photogenic drawing," illustrated with actual photographic prints — in 1844, the photography book was born.

Photography brought with it a capacity for remarkably accurate reproduction of its images via the photogravure and halftone processes; these were methods by which theoretically infinite multiples could be generated. For this reason, and because the photograph is a graphic form in which large amounts of visual data can be systematically encoded, photography rapidly became the dominant medium for book illustration, thereby fulfilling one of Fox Talbot's many prophecies for its future. In less than a century and a half, the lifespan of the photographic medium to date, more books illustrated with photographs have appeared than were produced during the previous two millennia using all other forms of graphic illustration combined.

These photography books have been of many kinds. The most common have had a primarily informational purpose: textbooks, histories, guides, manuals, and the like. In a second, frequently encountered category are the more image-oriented photography anthologies: thematic collections of pictures, monographs, and so forth. As a rule, these books have all incorporated both words and images; but, generally, either one or the other of these communicative modes has been dominant and the other secondary. If the book was built around text, the photographs served as more or less literal illustrations (or even as design devices) whose quality or lack of it was not a vital issue so long as they were serviceable. If the photographs were the book's core, the text tended to be equally literal, annotative, and incidental.

Since these have been the prevalent forms of the photography book, we have become accustomed to approaching volumes combining words and photographic images with the expectation that they will fit into one or the other of these molds. For that reason, little attention has been paid to another genre of photography book, in which words and images are merged in vital, organic ways so that they nourish and amplify each other, joined in such fashion that the work (whether or not it ultimately succeeds) could not be considered complete if one or the

other were removed. Such books have been, comparatively, few and far between. Yet they do exist, and in growing numbers.

Occasionally, both the words and the images for this latter variety of book have been produced by the same individual, functioning as both author and image-maker. Jacob Riis's *How the Other Half Lives*, in which the woodcut illustrations derived from Riis's photographs are employed to provide visual data on the tragedies of slum life, is such an entity. So is Margaret Bourke-White's scathing report on the fall of the Third Reich, *Dear Fatherland, Rest Quietly*; Weegee's lusty, abrasive *Naked City*; and Edward Curtis's monumental ethnographic study, *The North American Indian*. The several collections of the images and poems of Gordon Parks certainly fit here, as do the books that form Wright Morris's unique, seminal photofictional trilogy: *The Inhabitants*, *The Home Place*, and *God's Country and My People*.[1]

But such volumes are exceedingly rare, there being few people equally adept at creating verbal as well as visual expressions with lucidity and power. Most often, the books in question have resulted from one or another form of collaboration between writer and image-maker.

In a few cases these collaborations have taken place *ex post facto*, inside the mind of an inspired editor who has wedded two (or more) distinct and separately created extant *oeuvres* into a unified new statement. One such merger brought together I. B. Singer's colorful stories of the pre-World War II Jewish ghettos of eastern Europe with Roman Vishniac's evocative photographs of that now-vanished milieu; another interwove passages from the precise, detailed prose of Marcel Proust with the Parisian photographs of Eugene Atget.

As a rule, however, the collaboration has been more active: sometimes unilateral, with a writer or photographer choosing to engage with an existing body of work in the other medium, and sometimes bilateral, with both writer and photographer creating a book together.

Despite the considerable differences between the two media — or, perhaps, because of it — the list of writers and photographers who have been drawn to the making of such books is surprisingly long and illustrious. Among those who have worked more or less in tandem are James Aldridge and Paul Strand, Carl Sandburg and Edward Steichen, Yukio Mishima and Eikoh Hosoe, Erskine Caldwell and Margaret Bourke-White, Jean-Paul Sartre and Henri Cartier-Bresson, James Agee and Walker Evans, Paul Schuster Taylor and Dorothea Lange, Langston Hughes and Roy DeCarava, William Saroyan and Arthur Rothstein, John

Steinbeck and (among others) both John Swope and Robert Capa. Note-
worthy unilateral collaborations include Alvin Langdon Coburn's pho-
tographs for the fictions of Henry James and H. G. Wells, Edward
Weston's for Thoreau's *Walden*, Anita Brenner's *The Wind That Swept
Mexico*, Sherwood Anderson's *Home Town*, Richard Wright's *12 Mil-
lion Black Voices*, Wallace Stegner's *One Nation*, John Logan's poems
after Aaron Siskind's photographs, and Archibald MacLeish's *Land of
the Free*.[2]

A great many of these books were born during the decade be-
tween 1935 and 1945, which saw a true flowering of the genre. *Land of
the Free* was one of the finest fruits from that harvest, and one of the
earliest. Very few of the classic photo-texts of that era preceded it (*You
Have Seen Their Faces* by Bourke-White and Caldwell, published the
previous year, being perhaps the most notable exception). MacLeish's
work was virtually *sui generis*, though it anticipated and was soon joined
by the Agee-Evans *Let Us Now Praise Famous Men*, Anderson's *Home
Town*, Lange and Taylor's *An American Exodus*, and Morris's *The In-
habitants*. (The latter is the youngest of this group, first appearing in
1946. Its structural debt to *Land of the Free* is self-evident, and was
made explicit in the jacket copy for the first edition, which referred to
Morris's text as "the sound track" — a term originated by MacLeish in
his book.[3])

The past decade has seen a surge of new works in this vein:
Michael Lesy's *Wisconsin Death Trip, Real Life* and *Time Frames*; Danny
Seymour's *A Loud Song*; Gaylord Herron's *Vagabond*; Abigail Heyman's
Growing Up Female; Danny Lyon's *Conversations with the Dead* and
Paper Negative — these are just a few examples. Any meaningful as-
sessment of these works inevitably leads us back to their models and
progenitors.

Whether they involve a significant image-text relationship or
are exclusively visual, many of the recent and current photography books
are meant to be taken as extended statements. They are intended to be
dealt with as unified ideas, organic wholes whose components may be
thematically linked or serially joined through narrative form or other
structures.

This poses a challenge for us as an audience, since we've be-
come accustomed to treating photography books as anthologies, to be
opened anywhere and flipped through randomly in either direction. Many

photography books, of course, are "greatest hits" compilations whose arrangement (if any) is merely chronological. But an increasing number are not, and we need to re-educate ourselves to sitting down with that kind of book and spending time with it. Such books require the same kind of attention as does a novel; you can't engage with work in an extended form on a page-by-page basis, or treat its intended order casually, and still do it justice.

In fact, book form is a more suitable vehicle for much contemporary photography than the original-print form we've come to value so highly. As a form, the original print carries with it a whole set of assumptions that in many ways are antithetical to the ideal situation in which to experience work and be most receptive to it.

Few people can afford to buy sequences of original prints; thus original-print form necessitates museum or gallery display in order to reach its audience. At the same time, the best way to come to terms with a sequence or any other extended statement is to encounter it on several different occasions. However, it's a rare individual who has the opportunity to return — and return yet again — to galleries or museums during the relatively short periods that specific exhibits are mounted. Even if one did, the work would still disappear after a month; one would not have the option of returning to it after a year, if the impulse occurred. Having the material accessible in one's own home is a significant alternative.

This may even hold particularly true for photographers themselves. As Lee Friedlander states, "I've never picked up a book by someone like Walker Evans or Cartier-Bresson or Garry Winogrand and not seen something that I never saw before, even though I might have had that book in my possession for 20 or 25 years. I always see something. So I think books are the best way to look at photographs."[4]

There's also a lack of intimacy in the museum/gallery context that interferes with the one-to-one relationship between the work and the viewer. I've found that being in the same room with shifting configurations of strangers is enormously distracting when I'm looking at pictures; it makes it difficult to slow yourself down to the rhythm of the work, because it involves you in the rhythm of the public life around you. Thus you're put in a situation in which, willy-nilly, you're going to be self-conscious in a way that you wouldn't be at home.

Also, the public arena as a forum for the presentation of work puts stringent limits on the moods and feelings the audience can bring

to the work. I like to read and look at books when the spirit moves me — early in the morning, late at night, in the bathtub, sitting on my front steps . . . times and places where I feel comfortable and open, ready to integrate someone else's perceptions into my awareness. Book form permits you to approach the work on your own terms, and to choose the psychological/emotional frame of mind within which the encounter will take place.

From this point on, when people write or talk about the illustrated book as a phenomenon in book cultures, they'll have to take into account the photography book as an entity in itself. Photography has become the predominant method of illustrating books; the relationship between the printed page and the photographic reproduction seems not only logical and organic but, in retrospect, inevitable. It makes possible the wide and rapid dissemination of photographic images, and of the ideas and feelings contained in them.

At a time when the classic silver print is dying out (due to the escalating cost of silver), it seems a very natural evolutionary step for photographers to move away from original-print form — or at least to free themselves from absolute dependence on it — and to reassert the primacy of the photograph as a multiple. Not just a high-priced, limited-edition, precious-object multiple, but an accessible one.

Let's remember that before the halftone was invented, photographic prints by people like Felice Beato and Francis Bedford were not manufactured as "unique" art objects but produced by the thousands. They were purchased in bound volumes or as individual prints that the public took home and pasted into albums. Future historians of communication may consider it an aberration that, for a period of sixty to seventy years, photography went in the direction of the unique, hand-made, original signed print as the primary vehicle for expression, and that only after a particular kind of print material disappeared from the market did photographers return to the original forms of photographic-image dissemination — through books or large multiples of the individual images.

(1981)

William Henry Fox Talbot, *The Open Door*, 1844, from *The Pencil of Nature*; courtesy The Gilman Paper Company Collection.

COLOR PHOTOGRAPHY:
THE VERNACULAR TRADITION

Though it tends to be considerably varied and amorphous, the concept conjured up for most people by the words "the history of photography" generally agrees on several assumptions. One of these is that this history can be tracked appropriately through individual images created by recognized stylists working in an arena that is analogous to — or even a direct offshoot of — what we think of as Art. Another is that this history is appropriately concerned primarily — even exclusively — with monochromatic photography, or "black and white."

Insofar as the standard written histories of the medium are concerned, these assumptions are givens. However, we are in a period of radical revisionism in regard to photography's history, and the time is certainly ripe for a challenge to these attitudes — especially since they embody a variety of prejudices and oversights.

There is ample evidence in the literature of photography to prove that the original goal — or, at least, the ideal — of virtually all the inventors of photography was a color imaging system. As an area of technical experimentation and conceptual interest, then, color photography is not significantly more recent than monochromatic photography. In fact, it is quite likely that, had a technically viable form of color photography been achieved at the outset, the medium might never have passed through the monochrome phase that now forms the bulk of its history — or might have experienced it as little more than a minor offshoot.

This is more than mere hypothesis. Monochrome was, *de facto*, the first photographic form actualized, rendered permanent, made dependably controllable, manufactured at democratically accessible prices, reproducible in multiples, translatable into ink-printing technologies, and technically manageable by amateurs. Color photography lagged well behind, sometimes by as much as half a century. George Eastman's first Kodak — the one that required only that "you press the button" — was introduced in 1888, making black and white photography available to the general public. It was not until 1936 that a color film made to fit all the standard small-camera formats, and the first that could be exposed at snapshot speeds by available light — that is, a color film that did not

119

require professional equipment and expertise — was placed on the market.

Given this lag in color's development, it is not surprising that on the part of photographers, critics, and historians of photography a distinct bias against color came into existence, especially among those who were committing their energies to exploring the much-debated and often maligned creative potentials of photography. The "seductiveness" of color itself — the intellectual shallowness of our purely optical response to it — was evident to photographers and photography critics decades before Marcel Duchamp decried the retinally sensuous branch of painting. "Photography's true sphere, the place where she catches the hot instant on tip-toe, and perfectly prisons it forever, must always be the world of monochrome; for colour is too frail and sensitive a thing to submit to these sudden pouncings and butterfly captures," wrote Dixon Scott in his introduction to a volume of fine reproductions of Autochromes — an early color-photography process — published in 1908.[1]

Yet despite that bias and that time lag, it is inarguable that whenever the technology and economics of color photography come abreast of black and white enough to be competitive with it, color is automatically preferred — in virtually every sphere save the purely "artistic." Thus there are few advertisers in any field of manufacturing who prefer monochrome to full color if cost is no object; few magazines that do not run "as much color as we can afford"; few current television programs produced by choice in black and white. Newspapers are currently developing a form of color reproduction to supplant their black-and-white halftone printing. Virtually all major motion pictures are now photographed in color; it is only when a director seeks to evoke a nostalgia based on anachronistic signifiers of realism that he or she will choose what is now an outdated form, black and white. (Woody Allen's *Manhattan*, Peter Bogdanovich's *The Last Picture Show*, and Joan Micklin Silver's *Hester Street* are three cases in point.)

Kodachrome has played no small part in this transformation of the image environment. Within a few years of its appearance in the marketplace, it was the dominant vehicle for amateur photography. Today, more than ninety percent of all photographs made are encoded on one or another color film, with Kodachrome still at the head of the pack.

Small wonder, then, to find a poet like Paul Simon singing "Kodachrome/They give us those nice bright colors/They give us the

greens of summers/Makes you think all the world's a sunny day/ . . ."
Color photography, both still and kinetic, has shaped the contemporary
vision of the world. And it is the vernacular usages and forms of color
photography — in advertising, in television, in photojournalism, and in
amateur photography — that have shaped our understanding of what
color photography is.

Thus the current rush of artists and "art photographers" into the
field of color photography is not avant-garde but distinctly reactive —
and a long-delayed reaction at that. Little of what we are being shown
in galleries, museums, and monographs as the "new wave" of color
photography is in fact innovative. For the most part, its only novelty is
recontextualization — the transference of approaches and ideas long
since commonplace in one or another form of vernacular photography
to a territory that has hitherto disdained and excluded those functions of
the medium.

In coming to terms with this "new wave," then, it is essential to
understand it as a response to the vernacular history of the medium. It is
in that vernacular experience that the primacy of color in photography
has been established by democratic vote. The current experiments in
color are automatically gauged against the cumulative history and tra-
dition of color photography that we have internalized as members of
this photographic culture. And, by virtue of "serious" photography's
prolonged neglect of the coloristic potentials of the medium, that tradi-
tion and history have little or nothing to do with "art" or "Art Photogra-
phy." They are derived much more clearly from the distinctive orange
of fading Ektachrome snapshots; the wishfulness of cheeks hand-tinted
rose in family-album portraits; the intensely saturated and attractive reds
in the My Lai massacre photographs: the feathery-edged richness of
Sunday rotogravures; and the "nice bright colors" that we fell in love
with not formally installed on gallery walls but projected onto the glit-
tery surface of cheap folding screens in our darkened living rooms.

(1980)

Is Criticism of
Color Photography Possible?

The question with which I have titled this talk is not intended facetiously, nor rhetorically. There is no doubt in my mind that an effective exegetical structure (and perhaps even more than one) for the critical analysis of color photographs will evolve, along with an accompanying and adequate vocabulary. We will develop these tools because we have no choice; color photography is here to stay, so we have no alternative but to come to terms with it.

I find it curious and revealing that the widespread urge toward a critical structure relevant to color photography has only manifested itself during the last few years, precipitated by the burgeoning of a color-photography branch of the art-photography mode. So long as color photography was "restricted" to such quantitatively enormous but ostensibly unaestheticized purviews as photojournalism, magazine illustration, commercial photography, and the vernacular snapshot, critics obviously felt no need to trouble themselves by considering it. After all, if it was not being used by artists, why bother?

I think this reflects an elitist and archaic bias on the part of photography critics in general. Certainly, whatever the reasons for it might be, the fact is that all of us active in photography criticism are currently scrambling to find ways of talking about color photographs without falling into the trap that has snared so many art critics in their approach to painting — which is to discuss the works as though they were monochromatic.

I used the word "us" deliberately, for I feel the lack of these tools as acutely as any of my colleagues, and am as embarrassed as any of them to find that the span of my own critical writing contains no effective commentary on any body of color imagery and raises few of the right questions. I cannot rectify the first of those omissions here today, but perhaps I can work on the second.

•

The initial problem we face, critically, is the relative novelty of color as both an accessible and a controllable medium for photography.

As an area of technical experimentation and conceptual interest, color photography is not significantly newer than monochromatic photography. Indeed, there is evidence in the literature to prove that the original goal of virtually all the pioneer inventors of photography was a color imaging system, and that the public yearned for the advent of such a system from the medium's inception. It is quite possible that, had a technically viable form of color photography been achieved at the outset, the medium might never have passed through the black-and-white phase that now forms the bulk of its history.

That's not the way it went, however. As an accessible medium — meaning one whose materials and techniques are commonly available to people of average income and education — color photography is a novelty by comparison with black and white. And as a controllable medium — meaning one in which all the processes and tools necessary for realizing an image from exposure to finished form are at the disposal of the individual photographer — color is still in its infancy.

When I began looking seriously at photographs, photographers working in color who made their own prints — like Dorothea Kehaya, Charles Pratt, Eliot Porter and Murray Alcosser — were rare birds indeed. Today, less than fifteen years later, we have beginning students who take that option for granted.

Consequently, we have a standardized and outdated vision of the history of photography, one that treats color photography as a mutant variant of the medium. We have a critical tradition whose general skimpiness multiplies geometrically where the subject of color is concerned. And we have an audience for the medium not only accustomed to looking at color photographs but habituated to making them, yet lacking any useful criteria for considering them as images in color.

One of my readers once suggested that it was from this vernacular tradition of color photography that our understandings should be drawn, since that was our primary tradition of color usage. Certainly the historical study of our culture's experience with color photography must devote long chapters to the color snapshot, as well as to the use of color in photojournalism and advertising/commercial photography in the mass media. At this point in the evolution of color photography, those usages have been far more instrumental in shaping our attitudes toward color photography than the output of any group of "art" photographers working in color.

It is difficult to formulate a critical approach to any medium without a relatively clear historical overview. It is almost impossible to do so when you lack not only an historical perspective but also an effective working vocabulary.

Where might such a vocabulary come from? There are two potential sources: theory and practice.

The critic in search of a vocabulary has at least five major theoretical approaches to color from which to choose. All are complex, arbitrary, and to a considerable extent mutually exclusive. None of them is derived from photography *per se*. Briefly put, these include:

(1) The traditional symbolism of color as established in the history of western art, wherein colors have specific symbolic meanings drawn from mythology, religion, or politics.

(2) Color as a culturally based but relatively constant psychological symbolism — as in the Madison Avenue formulation (noted by Vance Packard) that a red convertible represented a man's sublimated wish for a mistress.

(3) Color as a personality-based psychological affect that shifts as the individual psyche evolves — a proposition put forth and elaborated by Dr. Max Lüscher in his *Color Test*.[1]

(4) Color as a system of abstract, formulaic optical relationships, as treated in the writings of Johannes Itten and Josef Albers.

(5) Color as a retinal function of human perception — a purely scientific phenomenon rooted in human physiology.

Above and beyond these there is an additional range of provocative speculations, including novelist Tom Robbins's proposition that color is "a disease which attacks light."

Each of the major approaches has its own distinct vocabulary, any one of which is certainly preferable to the terminology most critics have adopted to date, alternating as it does between poetic-evocation-of-vague-mood and gee-that-would-look-swell-above-the-couch. The problem with selecting any one of them as a critical tool, however, is that it may not be effective in addressing the entire span of contemporary work in color.

This span includes everything from color-as-information (in the group portraits of Neal Slavin, for example) to color-as-mood (in Joel Meyerowitz), and from "real" color (in John Pfahl's work) to various forms of synthetic color (Kenda North, Sonia Sheridan). To attempt to apply any single vocabulary to all these is to come to a rapid recogni-

tion of the limits of critical systemization.

This problem of choice and application is compounded by the fact that we have currently a great deal of activity and experimentation in the field of color photography, but very few exemplary and resolved bodies of imagery therein. What have we as reference points? What are we to gauge new works against? I am hardly a traditionalist, but criticism in any field devoid of distinct and coherent *oeuvres* is hard-pressed to be anything more than rampant taste-mongering.

Aside from the historic bias against color, this situation is attributable in large part to the comparative novelty of accessible and controllable color photographic technology. Color photography is problematic for critics and audience to a considerable extent because it remains a problem for practitioners. Most of the latter are still struggling to master the various new materials and processes, and to discover their own personal affinities within the available latitude. (Their collective task is not made any easier by the continual and rapid changes ongoing within that technology. Color systems obsolesce at a remarkable rate; no sooner have photographers learned to control materials than they become unavailable. SX-70 film is a case in point; the latest version thereof, the so-called "Time-Zero," has a thinner emulsion than its predecessors and hardens or "sets" much more quickly. This decreases the manipulability of that emulsion, a quality explored at length in the work of Les Krims, Lucas Samaras, and many others.)

Thus we might say that most current work in color is not only experimental but premature. We might also say that the decision of image-makers, gallery owners, curators, and publishers to present enormous quantities of it at this time is questionable in its wisdom, insofar as it compounds the legitimate and understandable confusion of all concerned.

This confusion is further amplified by such people as the prominent curator who hyperbolically declared that one particular contemporary photographer was "inventing color photography," and the prominent art critic who — in addition to writing critical essays about color photography and functioning sponsorially as curator of a major traveling color exhibit — has severely undermined his credibility and usefulness by persistently and presumptuously exhibiting color photographs of his own making that are imagistically imitative and ineptly crafted.

Color photography, at the moment, is a bandwagon, and those leaping onto it are doing so for a variety of motives, not all of them

healthy. This certainly includes many of the form's practitioners, who would be well advised to ask themselves if they're "doing" color because it's essential to them, because they're truly curious about it, or because it's presently the thing to do. The premature exhibition of unresolved, inchoate work does a disservice to the audience, to the medium, and to the image-makers themselves.

Insofar as a color photograph is strictly "about" the solutions of problems inherent in the technology, it is an exercise in craft. Such exercises can be instructive not only to the photographer who performs them but also to his or her fellow image-makers, and even to the audience. Certainly we all need to be better informed as to the hermeneutics of color photography — those infrastructural aspects of craft that determine what can and cannot be done with the medium. As I've suggested previously, any effective method for critical exegesis will incorporate both a coherent theory and an awareness of the issues of praxis. Yet all of us need to distinguish between those works that are created during an image-maker's apprenticeship in the specific craft of color photography and those works in which a fully mastered craft is placed at the service of a realized personal vision.

This does not mean that color photography at present is unexhibitable. But I think that all concerned in the presentation of color photography — photographers, gallery owners, curators, and editors in particular — should be far more careful in choosing what they show, in structuring those presentations, and in defining the work presented. The audience — among whom I certainly include the critics — needs much educating in this instance. (A good beginning would be one or more exhibitions in which the various available technologies for the production of color photographic imagery were illustrated and compared, so that the present range of options and their influence on individual ways of seeing could be better understood.)

I would also suggest that we need far more writing by photographers working in color than we have had to date. There is, to my mind, a significant difference between credo and criticism, and I am not suggesting here that color photographers should enter the field of criticism *per se.* But the availability of writing by practitioners in which they articulated their own concerns as image-makers, their ideas about color photography, their experiences with the materials and processes, and their reasons for choosing among them and utilizing whatever systems they've evolved, would be enormously useful to the critics. They, in

turn, might be able to use such information in their attempts to communicate about the resulting images to an audience that is too often left floundering in the shallows of taste. The absence of such writings — the hermeneutic reference points — is another factor that contributes to the lack of a provocative and cogent critical dialogue on the subject of color.

Such dialogue as does take place generally occurs within the pages of art and photography publications — accompanied often by reproductions of some of the work under discussion. In many cases, those reproductions are the closest that readers will come to a direct encounter with the images. Yet the relationship of those illustrations to the originals tends to be, at best, tangential. Reproductive inaccuracy is even more a plague in the publication of color photography than it is in regard to black and white. Also, the exorbitant present cost of state-of-the-art color reproduction makes it financially impractical for book and magazine publishers to do true justice to the work of most color photographers. Nevertheless, the versions of color photographs that they provide us — erratic in quality and sometimes wildly distorted — are the basis for much of our encounter with and response to contemporary color photography.

Finally, I think that the question of color photography's stability — or, more accurately, the fact of its instability — is a critical issue as well. I am not much concerned with the effect of that impermanence on the collectibility of color — critics are not the collectors' consumer guides, unless they set out to be. But if, as Henry Wilhelm indicates, no color image made with currently available materials can be expected to remain physically unchanged for more than six years, and may alter dramatically in a much shorter space of time, we have come up against a major stumbling block. Can we as critics (and as viewers in general) safely assume that the image we are seeing, interpreting, and writing about is in fact the same image that the photographer made and approved? Or has its chemistry altered sufficiently to change its chromatic relationships and thus alter its effect? Conversely, can we as critics safely assume that the color image we write about today will be the same one that a viewer will encounter one month, or six months, or six years hence?

The answer to these questions would appear to be no, yet criticism of the visual arts in general makes no provision for deterioration of the work in question, a factor that has always been treated as negli-

gible. In color photography, image decay seems to be inherent in the materials, and cannot be avoided critically in the long run — though we are all, understandably, closing our eyes to its implications at present.

Getting back to the title of this talk — is criticism of color photography possible? — I will conclude by providing my own answer: Theoretically, yes; practically, no — at least for the present.

When the needs I have tried to outline here — a history of color photography, an agreed-upon group of resolved bodies of work, a few applicable theories, and so on — have been met, then effective critical writing about color photography will become possible. Until then, what we will have is a provisional kind of writing — some of it directed at filling those gaps, some of it a sort of optimistic speculation, much of it (like the cartoon villain outwitted at cliff's edge) blissfully unaware that it has no foot on the ground. Think of it as exegetics waiting for a hermeneutic base to appear. Different critics will take different paths while wending their way among these alternatives, but none of us can stand still any longer without the medium passing us by.

One of the most exciting aspects of contemporary color photography is that everyone concerned with it — inventors, manufacturers, historians, critics, curators, dealers, collectors, audience, and photographers — are all operating in a state of roughly equivalent ignorance. If we can accept the challenge of coming to terms with this medium as a communal act of self-education, it may teach us much more than we could possibly anticipate.

(1982)

THE AUTOBIOGRAPHICAL MODE
IN PHOTOGRAPHY

The urge to communicate our perceptions and experiences appears to be inherent in our nature as human beings. That impulse underlies our creation of visual and verbal language systems. We seem also to have a deep need to perpetuate those perceptions and experiences, perhaps in a symbolic search for immortality. Humans have evolved highly complicated methods of codifying and making permanent the major events of their lifetimes. In some cultures, these events are integrated into an oral tradition, passed down from generation to generation via the spoken word. In other cultures, they take written or pictorial forms.

The creation of such running accounts takes place on many levels, from the international to the individual. All are modes of history. The most personal of these is autobiography, which *Webster's* defines as "A biography written by the subject of it: memoirs of one's life written by oneself."

Many people — from troubadours to philosophers — have sought to distill and transmit the essence of their lives and thought. However, the act of opening the doors of one's identity to others is so intimate and so emotionally charged that we have created specialized and highly structured cultural channels — the confessional, the psychiatrist's couch — to protect the unwary from the raw power of individual self-revelation.

In our society, anyone who habitually seized every third passerby's lapels in order to gabble interminably about his decaying albatross would soon be restrained legally and, if necessary, physically. An ability to transmute such an obsessive vision into a visual or verbal equivalent can earn it tolerance and even fame. Over the centuries, we have evolved certain public forms within which the presentation of self and the exposition of personal history are considered permissible. Literature and art — as we in the post-Renaissance west use the terms — are such outlets. Both are accepted vehicles for the presentation of self, partly because both of them grant the viewer/reader the protection of aesthetic distance. Many people do not want their privacy invaded by others, and most of us demand the right to turn away from another's

picture, to close another's book. The works of art and literature we resent most tend to be those that make us uncomfortable but that we cannot ignore or forget.

All creative activity is about its maker to some extent; it cannot help but be so by its nature, even if not intended as an expression of self. Some creative activity, however, is specifically and explicitly built around a visible core of personal history and self-exploration. This we call autobiographical. The shape of such work is not fixed; it may appear as family chronicle, journal, self-portrait, diary, letters, or various other forms.

It is not always a constant theme in an artist's work, though even Michelangelo once painted himself into a crowd scene (as a flayed skin). But self-portraiture has been a recurrent concern of artists from Rembrandt through Picasso to Francis Bacon. A partial list of autobiographically based writing could include works by Benvenuto Cellini, Ben Franklin, Maxim Gorky, Walt Whitman, Marcel Proust, Herman Melville, Mark Twain, Virginia Woolf, Sean O'Casey, Gertrude Stein, James Joyce, Anne Frank, Jean Genêt, Samuel Beckett, Malcolm X, Brendan Behan, Henry Miller and Anaïs Nin, yet still be considered full of the most glaring omissions.

Clearly, autobiography is a robust and vital mode with an extensive tradition of its own. To dismiss it from the lists of artists' legitimate concerns would be to impoverish drastically our creative heritage.

Until the invention of photography, the word — spoken, sung, written — was the most frequent vehicle for autobiographic expression. Painting and sculpture, the dominant visual arts, were far too procedurally tedious and physically cumbersome to lend themselves readily to any ongoing account of personal life. Moreover, the church, the state, and the wealthy — the only ones who could afford to buy art, and thus the only economic games in town — didn't want portraits of artists, but images reflecting their own glory and portraits of themselves. Out of vanity? No doubt, but not exclusively. Money gave them access to a kind of information that can be most instructive, information concerning the way in which others saw them. To the extent that their vanity overcame their curiosity, they subverted their own education and settled for flattery in place of insight. Nonetheless, until 1839 a privilege we today take for granted — that of seeing and possessing likenesses of ourselves, our families, friends and forebears — belonged almost exclusively to the rich and powerful.

Betty Hahn, *Mejo, Passport Photo*, 1973;
courtesy Wltkin Gallery, New York.

Photography made the experience of living with a visual personal history accessible to everyone. George Eastman's 1888 Kodak ("You press the button, we do the rest") placed the creation of such a document within the hands of its subjects. It was adopted immediately by people on every stratum of western society, and has since spread around the world. The result has been a perceptual revolution. Today, there are billions of photographs commercially processed each year in the United States alone. Most of these are snapshots destined for scrapbooks and shoe boxes. To be sure, they are often made incompetently, acquisitively and gluttonously. Still, they are made, treasured, scrutinized, lived with and passed on. As a demotic artifact, the photo album is so ubiquitous and so much taken for granted as a part of life in our society that it seems somewhat shocking and revealing to encounter one of those rare families — the Nixons, for example[1] — that has kept no family album. And it is a rare person indeed who has not appeared in dozens, even hundreds of photographs.

Photographic self-portraiture is also a commonplace activity in our culture. The most frequently employed tool for this purpose is the four-for-a-quarter photobooth, which provides sets of sequential self-portraits in a standardized format at minimal cost. The purposes these are made to serve are diverse: identification, cut-rate narcissism and the commemoration of interpersonal relationships. This device — whose history is still inadequately annotated — is the most accessible, most ubiquitous, and most widely employed instrument of self-portraiture in the history of humankind: a tool devised for that purpose and no other.

Demonstrably, then, in the evolution of photography to date, the branch of the medium with the deepest roots in daily life and the most extensive vernacular tradition is photographic autobiography. It should therefore startle no one to discover that an increasing number of artists are using one or another aspect of the autobiographical mode as the structural framework for more formally presented bodies of creative work.

Though they overlap considerably, the three primary forms of the autobiographical mode in photography are self-portraiture, the diary and the family album.

On the formal level, self-portraiture is as old as the medium itself. Photographers tend to make periodic self-portraits, even if inadvertently; the medium lends itself to accident in that regard, beyond its versatility as a purposefully used mirror.

For many photographers, these images acquire significance as private prognostications and testimonies — frozen, tangible epiphanies, splinters from the true cross of time. (Arthur Freed has gone so far as to say that he'd trust the accuracy of one of his own images over his own recollection of the event.) For some, they become integral as periodic road signs within a body of work. And, for a few, they evolve further, into an extensive line of public inquiry, a vehicle for self-scrutiny and the exposition of one's *personae*.

One could attribute this to the increasing narcissism to which extreme individuality often falls prey in a decadent society. One could explain it as evidence of that turn inward which has taken place in all the arts since World War I. One could read into it a necessary step toward the higher consciousness required for this new stage of human evolution. It is my own belief that self-love is the basis for love, self-respect the basis for respect, and self-knowledge the basis for knowledge, so I am obviously biased in favor of such investigations. True, as I can testify from experience, the risk run in engaging with such works is that of encountering instances of boring egomania and severe cases of premature autobiography, the latter being a fate to which first books of photographs are prone no less than first novels. On the other hand, how many photographs of Moroccan children and Portuguese fishermen by American tourists do you really want to see?

Most every photographer has made at least one self-portrait. David Octavius Hill and Robert Adamson photographed themselves a number of times, singly and in tandem. Alfred Stieglitz, Edward Steichen, Imogen Cunningham, F. Holland Day, and Man Ray are representative of older photographers who have turned their lenses on themselves regularly; Ralph Gibson, Keith Smith, Sonia Sheridan, Duane Michals and Jerry Uelsmann are a sampling of younger ones who have done the same. Within the past decade there has been a notable increase in published and exhibited self-portraiture, along with the appearance of a number of extended works based on that theme.

The first public presentation of an extensive body of photographic self-portraiture within this current cycle was Lee Friedlander's *Self Portrait*, a collection of images made between 1964 and 1970, which Friedlander published himself. Of them he wrote, "These self portraits span a period of six years and were not done as a specific preoccupation, but rather, they happened as a peripheral extension of my work. They began as straight portraits but soon I was finding myself at times

in the landscape of my photography. I might call myself an intruder. At any rate, they came about slowly and not with plan but more as another discovery each time. I would see myself as a character or an element that would shift presence as my work would change in direction."[2] This archetypal volume is for me Friedlander's strongest and most honest piece of work, his least snide — though perhaps his bleakest — statement.

Another seminal work in this genre, Lucas Samaras's *Samaras Album*, appeared in 1971. Samaras is not nominally a photographer, but this suite of several hundred "autoPolaroids," in color and black and white, is a collection of strange, wonderful and intelligent photographic imagery. It is also the most virtuoso use of Polaroid as a medium in itself that I have seen to date. Samaras's techniques include multiple exposure and the alteration of the print with inks and other materials, practices alien to Friedlander's "straight" style but well-suited to Samaras's playful approach and necessary for his demonic, obsessive, theatrical examination of himself.

Of the Polaroid as a tool, Samaras says, "the speed with which a result is obtained without outside help and the complete privacy afforded me an opportunity of doing something impossible with regular photography. I could tune up or tone down emotion. I could move a little to the left or shift this or that and be my own critic, my own exciter, my own director, my own audience."[3]

A more modest series, Mike Mandel's slender *Myself: Timed Exposures*, was issued by the photographer in the same year. In this quietly humorous book, Mandel is seen in a number of odd and incongruous settings: seated in a bank's display window, standing before a long line of helmeted police, amidst a Black family, beneath a hairdryer in a beauty salon.

Other recent works of self-portraiture include David Pond-Smith's *Manself* (1974), an uneven but sometimes powerful allegory about coming of age; Adal Maldonado's collages in *The Evidence of Things Not Seen* (1975); and Arthur Tress's new photographic "novel," which stars the photographer's shadow and is titled after it.

I find it significant that, Samaras excepted, few men have used self-portraiture to study their own bodies, whereas this has been a frequent motif in the work of many women. Chris Enos, Ronnie Ginnever, Donna-Lee Phillips and Joan Lyons are among those who have published and shown nude self-portraits.

Athena Tacha has produced several works relevant to this theme. Her *Heredity Study II* is a series of photographs of various sections of her anatomy, accompanied by a text in which she describes her physical, intellectual and psychological characteristics and their derivation from her parents' traits. ("My feet, toes and toenails are almost exactly my f.'s: large toe slanted towards other toes, rest of toes small and regular. From my m. I took only the tendency for corns [my f. had none].") And her *Expressions I (A Study of Facial Motions)* is a series of 32 self-portraits, printed in four rows on a single large foldout sheet. Each image is a close-up recording a different chin, nose, tongue, mouth, eyebrow or eye motion, and the whole forms a comic broadside on the subject of human physiognomy. These two (along with *Heredity Study I*, which is pertinent but not autobiographical) were self-published by Tacha.

In the *U.S. Camera/Camera 35 "Personal Pictures" Annual* (1973) and in *Creative Camera* (England), Melissa Shook has published excerpts from a lengthy series of one-a-day self-portraits, many of them close-up nudes intended not to flatter but to confront the reality of the body. Barbara Bruck's *Catharsis* [3] (1973) is a harrowing study of the effect on the photographer of a disease that causes total loss of hair, and of the costuming and makeup required to disguise this condition. This is a painful, courageous statement.

•

Around most of us there accumulates — usually haphazardly — the raw compost for a diary, made up of snapshots, graduation pictures and assorted memorabilia, fragile mementos of who we've known and where we've passed, what we've seen and who we've been. Over the past several decades, however, this has become a way of working for some photographers. Accelerated by a shift in viewpoint from the camera as ostensibly impartial witness to the photographer as picaresque voyager, this relatively new formal stance emerged out of the same rootlessness and *anomie* that can be felt in the work of American writers from Thomas Wolfe and Ernest Hemingway to Jack Kerouac and Thomas Pynchon.

The myth of so-called "objective" reportage, always at best a chimera, is at last being recognized as such. Concurrently, there has arisen a genre of openly subjective, impressionistic response to and interpretation of personal experience. Such imagery tends to concentrate on the momentary, evanescent, and metaphorical rather than the static,

monumental and stereotypical. In many cases, these fleeting glimpses, even though publicly presented, remain uncommunicatively private, random jottings in a secret code. As a form, the diary surely has its own particular set of problems, among them its stress on sensibility and on the imperatives of context. These require the audience to join in an extended acquaintanceship, and necessitate the viewer's awareness of the photographer's presence in the photographic event, if not in the image itself.

The key work in this form is unquestionably Robert Frank's *The Americans*, first published in 1958. This book is a major bridge in contemporary photography, achieving the transition from the classic style of "documentary" photography to a camera-based personal journalism. In an era of gray, "neutral" reportage, *The Americans* reaffirmed the validity of subjectivity. Understated and elliptical, Frank's suite of sharp glances at the sad banality of American culture is obviously a participant's journal of everyday experience, as much about the perceiver as the perceived. (This becomes even more explicit in his later book, *The Lines Of My Hand*.)

There were precedents for this way of working — diaristic elements in W. Eugene Smith's work, especially "The Loft From Inside In," and in J. H. Lartigue's work, which was not yet widely known here. But none had enunciated it so lucidly; photography was still presumed to be concerned primarily with external rather than internal reality.

Since the publication of *The Americans*, an increasing stream of work in this vein has begun to bubble forth. Dave Heath's *A Dialogue With Solitude* and John Max's *Open Passport* are visual accounts of these photographers' ongoing experiences with other people. Larry Clark's *Tulsa* is a nightmarish description of the Oklahoma drug scene by a participant therein. Michael Martone's *Dark Light* is a brooding, haunted tour through a private world. Nancy Rexroth's blurry dreamscapes made with the Diana-F camera, collected in her book, *Iowa*, are attempts at recreating half-remembered images from childhood.

A number of works in this genre have incorporated words along with images, often quite effectively. Wright Morris, in his remarkable trilogy — *The Home Place, The Inhabitants, God's Country and My People* — succeeds in making one see with words the semi-fictionalized people who once occupied the empty buildings and spaces of his photographs, made in the midwest of his youth. (Lee Foster attempted something similar in *Just 25 Cents and Three Wheaties Boxtops*, pub-

lished in 1970, but did not achieve it nearly so consistently as Morris.) In *Elsa's Housebook* (1972), Elsa Dorfman offers candid sketches of the friends — many of them artists and writers — who pass through her New England home. Though it is not likely to become a book, pertinent diaristic work was created by Bernadette Mayer and exhibited in New York in 1972 under the title "Memory." Mayer exposed a roll of color film each day for a month and mounted all 1000-plus images in order, accompanying them with several hours of taped reminiscence triggered by the images, and recollections of the events that occurred between them. It was an apt, if exhaustive, demonstration of how little of one's experience could actually be encapsulated in a photograph.

•

In the family album as a creative vehicle, we have once again a traditional vernacular format utilized as the unifying framework for a more intentional, coherent exploration of the functioning of photographs in our lives. In this case, the emphasis is not exclusively on the photographer's physical self as a constant, nor strictly on his or her sensibility as defined through interaction with the outside world in the largest sense. Rather, the stress in this form is on a plexus somewhere between those two poles: the matrix of symbolic relationships inherent in the family unit (usually extended to include close acquaintances as well as relatives), the embodiment of those relationships in specific people, and the interplay between the two as they are both subsumed into the mellow, melancholy poetics of time — all of this contained within the parameters of what is by now a common household object.

A cornerstone work here has been the *Boyhood Photos of J. H. Lartigue: The Family Album of a Gilded Age*. First published in 1966, it has already had a marked impact on photography. Lartigue's photographs of his family and their circle of friends are full of exuberant humor and spontaneous, inventive seeing, reaffirming the richness and variety of one's own daily life as a source of imagery.

Obviously, persuading outsiders to involve themselves with oneself and one's loved ones, even abstracted in photographs, requires the photographer to engage the audience with the people and events in the images, or with his or her sensibility — or, most frequently, with some combination of both. The audience, in turn, must make its own choices on the basis of responses that may have little to do with aesthetics but that are no less valid because of that; and, if the response is favorable, the audience must to some extent be willing to commit itself

to a long and even ongoing relationship.

There are advantages to such a relationship, however. As Alfred Stieglitz argued, a true photographic portrait cannot be made with only one image; it requires dozens, even hundreds of images made over a period of time to render anything resembling the complexity of another human being. (He himself created just such a multi-faceted portrait of his lover and then wife, the painter Georgia O'Keeffe, a composite of perceptions that is one of the most comprehensive descriptions of another person in the history of the medium.)

Harry Callahan has made an equally open-ended, cumulative portrait of his wife Eleanor, which has come to be one of the central threads running through his work. And it seems likely that the examples of Callahan (with whom he studied) and Stieglitz influenced Emmet Gowin, who makes photographs about many different things but continually returns to his family and most particularly to his wife Edith.

Gowin has published and exhibited many photographs of his people over the past half-decade. Not a long time, to be sure, yet long enough for a son to be born and an older relative to die, long enough to see Edith in bed with the children and pissing on the barn floor. There is in Gowin's work an awareness of the density and texture of closely joined lives, a full acceptance of the freedoms and limitations of being human. These qualities, accompanied by an abiding tenderness, give Gowin's work a curious kinship with Roy DeCarava's *The Sweet Flypaper of Life*, a collaboration with Langston Hughes that is also a lyrical (though essentially fictional) family album.

Perusal of large dosages of such pictures heightens the awareness of *leitmotifs* that are by now deeply imbedded in the traditions and rituals of vernacular photography. There is a ceremonial quality to such images as those of the family gathered around the festive board, the high-school student arranged alphabetically among his or her classmates, and the presentation of the newborn (in which an infant is offered to the camera, usually by a female relative, for certification). The inevitability of these archetypes' occurrence and recurrence within each family's visual history, and the visible changes that affect and alter the cast of characters, give such images the potential of becoming powerful metaphors for the human condition. That potential can be more dependably fulfilled if the imagemakers are articulate. However, inarticulate and even technically inept images of this sort often have an energy and poignancy all their own; their placement in an appropriate context can some-

times give them voice, or at least make effective use of their muteness.

A number of recent works have concentrated on such placement. Wall Batterton's *10 April 1932* is a book of reproductions of personal memorabilia — much of it photographic and none of it uncommon — that tells much about him yet simultaneously points up the disparity between events lived and the trail of mementos dropped behind them. Danny Seymour's *A Loud Song*, which preceded Batterton's book, works in much the same way though it uses photographs and text. "Judy and Adrienne," an exhibit held in New York in 1973, employed a chronological arrangement of memorabilia — report cards, garter snaps, pressed flowers, and many different kinds of photographs — to show the two parallel lives of its subjects, Judy Levy and Adrienne Landau, moving inexorably through American middle-class life in the 1950s and 1960s toward the divorce of one and the separation of the other.

Dave Heath's multi-media presentation, "Un Grand Album Ordinaire," is one of the most elaborate projects in this vein ever undertaken — 840 slides of "found" vernacular images arranged both chronologically and cyclically. Unfortunately, it has not been widely shown, and is unpublished.

Some other pertinent books and exhibits in this mode are Robert Delford Brown's "Bob Brown and Friends," a 1971 show that made early use of family-album imagery; the sometimes goofy, sometimes dull *Fun Friends & Relatives by/of Ramon Muxter* (1973); Richard Avedon's photographs of his dying father, shown at the Museum of Modern Art; and Mark and Don Jury's book, *Gramp*, about the aging and death of their grandfather. One would also have to include Dorothea Lange's unfinished last project, a study of her family in their home on the rocky coast, posthumously completed by Margaretta Mitchell and published as *To A Cabin*; Catherine Noren's *The Camera of My Family*, containing the work of six generations of talented amateur photographers in one family; Robert Frank's film, "Conversations in Vermont," in which Frank and his children use photographs of their past as guides in coming to terms with it; Robert Cumming's parody of photographically illustrated autobiographies, *A Training in the Arts* (1972); *The Family Album*, edited by Mark Silber; and Ralph Eugene Meatyard's photographs of his family and his cohorts with their masks and their friend Lucybelle Crater, a body of work about the multiple identities we reveal to those who come close to us.

In the three primary forms of the autobiographical mode, the

disparity between the photographic image and "the thing itself" is not only a given but, in most cases, a known factor employed for its paradoxes and ironies. A photograph may, at the time of its making, provide the cheering illusion that time can be stopped and held; as we move further away from the moment it purports to preserve, however, each photograph becomes another proof of our helpless drift through time, a mockery of its own illusion. (Sylvia Plath, in "The Babysitters," spoke of ". . . A gallery of creaking/ porches and still interiors/ stopped and awful as a/ photograph of somebody/ laughing/ but 10 years dead.") Nowhere is this more true than in photographs of human beings, ourselves or others.

All three of the above aspects of photographic autobiography also de-emphasize the single image, bypassing it in favor of the series, the chronological cluster and the ongoing narrative. Thus they move away from veneration of the superbly crafted print as precious art object, directing themselves more toward the image as idea and archetype.

Stylistically and philosophically, the works I have discussed and listed have little in common. What they share are ideas and premises concerning the operation and impact of the phenomenon of photography itself, as we integrate it into the context of our lives.[4]

(1975)

SEP · 75

William DeLappa, from the series, "Regeneration: Images and Icons";
courtesy of the photographer.

Zeke Berman, *Table Study*, 1983;
courtesy Museum of Modern Art, New York.

THE PHOTOGRAPHIC STILL LIFE:
A TRADITION OUTGROWING ITSELF

To paraphrase Sir Kenneth Clark's statement on the nude, the still life is not a subject of art, it is a form of art. And, over the past century, photography as an image-making medium has redefined this "form of art" in radical ways.

What exactly is a still life? That's no longer an easy question to answer, though it's certainly possible to indicate what it once was. The term itself originated in Holland, where still-life painting is generally considered to have emerged as a distinct form in the seventeenth century. The Dutch word was *stilleven*, which translates simply as "motionless models."

The following passage from Hans Koningsberger's book, *The World of Vermeer*, establishes some of the fundamental concerns of the still-life tradition:

> Though it started in the kitchen, still-life painting soon branched out to include the whole catalogue of decorative and useful items with which Dutch burghers surrounded themselves.... As the century wore on, still lifes reflected the increasing degree of middle-class luxury... . Such glorification of the Good Life matched the mood of the prosperous art buyer. The paintings obviously fit nicely on the wall over his dining table, and the artists who made them were assured of a steady demand.
>
> At first these specialists often included an overt message in their work.... A popular theme of their paintings was the vanity of all earthly affairs, and the works were thus known as *vanitas* still lifes. They always included some objects that spoke of the impermanence of life — a skull, an hour-glass, some flowers, a snuffed-out candle. There were countless other symbols, each with its special meaning... . Some artists even painted still-life motifs for the enjoyment of clever observers who were supposed to guess the appropriate symbolism.[1]

As Koningsberger goes on to indicate, subsequent painters developed the still life into a vehicle for the exploration of more strictly sensory issues — tone, texture, composition and light — and minimized or abandoned any significant relationship to the symbolism of subject

matter. We can see this as an early manifestation of one of the inherent dialectics in the still life as a form. Yet though that form has become ever more diversified over the centuries, it is important to keep in mind that the cultural premises from which it sprang were quite practical ones: it was conceptually safe, middle-class oriented, and eminently merchandiseable. To quote Koningsberger again, "It reflected the tastes of the new, bourgeois art patron and his interest in strictly representative art," and "the subject lent itself admirably to display in the home."[2]

Such contemporary critics as Anthony Burgess and Kenneth Burke have argued that the meaning of the term *aesthetic* is *shock* — that the aesthetic is that which forces the audience into reconsideration of an established reference point. Its opposite, they propose, is not "ugly" but *anaesthetic* — that which soothes, numbs, and corroborates. In that light, it could be said that the original purpose of the still-life form (partially excepting the *vanitas* approach, with its brooding on mortality) was *anaesthetic*.

Certainly this is no longer true of the form as a whole. In fact, it has become increasingly difficult to generalize about any aspect of the still life — even its nominal subject matter. For example, as originally articulated, the concept included a strong emphasis on organic materials. The French version of the term *still life* is *nature morte* — dead nature — which makes that emphasis explicit. Yet it is not uncommon today to encounter still lifes that do not include the presence of formerly living things. Others have employed inanimate objects in configurations that suggest movement and life. And still others have incorporated living creatures into their images. (I think here of an André Kertész image, titled "Still Life," portraying a table top on which a teacup sits. Inside the cup crouches a white mouse, seemingly frozen with fear; wrapped around the outside of the cup is a snake.)

It's important to keep in mind that the objects employed by the early still-life painters were (their symbolism notwithstanding) simply the materials at hand. Unless it is deliberately anachronistic, the contemporary still life will also use the materials at hand — but those have changed, and the wine goblet, kitchen knife and poached fish of the seventeenth century may be transformed into the beer can, Cuisinart and cheeseburger of our own day. There are another three hundred years' worth of objects at the disposal of the contemporary still-life maker, whose choosing among them may have many premises, from narrative concern to repetitive patterning.

All this is to say that the categorical boundaries of the still life must now be considered extremely flexible, so that to a considerable extent we are obligated to accept the imagemaker's own definition of the work. Even if it incorporates untraditional elements or otherwise violates our assumptions about the form's parameters, it's essential to recognize that the photographer may nevertheless be asking us to consider a given image in relation to our attitudes toward and assumptions about the still-life form — that is, to understand an image, or even a body of work, as critically commenting on that tradition or jumping off from it.

•

Photography's impact on and revision of the still-life form have been considerable, though initially they could not have been predicted. At the medium's inception, photography's approach to the still life aped painting's — not only because photographers were then mimicking established styles in the "high" arts, but also because the early photographic technology was no less cumbersome (and little faster) than that of painting. Soon this changed, and rapidly.

Take, as one case in point, the location is which the work is created. In painting, the still life has always tended to be an image made in the artist's studio. The reasons for this are, for the most part, practical: the painter needs his or her subject matter, once arranged, to remain unmoved (and, in the case of foodstuffs, uneaten) for long hours, even days; the light, preferably, should be consistent and controllable.

These are conditions on which one cannot rely when working around others or out of doors. Too, the painter's tools — easel, canvas, paints and brushes — are tedious to transport and generally unwelcome in the living quarters, particularly the kitchen. So the hermetically sealed environment of the studio proved to be the most suitable incubator for this "form of art."[3]

Within fifty years of the invention of photography, the camera as an instrument had evolved into many different types, some of them miniaturized and easily portable. One direct consequence of this transportability was to make the whole world into the photographer's studio. A photograph could be made almost anywhere, under almost any conditions — in any room of one's own house, in the homes of others, even out of doors.

With the locale of its making no longer restricted to the studio, what had previously been an exclusively directorial mode — with the

early photographer, like the painter, largely responsible for the selection, arrangement and setting of the objects depicted — was no longer so. Small-format cameras, pocket-sized and unobtrusive, in combination with versatile films able to register information at even low levels of light, allowed the photographer to deal with "found" subject matter — happenstance configurations of objects, or the deliberate ordering of them by someone other than the image-maker.

Just as photography undermined the viewer's assumption that the material depicted in a still life was necessarily under the photographer's control, so did it invalidate the assumption that the image was the result of long, contemplative observation of the subject matter. Photographic images can be encoded in negative form in fractions of seconds; some of our newest technologies — Kodak and Polaroid instant-print systems — actually offer up the finished image in a matter of minutes. Smaller and smaller fragments of time can be rendered, ever more subtle nuances and shifts of available natural or artificial light. Thus what originated as a slow, meditative and directorial form has expanded to include a rapid, intuitive and responsive approach as well.

Some photographers, then, have trained themselves to be alert to significant moments in the flow of events around them, and use the camera to fix and extract them from the flux. Others construct what are essentially temporary sculptures or assemblages for the purpose of photographing them. Some photographic still lifes declare their studio birthplace unequivocally, just as others announce clearly their coincidental, "discovered" origins. There is, of course, a range between the two. Thus the relationship of photographer to subject matter is not always clearcut, particularly insofar as the symbolism of specific objects or groups thereof is concerned.

Consequently, we're often left in the position of Koningsberger's "clever observers who were supposed to guess the appropriate symbolism," but without any assurance that the symbolism is either deliberate or shared. In a pluralistic society such as ours, with its dozens of apposite microcultures, alternative symbol systems abound. This heterogeneity makes definitive interpretation of much artwork — including contemporary still-life imagery — arbitrary, if not impossible.

Such images virtually demand a "reading" of the relationships between the objects and events they depict. Yet they are often cryptic, elliptical, enigmatic and oblique, their references obscure or highly id-

iosyncratic. Freud is reported to have said, in regard to symbolism, "Sometimes a cigar is just a cigar." Can we safely assume that the "cigar" in any of these images is just a cigar, that the rose is a rose is a rose? Not really. All we can count on is that the photographer has, in a phrase I first heard from Emmet Gowin, "given his or her consent to the image" — that is, accepted responsibility for it.

That, it seems to me, is one of the critical dilemmas produced by the recent surge of photographic still-life imagery. That polarity which first emerged in the late seventeenth century — between those who used the still life as a vehicle for symbolic statements and those who employed it to address more narrowly visual concerns — seems operative now more than ever. Inevitably, those whose intent is narrative and/or symbolic are understandably upset when their content is ignored; conversely, those whose goal is a deliberately contentless picture-making become irritated at critical attempts to decipher the symbolic logic of materials and objects selected strictly for their formal qualities.

I can foresee no easy resolution of the problem. The photographers may decide to offer clues — in image structure, caption, title, credo, or other form — to point us toward one or another end of the interpretive spectrum. And the critics and audience (who are, after all, extensions of each other) may learn to become more adept at decoding the photographers' intentions out of the images they offer us.

•

The emergence of such a diverse and strong still-life movement in photography over the past decade is a notable phenomenon. Two factors seem to have played particularly significant roles in this development.

The first is photography's belated entrance into the art market as a "collectible" medium, which has occurred in the years since 1970, roughly speaking. This shift of attention, from the photograph as image to the photograph as object (and marketable, precious *objet d'art* at that), touched off an indiscriminate bartering of any and every kind of photographic image that had ever been rendered in "original-print" form and survived as such relatively intact. Among those survivors were considerable numbers of images made for professional commercial and/or advertising purposes by such photographers as Paul Outerbridge, Irving Penn, Edward Steichen, and many others. A considerable number of these product shots were still lifes. In the marketplace and the presentational arenas, these images have been intermingled arbitrarily with work

(sometimes by these same photographers, sometimes by others) that has nothing to do with persuasive merchandising.

The demonstrated existence of a market for still-life photographs of all kinds naturally led those photographers who wished their work to be considered in that context to shape bodies of imagery that could attract such patronage. Some of that support has come from the economic elite (including the corporate art-investment forces); much of it came from the middle class, for whom photography remained one of the few affordable graphic-arts media.[4]

Unquestionably, then, some of the practical imperatives motivating this turn to the still life have been the same as those Koningsberger points out in Holland three centuries ago. I do not mean to suggest by this that the still-life photographers of our time are any more "commercial" than the still-life painters of Vermeer's day. We could simply say that the still-life form in general lends itself to patronage, and that its relatively sudden popularity in photography at a time when the collecting of photographs has become fashionable is not coincidental.

The second factor at work, I think, has been the chronologically simultaneous sophistication of photographic color technology. This same decade-plus, from 1970 on, has seen the introduction of an unprecedented range of coloristic options for photographic imaging — including the SX-70, the 3M Color-in-Color machine, the Xerox Color Copier, and a host of color printing systems and materials.

Among other things, this has meant that for the first time in the medium's history photographers have had at their disposal the means — technically and economically — to control the production of color photographs from the moment of exposure through to the finished print. The variety of recently introduced color systems and materials also means that photographers now have a range of structural and creative options from which to choose — that color photographs, as completed works, no longer have to look alike as objects.

In coming to terms with these developments, we should keep in mind that our experience of "the history of photography" as primarily monochromatic (or, in less precise terms, *black and white*) is the consequence not of desire or choice on the part of photographers, but rather of an evolutionary fluke. Virtually all the pioneer inventors of the medium were seeking a color imaging system, but were unable to perfect one as manageable, versatile and durable as the monochromatic processes. Certainly it's been demonstrated that whenever a viable color

photographic imaging system has been introduced it has rapidly come to dominate the field.

Within a decade of the introduction of Kodachrome film after World War II, some eighty percent of all amateur photographs were made in color. Once the ink-printing technology became sophisticated enough to handle the reproduction of color photographs, color became by far the preferred form for advertising and illustrative photography in books and magazines — and, more recently, in newspapers also. Almost all television programs and films (except those which use monochrome as a signifier of documentary seriousness or nostalgic intent, such as Woody Allen's *Manhattan*) are now made in color. Had photography originated as a coloristic medium, it seems likely that the monochromatic imagery that dominates its history to date would be instead only a sidebar or footnote to that chronicle.

The abruptness of this transition and its dramatic consequences cannot be overemphasized. As recently as 1970, it would have been remarkable (indeed, almost inconceivable) to find that three-quarters of a group exhibit of photographs whose central theme was *not* color were nonetheless color photographs. Yet that is often the case today, with enough frequency that it already comes as only a minor surprise. To be sure, many contemporary photographers continue to choose to work in monochrome, for various reasons: its austerity, its abstractive function, its documentary connotations. But so-called "black-and-white" photography is now a choice, not an inevitability. Photographers are beginning to learn to think and see in color, to make photographs that cannot be imagined in monochromatic versions.

We are witnessing an explosion in color photography, and its strong and successful bid for entry into the presentational contexts of galleries and museums and the art marketplace. Yet the very novelty of this technology predetermines that the work initially produced with it will be experimental in nature — that is, the image-makers are involved at least as much in the craft activity of learning how to handle color as they are in discovering what they have to say with it.

Writing about this very problem as far back as 1908, in an essay on the Autochrome process and the early experiments therewith, Dixon Scott noted with sympathy the difficulty of *finding* color relationships and subject matter in appropriate combinations. The Autochromist, he pointed out, "must idealistically fix his hopes upon the presumptive existence, somewhere in the labyrinth, of that wonderful coincidence,

that miraculous and abnormal duet."[5] He suggests that, for the "colour-worker," the best results are to be obtained by the method he calls "Creation by Isolation":

> . . . when he deserts landscape for *genre* work, for a certain kind of portraiture, and (especially) for a certain sort of still-life treatment, he reduces the difficulties of the game so considerably that he makes it a very genuine and legitimate mode of activity. For, once indoors, he can himself play the part of *deus ex machina*, and, descending to the *role* of stage-manager, can drag properties hither and thither until he succeeds in producing something which contains that much-desired coincidence.[6] [Italics his.]

We might then conclude that color photography is a new form of what we call "creative" or "art" photography — new to photographers, audience and critics alike. And it is not uncommon for those experimenting with new techniques and styles to utilize a recognizable form or content as an anchor, a reference point for experimenter and observer alike; the reason, as Richard Kostelanetz pointed out in speaking of literature, is "precisely because unfamiliar experiences are more easily understood and communicated in familiar formats."[7]

However we explain this resurgence, and wherever we trace the impetus behind it, our difficulty in defining satisfactorily the still life in its current manifestations will continue. The tradition is outgrowing itself, the form expanding far beyond its original boundaries, and what we see today are only the seeds of some harvest yet to come.

(1983)

rence Henri, *Untitled* (Ball with Grate on Mirror), ca. 1928,
atin-silver print, collection Museum Folkwang, Essen, Germany.

Hannah Höch, *The Sweet*, from the series
"From an ethnographic museum," 1926, photomontage;
collection Museum Folkwang, Essen, Germany.

HYBRIDIZATION: A PHOTOGRAPHIC TRADITION

No sooner had our culture witnessed the first appearance of the photographic image, with its seamless illusionistic rendering of optical reality, than the impulse to expand the medium's physical possibilities was born.

This is not so surprising when you consider that the form in which the general public initially encountered photography — the daguerreotype — was astonishing not only as a new kind of image but also as an unprecedented type of physical object. To confront suddenly an imaging system that offered exactly detailed, two-dimensional versions of the world without the manual (or, so it seemed, conceptual) intervention of a human being was a major event in itself. To find those images encoded in miniature, etched by light itself into unique, small, flat silver-coated plates, was equally marvelous and entrancing. Reading the early responses to photography in the press of that time, one can sense the writers' dilemma: which of these two aspects should take priority of consideration? Virtually all the early respondents to the medium resolved that problem by applauding equally the fidelity of the rendering and the "exquisite," "jewel-like" qualities of these "gems."

Befitting a medium that employed precious and semi-precious metals as its base elements, presentational treatments were devised to emphasize that sense of rarity. The standard form for containing daguerreotypes was in itself much akin to a jewelry box: an embossed, plush-lined case with a dainty clasp, protective glass, and gilt framing. There were other, even more specifically jewel-like usages also — brooches, rings, lockets, and stickpins, for example, containing tiny daguerreotype portraits.

With the arrival of the negative-positive process, hot on the heels of daguerreotypy, there came the option of making photographic prints on paper, and thus of producing multiple prints of any given image. Eliminating thus the one-of-a-kind scarcity inherent in the daguerreotype, the negative put an end to the sacrosanctity of the photograph as object: the print could be altered without fear, since another could be generated from the original negative. (The halftone process of ink reproduction, introduced in the 1880s, extended this cloning virtually *ad infinitum*.)

All of this made possible the application to photographs of other techniques — collage, montage, and a variety of hand-coloring methods among them. These approaches were applied in short order to many of the primary types of photograph: portraits, postcard imagery, genre scenes, and the like. Portents of things to come. Within the next few decades there would be attempts — many of them successful — to alter photographs in diverse ways, and to blend them with a wide variety of materials: wood, leather, cloth, glass, ceramic, metal. The result is a range of unusual and wondrous objects, some purely decorative and some partially utilitarian. Among their offspring are the computer-portrait T-shirts and Elvis Presley dinner plates of our own day — and, at the more rarified, estheticized end of the spectrum, an enormous range of exploratory works by artists and photographers.

The possible combinations and permutations are so abundant — and those pursuing them so numerous — that no list is likely to be comprehensive. A few central approaches should be noted, however. Additive or "synthetic" color is certainly one of these. (The absence of color was one of the earliest laments over the photograph's limitations.) Means currently being employed toward this end range from the relatively traditional procedures of hand-coloring now being explored by such photographers as Colleen Kenyon, Elizabeth Bryant, Judith Golden and Aneta Sperber — who use techniques for the hand-tinting of prints that can be traced back to the days of daguerreotypy — to the more radical approaches of Benno Friedman, Kenda North and Todd Walker. Friedman and North have developed idiosyncratic procedures for chemical manipulation of color in the darkroom, while Walker works with colored inks and offset lithography.

To these can be added Sonia Sheridan and many others involved in working with "generative systems" — the mechanical image-duplication and image-transmission devices of our era. They are investigating new "photographic" technologies such as the standard office copy machine, the color Xerox, and the 3M Color-in-Color Printer — complex tools whose visual information-gathering instrument may not be the lens as we know it, but rather the copy machine's platen.

Part of the widespread interest in such generative systems is due to the coloristic options they afford; another attractive aspect is the potential of these tools for collage. Pati Hill, William Larson, Joan Lyons and Ray Johnson (to name just a few) are applying this new technology to photocollagist ends. This is only the most recent development in the

evolution of photocollage, an inadequately annotated process that is really a medium in its own right.

The works by current practitioners of photocollage have many antecedents in the history of photography, though their forebears have generally been academically scorned and even excluded from the sadly-limited "official" versions of the medium's morphology. To its detriment, photography has been severely afflicted with biased historians who have insisted on a rigid territoriality based on specious issues of praxis.[1] It has also suffered from the pervasive corrosion of elitist art-appreciation strategies, under whose dictates no creative idea is considered to be worthy of note until it is employed by an establishment-certified artist.[2]

This has made it unnecessarily difficult to trace the actual chronology and morphology of various approaches to photography. Our case in point is an excellent one. Photocollage can be defined as the physical combination of parts of one photographic image (whether a photographic print or a reproduction thereof) with other photographic-image segments or with other two-dimensional materials. Photo historians have given this image-making procedure short shrift; it does not even appear in the index to Beaumont Newhall's *History of Photography*, the standard North American reference.[3] Art historians habitually trace it back to the Dadaists, often co-crediting Raoul Hausmann and Hannah Höch as its "discoverers." Yet, in fact, photocollages were made, and widely published — as book illustrations, *cartes-de-visite*, postcards, novelties, and other vernacular artifacts — in the latter decades of the nineteenth century. The artists who have employed these means more recently — from John Heartfield and Mieczyslaw Berman at mid-century to such current workers as Romare Bearden, Robert Delford Brown, Bea Nettles and Robert Rauschenberg — are quite likely to be as aware of their nineteenth-century predecessors as they are of the more celebrated twentieth-century "high art" practitioners of the form.

The fusion of photography with techniques drawn from the graphic and plastic arts has become increasingly frequent of late. Lucas Samaras in his "autoPolaroids" and "photo-transformations," Duane Michals in his oil-painted photographs, Michael Martone and Andy Warhol exemplify those exploring the combination of photography with painting and drawing. Naomi Savage and Pierre Cordier have evolved idiosyncratic versions of intaglio methods employing photographs. Joyce Neimanas, Barbara Astman, and Barbara Kruger superimpose handwrit-

ten, typewritten, or typeset texts over photographs; Keith Smith and Robert Heinecken variously combine photography, drawing, painting and the traditional printmaking processes.

Heinecken has been a truly seminal figure in this area. His diverse output emphasizes process over product, concentrating on the political relationship between sex, violence and the mass media in our society. Working sometimes with photographs he makes himself but often with found images, Heinecken has produced collages, montages, sculptural pieces, altered artifacts, prints and paintings as part of a restless inquiry. He has also exerted an enormous influence through two decades of teaching at UCLA.

Due in part to Heinecken's impact as an artist and teacher, the sculptural extension of photography into three-dimensional structures now has many advocates. Carl Cheng and Darryl Curran, for instance, create photographic facsimiles of objects and events by using hard materials, particularly plastics. Betty Hahn, Lou Brown DiGiulio, Keith Smith and Ellen Brooks, on the other hand, make "soft" photosculptures involving sensitized fabrics and stitchery.

It is only a short step from such works to the environmental pieces of Hank Stromberg, Bob Brown, Esther Parada, Catherine Jansen and Gillian Brown, who create photographically illusionistic "room" installations, typifying those whose strategy is to redefine the physical space of the gallery. To them we could add those who, like Wanda Hammerbeck, create site works that integrate photographs with the real world outside. In her "Depositions" series, Hammerbeck printed photographs of such common objects as a calculator, Bible, dog bone, hair dryer and footprint onto slabs of sandstone. These were then deposited at various spots on the landscape with a stamped, self-addressed postcard attached, to be filled in and mailed back to Hammerbeck by whoever might chance to discover them.

Over the past decade there has been a dramatic increase in the production of work in these and related hybrid forms. Much of this output has found its way into the public eye, either in solo exhibits or through broader survey shows such as the groundbreaking "Photography as Printmaking" (1968) and "Photography into Sculpture" (1970) organized by Peter Bunnell at the Museum of Modern Art.[4] Bunnell's pioneering efforts opened the door for further scrutinies, notably including the Museum of Contemporary Craft's "Photo Media" extravaganza (1971) and the more recent traveling exhibit "Photofusion," which pre-

miered at Pratt Institute in New York in 1981. Attendance at these shows — particularly the group surveys — has been remarkably high, suggesting that there is great interest on the part of critics, artists, photographers and the general public in these extensions of photography.

A general confusion, however, much of it ultimately semantic, is still the rule in discussions of these works. Certainly they all involve and/or address some aspects of photography. In most instances, photography is their central medium — the core around which they are built, the provocation for their inquiry. Nevertheless, many of them resemble only tangentially what we usually refer to as *photographs*; and quite a few should not be thought of or described simply as photographs, in the literal sense of the word — either because that's not *what* they are, or because that's not *all* that they are. How, then, are we to consider them?

We might begin by distinguishing between the noun *photograph* and the adjective *photographic*. Many of these pieces incorporate photographs as only one component of their physical totality; they are better described literally as collages, environments, image-text pieces, vacuum-formed plastic sculptures, and a host of combinatorial forms for which the term *photograph* is too limited and often inappropriate. Yet each of them contains a strong photographic element, which in most cases is the dominant one, with one or more aspects of photography serving as reference point for the work's conceptual thrust.

To talk about them, therefore, we might profitably group them under the generic heading of *photographic works*, a term we could use to denote any creative activity in which a photographic component plays an essential role. (That a given work might thus be claimed by more than one medium does not strike me as a failing.) Under that rubric we're then enabled to examine different groupings of such works to see which aspects of photography they explore and exploit — and perhaps to learn, from their probings at the borders of the medium, something about what *photography* as an encompassing description may come to mean in the near future.

Thus, to the question "Are these photographs?" we must answer that some are and some aren't, but that these are all photographic works that fall within a tradition of hybridization in photography — a tradition that stretches back to the medium's inception, in both its vernacular and its estheticized forms.

What is it that these artists are seeking from photography? Why have they gone to such lengths — and, in more than a few cases, over-

come considerable technical difficulty — in order to provide their work with that photographic component?

The answer might vary considerably from instance to instance, but it seems fairly clear that (excepting those who, like Jack Sal in his *cliché-verre* prints, are exclusively exploiting some quality of the materials used in photographic printmaking) they are after the visual reference to the real world that the photographic image encodes in its unique and unmistakable fashion.

However misplaced and dangerous, our culturally imbued trust in photographs as the most accurate system of visual description available remains strong. Even though we have been learning, slowly, just how biased the photographer can be and how unreliable the photograph is as evidence, we have yet to find a viable replacement. Consequently, artists who want that connection to the "real world" embedded in their work — something to signify the particularity of a time and place, the surface appearance of specific things — today turn naturally and instinctively to the photograph as the most effective signifier of those qualities. Printmakers, weavers, ceramists, sculptors, dancers, writers, painters — David Hockney, André Breton, Robert Wilson, Philip Glass, Chuck Close, Merce Cunningham, countless others — have all fallen into photography's embrace at one time or another for just that reason.

The avant-garde art forms whose output is most ephemeral — conceptual art, performance art, and the like — especially depend on photography to annotate and amplify their transient creations. Site pieces and earthworks (Christo's *Running Fence*, for example) reach the world through the camera. The current artists'-book movement has consistently explored the relationship between photographic image and text; it relies heavily on photography's versatility as a medium of illustration. Even such comparatively traditional, precious-object-oriented forms as painting have forthrightly confronted the influence of the lens-formed image. Photo-realism is the clearest example, though hardly the only one. (There are photorealists who have gone so far as to paint in the monochromes of the black-and-white snapshot, or to imitate the photographic blur of incompletely arrested motion.)

In fact, it is difficult today to find major contemporary artists in any medium whose work is not to a considerable extent photographically informed. The pervasive influence of photography has proved unavoidable. By changing the way in which we see the world, it has altered the ways in which spaces, objects, surfaces, and the relation-

Robert Heinecken, *The S.S. Copyright Project "On Photography,"* 1978,
B/W instant prints attached to two homosote boards with staples;
collection The Museum of Modern Art, New York.

ships between them are perceived. With a curious irony, we appear to be resolving finally the hoary debate over the status of photography as art. The resolution seems to be that the question is unimportant and wrongheaded. The crucial understanding may well be that all art is merely pre-photographic — by which I mean that photography is the culmination of the ancient human drive to evolve a versatile, easily practiced visual communication process, and what we think of as the previous visual "art forms" are nothing more than earlier, clumsier, less adaptable means to that end.

Under those circumstances, it is not surprising to discover increasing numbers of artists — including photographers — who feel comfortable in integrating photography with the other media. This may be especially true of the formally trained. Art institutes and university art departments today tend to be fertile ground for hybridization. Studios devoted to the different media coexist side by side in such schools, and young student artists receive a grounding in a multiplicity of craft techniques and materials. Small wonder that some of them develop an inclination to bring different combinations of these together in their work.

In that regard, it is worth noting that many — though by no means all — of the people involved in these media mergers have spent time in the academic environment as students, as teachers, or as both. Some of them are nominally categorized as photographers, while others are not. It would be almost impossible to tell which are which simply from scrutinizing the work. Clearly, they feel no obligation to be "faithful," either to photographic tradition as it is commonly understood or to the neutral presentation of the data encoded in any photographic image. They use the photograph to refer us to the real world, but they also feel free to alter that same photographic image, when necessary, to make it conform to their personal vision. A quote from Man Ray, one of the major pioneers of this mode in our century, comes to mind: "A certain amount of contempt for the material employed to express an idea is indispensable to the purest realization of this idea."

(1981)

COLLABORATIONS THROUGH THE LENS: PHOTOGRAPHY AND PERFORMANCE ART

> There must be *some* examples of Performance Art which were not recorded photographically, but not to do so has become as unthinkable as not having a photographer at one's wedding.
>
> — *David Briers*[1]

The simple fact is this: *There are no neutral photographs.*

As Thomas Kuhn has pointed out, "any description must be partial."[2] By its nature, a photograph is a descriptive rather than a transcriptive artifact. As such, it reflects inevitably at least two sets of biases, two viewpoints, on which its existence in the world is predicated:

• Those of the inventors, designers, and manufacturers of the system — camera, lens, film, darkroom equipment and chemistry — employed in the physical production of that particular image.

• Those of the photographer who controls the specific application of that system to the occasion of the image in question.

To assume that these biases merely inflect — or even *infect* — the photograph is to miss (almost entirely) the point. Which is: This conglomeration of biases, this stew of viewpoints — these *are* the photograph, these (in combination with its contents, the physical things represented) form its *content.* Every photograph, therefore, is a manifestation of these biases interacting with whatever was before the lens at the moment of exposure.

This is inescapable. Consequently, any response to a photograph — whether from an actively analytic critical attitude or a more passively absorptive, spectatorial mode — necessarily involves the viewer with the ostensibly invisible presence of the photographer as well as the more insidiously covert influence of the medium itself.

In short, we must think of every photograph as a form of collaboration between subject, photographer, and medium. The last of these operates subcutaneously, beneath the skin of the imagery; most commonly, it calls as little attention to itself as possible, seeking no credit for the final results, even if in fact it dictates them outright. The more immediate, observable transaction is between subject and photographer;

it is in this dialogue — sometimes contestual and sometimes coopera-
tive — that control of the final image is negotiated.

In that bargaining the photographer almost always has the up-
per hand. What I mean by this goes well beyond the fact that some
subjects are extremely pliable, perhaps even helpless, insensate, inani-
mate. Any photographer worth his or her salt — that is, any photogra-
pher of professional caliber, in control of the craft, regardless of imagis-
tic bent — can make virtually anything "look good." Which means, of
course, that he or she can make anything look *bad* — or look just about
any way at all.

After all, that is the real work of photography: *making things
look*, deciding how a thing is to appear in the image. For photographs
do not "show how things look," since there is no one way that anything
looks. Every thing has an infinitude of potential appearances, a multi-
plicity of aspects. *What a photograph shows us is how a particular thing
could be seen, or could be made to look* — at a specific moment, in a
specific context, by a specific photographer employing specific tools.

The photographer, then, is an active partner (most often the domi-
nant one) in the construction of any photographic version of the world.
For much of this century the avant-garde has displayed a peculiarly
ambivalent relation to that state of affairs. On one hand, it has eagerly
welcomed, even courted, photographic annotation of its activities, par-
ticularly (this is more than a little paradoxical) those acts, works, or
occasions ostensibly intended to be private, ephemeral, or site-specific.
On the other, it has persistently pretended to disdain that annotation,
encouraging as the "official" style thereof a virtually willful ineptitude,
presumably a signifier of photographic innocence. ("I didn't know this
was going to be photographed!") Hence the general appearance of pho-
tos of avant-garde events, most of which have been deliberately made
to look as if an uninformed, only marginally competent amateur pho-
tographer had stumbled upon the subjects accidentally. From the Dada
and Bauhaus days down to the present, this style — and it must be
understood as a *style* — predominates; even Man Ray, an otherwise
highly sophisticated photographic craftsman, adopted it when document-
ing the hi-jinx of his Surrealist circle.[3]

Professionals in theater and dance, of course, had been con-
fronted with the necessity of *some* relation to photography virtually from
the medium's inception. By the 1940s, experiments in collaboration
between these media were underway. Barbara Morgan's celebrated stud-

ies of the Martha Graham troupe form one famous example. Less well-known, but equally influential in its own subterranean way, was Minor White's exploratory work with the Portland Civic Theater, the San Francisco Civic Theater, and the San Francisco Interplayers[4] — important not because the pictures became celebrated (they didn't) but because the experience helped White to recognize that the structures and metaphors of what sociologist Erving Goffman called "the theatrical frame" were relevant and applicable to photography. As an extraordinarily influential teacher, White would subsequently transmit this theatrical model to several generations of students (even using Richard Boleslavsky's classic *Six Lessons in Acting* as one of his basic teaching texts for beginning photo students).

This alliance between traditional performance media and photography was secure by the 1960s, when such virtuoso pieces as Max Waldman's eccentric, idiosyncratic, highly stylized *Marat/Sade* images appeared. Like Morgan and White before him, Waldman essentially restaged and redirected the work (in this case, the play by Peter Weiss) in his studio, so that the performers were consciously *working towards the photographic image* that would result.

Such images, which effectively extended the scope and impact of the original works by re-presenting them in photographic terms, opened the eyes of dancers, actors, choreographers, directors — proving the value of a more thoughtful relation between performance and photography. Nowadays, in those media, this is well-established: photographers of the caliber of Richard Avedon, Ralph Gibson, Elaine Mayes and David Hamilton have worked with theater/dance groups, while Merce Cunningham, Marleen Pennison, Philip Glass and many others have incorporated photographs into their stage pieces.

However, there is another group of performing artists whose embrace of the photographic image as a means for further amplifying their work has been unequivocal: rock musicians. No performers of the past two decades have been more wholehearted, collectively, in pursuing an interaction with photographers — an interaction that gives these performers an ability to shape, refine, and control the visual presentation of their *personae* as well as the visual re-presentation of the attitudes, ideas and emotions explored in their music. Beyond any other category of performers, they have come to terms with the truth that active participation in the production of photographic images of themselves, in and out of performance, is an integral aspect of the medium in

which they choose to work.

In return, photography has provided rock musicians with gener-
ous feedback on their visual presentation of self, stimulating them to
hone, elaborate, or manipulate that presentation, to conceive of ways of
communicating photographically. (Think, for example, of the Rolling
Stones' controversial, powerful *Black and Blue* billboard — or their
choice of that Robert Frank photo for the cover of *Exile on Main Street.*)
I think it is safe to say that the increased sophistication and complexity
of rock-and-roll stage shows since the early 1960s is a direct result of
musicians studying still and kinetic photographic images of themselves.

Rock musicians, then, have set the pattern for the performer's
active relation to the camera in our time. Partly because all concerned
have treated it as a conversation between equals rather than a contest, or
a distasteful chore, this has been a rewarding dialogue for both media.
No performing artists in our time have been more effectively photo-
graphed than rock musicians — and no genre of performer has provided
the subject matter for more memorable photographs. This dialogue may
have reached an apogee of sorts in the recent *Time* cover for a feature
story on the Talking Heads's David Byrne: a multiple-image photo-
graphic self-portrait by the musician/composer/director himself.

The same cultural forces that sparked and molded rock music
from the '60s onward created the environment in which what is now
generically called "performance art" arose. Thus it is not coincidental
that there is considerable overlap between performers in the two media
(Laurie Anderson being only the most famous example; Todd Rundgren
is a less obvious one), nor that a sizeable segment of their audience is
shared. Nor, for that matter, that performance artists are the first mem-
bers of the avant-garde to abandon any pretense that they don't want
their acts to be photographed — and photographed *well.*[5]

What we have reached, in these images, is a juncture discussed
in this exchange between Maureen O. Paley and Susan Butler:

> MP: [We are dealing with] the moment when people start to direct
> their performances at the camera, rather than simply using it to docu-
> ment events.
>
> SB: At that point you engage the potential of using the photography in
> a very controlled and directed way to embody a certain moral or imagi-
> native universe. The realisation that it is possible to orchestrate the
> image, to load it with certain references, visual effects, narrative im-
> plications, makes for the possibility of very rich and more autono-

mous statements, rather than the fragmentary quality of the early purely documentary images of performance.[6]

It may seem futile, perhaps even perverse, to work so hard at creating durable photographic images of avant-garde or traditional performing art — to craft static, silent, two-dimensional accounts of fluid events in space/time whose real meaning can come only through direct experience. Yet neither the photographers involved nor their subjects expect us to take these photographs as equivalents of, or substitutes for, the works themselves. These photographs are not the performers, nor the performances.

But they are more than mere records of those. The best of them constitute an experiment, an inquiry: What aspects of the performing arts are uniquely visual, accessible to the camera, and worthy of translation into still photographs? Or, to put it another way, how can the performing arts best be served by photography, and best serve it in return?

At this stage, the answers must be tentative. But a breed of photographers comfortable with both avant-garde art and pop culture may at last be emerging. And there is strong evidence that collaborations through the lens between performance artists and photographers represent a cross-fertilization of forms that can produce exotic fruit.

(1987)

Michael Martone, *New York Bookstore Window*, 1972. From page 168 of
the book dummy, "Notes From A Moving Ambulance by Michael
Martone." © Michael Martone 1996; courtesy of the photographer.

V
Comstockery Redivivus

CANDY CAMERA, CENSORED CHEESECAKE

Those who invent the technologies whose acceptance transforms our culture have a lot in common with Pandora. They're pioneers, to be sure, but their abilities as prophets are necessarily limited. It's not that they can't predict the logical, practical applications of their brainchildren — in many cases, those served as their inspirations. But there's simply no anticipating all the unforeseen consequences of a technology — the unexpected, eccentric, even lunatic uses for a new tool that a culture may find once it takes the ball and runs with it.

Photography is an excellent case in point. Its inventors certainly understood the radical nature of the medium they were unleashing on an unsuspecting world. Yet I don't believe that in their wildest dreams they envisioned what's become of their discovery — what we do with (and to) the world through this process, what we've come to expect and assume as a result of it.

Consider, for example, *Chocolate Photos*. That's right. Chocolate Photos is an outfit that, for a reasonable price ($.65 each for a minimum order of 250), will convert a photograph into an edible treat, thus making it possible to eat someone's face symbolically as well as euphemistically.

As was the case with the early daguerreotypists' studios, the specialty of the house for Chocolate Photos is portraiture. (Could it be said that we've gone from "not on your tintype" to "not on your bonbon?" The obligatory chorus of groans, please. . . .) The process begins with existing photographs. These are enlarged; then line drawings are made from them — much the same way as nineteenth–century photographs were converted into periodical illustrations prior to the introduction of the halftone process. In this case, though, the line drawings are next reduced, the subjects' names are printed underneath, and, in the words of the *New York Times*, "the whole thing [is] converted into negatives. The negatives then [go] out for photo-etching and [come] back as metal molds or disks, to be stamped onto gold [and, now, silver] foil. . . . The chocolate is poured onto the back of the foil, so in effect the foil becomes the mold."

You can order your "prints" on either light (milk) or dark (semi-sweet) chocolate. Mint chocolate and dietetic chocolate are also avail-

able. For what it's worth as sociological information on tonality, the dark chocolate does well in New York, badly in the Midwest. New Yorkers, it seems, are also prone to ordering imagery other than faces — boats, shoes, horses, and cars, for instance.

The inventor of this form of analogic cannibalism is an Austrian–born child psychiatrist, Dr. Victor Syrmis, who claims that this idea once actually "possessed" him. The business is already so successful that Dr. Syrmis has all but given up his work as a psychiatrist — though not his analytical bent. "The idea of eating the chocolate image of a loved one is very Freudian," he's been quoted as saying. "Our first contact with the world is oral. Chocolate is made with mother's milk [*sic!*], it's warm, sweet and melts at body temperature. The impulse is to incorporate that person into your system."

So now we can munch on photographic likenesses of ourselves, our loved ones, our pets, our favorite possessions. They've already done such movers and shakers as Lee Iacocca, Ronald Reagan, Mr. Ed, John Wayne, Alfred Hitchcock, Gregory Peck and — for the "I Love New York" campaign — Bobby Short, Pearl Bailey and Frank Sinatra. Who knows what the next step may be? Chocolate versions of famous photographs, perhaps? The celebrity portraiture of Yousuf Karsh, Philippe Halsman, or Richard Avedon would lend itself readily to this process. They might get even more ambitious: imagine Ansel Adams's classic "Moonrise over Hernandez" (a cake version of which has already been produced) in a combination of dark and milk chocolate.

From there it would be only a short step to commissioning experimental artists to conceive and produce original work in the photochocolate medium. Betcha Robert Rauschenberg or Claes Oldenburg would jump at it!

That way, in addition to using photography as a means of consuming the world, we could actually eat the evidence, thus consuming our consumption itself. Could this be what Susan Sontag meant when, at the end of her book *On Photography*, she called for "an ecology of images"? Or would that only pertain to those who disposed of their foil wraps properly?

•

Now this, as they say on TV: a court case I tracked from the moment the story first broke in July of '83. "Her nude jail pix yield negatives," proclaimed the New York *Daily News* headline on a dispatch coming out of Fort Madison, Iowa.

"A woman who wants to send nude pictures of herself to her husband in prison has accused state officials of interfering with her right to free speech," it began. "Debbie Frazer has filed suit in federal court, charging it is wrong for Iowa State Penitentiary officials to ban nude pictures of her while allowing nude pictures published in magazines like *Playboy*."

According to that report, Mrs. Frazer had first tried mailing the photos to her husband Gary, who is serving a life sentence for murder and rape. When they were returned by the deputy warden, she attempted to smuggle them in on her person. The discovery of this contraband — wrapped in plastic, secreted in her vagina, found during a strip search — resulted in a six-month suspension of their visitation rights. The reason for this prohibition, according to prison officials, is that "pictures of relatives or friends may incite inmates to argue or fight, while pictures of strangers are less likely to cause trouble."

Because it is beyond the purview of this essay, let us leave aside the logic (or lack thereof) of our penal system's "rehabilitative" policy of enforced sexual frustration, with masturbation and/or homosexuality as the only outlets for sexual energy. The issue is conflict of interest. On the one hand, there is the Frazers' desire for conjugal contact, or some symbolic version thereof; on the other, the prison officials' concern that intimate sexual talismans may cause disturbances.

What we have here is worlds — or, as the social scientists say, "universes of discourse" — in collision. In the world outside the prison, we all have the ability, and the right, to give each other images of ourselves with or without clothes on, involved in just about any activity you might name. Indeed, Frazer's attorney, Philip Mears, made just that argument: "The constitutional right of marital privacy is broad enough," he asserted, "to include the right to know what your spouse or girlfriend looks like without any clothes on."

Now that is an utterly astonishing statement. You certainly could never had persuaded any of the Constitution's authors to agree to such a construction of their writings; it would have been absolutely unthinkable, given the mores of their time. That Mr. Mears and his clients could even consider taking such a position indicates, in a small way, how very far we have traveled in the past two centuries. I would hold, too, that the vehicle on which we made this particular journey was the photographic image.

Remember that, before photography, only a few artists — and a

few eccentric patrons — owned images of themselves and/or their lovers in the buff. Even the introduction of photography did not alter this state of affairs dramatically. True, nude subjects, and explicit erotica, entered the medium with the daguerreotype; but few people made — or commissioned the making of — such images of themselves, for their own use. Even the so-called "Storyville Portraits" of E. J. Bellocq (which formed the basis for the film *Pretty Baby*), made well after the turn of the century, were circulated only privately in the professional network of New Orleans prostitutes and their customers.

The main problem for amateurs in producing such imagery was the censorship apparatus of the photo-processing industry, which refused to print and return anything considered to be "indecent." Thus it was only with the introduction of the Polaroid system that homemade nudes and erotica became commonplace in vernacular photography. Though never mentioned publicly by Edwin Land or any of Polaroid's executives, this aspect of the system's appeal made a major contribution to the success of the Polaroid process.

Nowadays, of course, it's even feasible to commission a respectable professional photographer to produce what the trade refers to as "boudoir photographs" of oneself. This, apparently, is a thriving branch of the commercial portrait business — enough so to be a specialty for some studios. The owner of one of these, Stuart Naideth of Los Angeles, has a clientele of "at least 95 percent . . . career women." That category includes the wife of a state senator, a bank vice-president, "lawyers, people in commodities, brokers and a lot of sales people," who are willing to pay $600 for a session and the resulting prints. According to Naideth, the images are mostly destined to be gifts for the men in his subjects' lives, tokens of their specific erotic relationships.

And, in a curious way, that may be what led to this odd debate in Iowa. What these folks were all addressing, in their diverse ways, is a unique quality of the photographic image — its capacity not only to describe but to particularize. Barred from actual contact with each other, the Frazers had apparently agreed that their sexual relation should be transacted through the most credible visual simulacrum available, the photographic version of Mrs. Frazer. The prison officials proposed that Mr. Frazer should generalize his sexuality, because particularizing it could be dangerous — Frazer might, in the words of Alfred Korzybski, "mistake the map for the territory," perhaps becoming upset if other prisoners saw or commented on the photographs of his wife. Mr. Mears,

the attorney, was insistent that, penal servitude notwithstanding, the Frazers had every right to particularize their marital sexuality through the symbol system of the lens image.

So there were a number of ironies here. Mrs. Frazer, in producing such pictures (or having them produced), was doing something that countless Americans consider to be not only normal but entirely respectable. (The girlfriend of the prison's warden could give him such a photo for Christmas.) Mrs. Frazer didn't set out to sneak them in, but sent them in without camouflage at first; she became devious only when she encountered the penal system's recalcitrance. Given that system's policy, it would have been easier for her to achieve her goal by publishing those images in a magazine — where everyone in the world would have access to them — than by fighting to get one set of prints to her husband for private use.

A case like this is a judge's nightmare but a reporter's dream. The eventual outcome? Mrs. Frazer's request for a preliminary injunction against the penitentiary was denied in September 1983, so the case — #83–385A, Southern District of Iowa, *Debbie Frazer et al vs. Crispus Nix et al* — went before a U.S. magistrate in district court in October of 1985. (Mr. Nix was the warden of the penitentiary.) A magistrate found in favor of the institution in April 1986. Mrs. Frazer appealed twice, but on January 2, 1987 a judge affirmed without comment the magistrate's original decision; and, later that same year, the U.S. Court of Appeals, 8th Circuit, upheld the decision of the lower court.

I'd have loved to attend the trials, especially to hear the arguments. Imagine what they would tell us about the belief system(s) that have come to surround photography! It's particularly disappointing that the courts involved published no opinions. Layne Lindebak, Assistant Attorney General for Des Moines, wishes they had — because, he informed me, there were several parallel cases at the time (*Pepperling vs. Crist* in the 9th Circuit, and another in the mideast district). One of these, he recalls, turned down the prohibition, while the other upheld it — both with published opinions. A comparison of these opposite lines of reasoning could be highly instructive.

But since the witnesses they really needed to help resolve this — Daguerre and the rest of that bunch — are beyond the power of the subpoena, if I'd been present I'd have volunteered myself as an *amicus curiae*. Here's the Solomonic wisdom I'd have offered, free of charge, to the Iowa Judiciary:

Temper justice with mercy, consummation with consumption. Put Mrs. Frazer in touch with the good people at Chocolate Photos. That way Mr. Frazer could have his cheesecake and eat it too. Keep in mind the following thought, from Guy Davenport's wonderful short story, "The Invention of Photography in Toledo." Davenport wrote, "The Pope has given his blessing to photography. A maiden can send her photograph to her swain and thus spare herself the indecency of a personal encounter."[1]

(1984)

"Porn," Polls and Polemics:
The State of Research on the Social
Consequences of Sexually Explicit Material

The only clearly demonstrated and thoroughly substantiated social consequence of the dissemination of sexually explicit material — written, graphic/photographic, filmed, videotaped or theatrically performed — is that it generates endless and apparently unresolvable heated debate among adults.

Recently I had occasion to fulfill a long-standing curiosity by surveying a cross-section of the current literature on what might be defined as "the impact of pornography on society." Because the literature is enormous, because it is constantly expanding, and because its ramifications reach into areas of moral philosophy and politics (particularly, in the latter case, into the terrain of social control, freedom of speech, and censorship), the survey could not be comprehensive. However, within its limitations it did have a focus: the relationship between theories about effects of pornography and their substantiation (or denial) via research, as well as the state of that research itself.

My survey emphasized two primary aspects of the literature; it's essential to distinguish between them. First, there are the polemics that I characterize as socially theoretical. These are arguments, usually abstract, either for the social tolerance of sexually explicit material or for the censorship thereof. Such arguments generally attempt (albeit fruitlessly) to offer working definitions of such terms as *pornography*, *obscenity* and *erotica*, and to make qualitative distinctions among them. They provide rationales for the acceptance (or suppression) of specific works or genres. The rationale for acceptance can be loosely defined as libertarian; for suppression, authoritarian. As this might suggest, the polemics tend to have a (sometimes hidden) agenda whose core is political.

A second type of investigation has emerged from the area of social studies, particularly sociology and psychology. These are scrutinies of the behavior (including responses articulated in polls and interviews) of specific individuals, behavior supposedly related to the presence and availability of sexually explicit material, or to direct contact

with such material. These investigations — like that broad field of the humanities from which they spring — aspire to the condition of science. Whether they can be said to achieve that condition is one subject of this paper; the other is the relation between such inquiry and the socially theoretical polemics of tolerance or censorship.

What Is "Pornography"?

Many books on the subject open with attempts to answer that question; virtually all contemporary writers on the subject, to their credit, feel obliged to offer some definition. Some go further, to distinguish between types of pornography or to separate *pornography* from "erotica," "erotic realism," "literature," or some other term for material that, though concerned with sex, is not to be confused with pornography because it has some higher (or, at least, *other)* purpose.

The notorious "Model Anti-pornography Law" drafted by Andrea Dworkin with Catharine MacKinnon asserts that pornography "is the graphic sexually explicit subordination of women through pictures and/or words that also includes one or more of the following" — after which comes a list of specific aspects of depiction, presumed hallmarks of the pornographic.[1]

Other writers proffer other definitions. Susan Brownmiller defines pornography broadly as "anti-female propaganda,"[2] by which lights the misogynistic plays of Strindberg are pornographic. According to Beatrice Faust, "Pornography is an aesthetic genre that presents a variety of sexual material by emphasizing content at the expense of all other considerations"; she suggests that its hallmarks include stylelessness, literalness, the anonymity of protagonists and an unreal/distortive perspective.[3]

P. Michelson calls it "the private confrontation of individual psyche with its sexual needs . . . the imaginative record of man's sexual will."[4] Malamuth and Billings use the term "without any pejorative meaning [!] to refer to material that is sexually explicit in referring to or visually depicting male and female anatomy."[5] D. H. Lawrence saw it as "the attempt to insult sex, to do dirt on it."[6] For the Kronhausens, "In pornography (*hard core obscenity*) the main purpose is to stimulate erotic response *in the reader. And that is all.*"[7] (Italics theirs.)

Abraham Kaplan concurs, at least in part: "*Pornography* is promotional: it is the obscene responded to with minimal psychic distance. Fundamentally, therefore, it is a category of effect. To say that a work is

pornographic is to say something about the feelings and actions which it produces in its respondents."[8] (Here Kaplan echoes the famous *New Yorker* cartoon that appeared during the 1950s court cases over the work of Lawrence, Miller and others. Two judges are shown coming out of chambers in their robes; one says to the other, "If it turns me on, it's smut.")

These definitions cover the spectrum of sources, from those who would suppress the material in question to those who advocate its free dissemination. What is fascinating is that, for all their diversity, the definitions are virtually useless. Save for the one proposed by Malamuth and Billings — according to which a medical school's models of reproductive organs, *Playboy*'s centerfold and Picasso's *Demoiselles d'Avignon* are *all* pornography — these are value judgments masquerading as definitions. A general semanticist would have a field day unravelling the assumptions buried in each; the prospect of applying them to particular works is terrifying. Truly, as art critic Morse Peckham noted with chagrin, "It appears, then, that there is no available definition of pornography and no prospect of creating a neutral definition."[9] That this lament was issued seventeen years ago, yet still holds despite almost two decades of subsequent debate, says much about the quality and substance of that debate.

The absence of a neutral, commonly agreed-on working definition of a subject would normally be considered a fundamental roadblock to critical inquiry. Astonishingly, as Malamuth and Billings aver without (so far as I can tell) the slightest hint of sarcasm, "The lack of a precise definition has not impeded empirical work on the functions and effects of pornography, especially since the 1970 Presidential Commission on Pornography and Obscenity, and more vigorously, in the early 1980s."[10]

Which Are Pornography?

Perhaps as a result of problems in definition, or perhaps because each medium is presumed to have its own critical context, there is no consensus in the field as to which works in any medium are to be considered as pornographic — even if only on an arbitrary basis, for the sake of the study itself. That is, a specific body of works whose consequences are to be scrutinized has not been established. Researchers thus may be correlating the responses of people exposed to *September Morn* and "Maggie and Jiggs" parodies with those of folks who sneaked peeks

at their family doctor's reference books and still others who got their hands on *The Story of O*, and so on. Apparently this is considered of no consequence; I have found *no* discussion of the lack of such a canon anywhere in the literature. (Goldstein and Kant mention it in passing, only to dismiss it.)

Further compounding this problem, researchers doing "empirical work" seldom if ever annotate items used in tests or referred to by interviewees. Such annotation — along with a working definition of the term *pornographic* — would enable other scholars to judge the purported effect of the work against the work itself; allow correlation between different studies of responses to the same work; and, of course, allow repeat testing of a particular work.

Studies to Date

Studies of the effects of exposure to sexually explicit material have two primary forms. The first is a retroactive interview/survey in which subjects recount the history of their exposure to sexually explicit material, as well as their own sexual history, the development of their attitudes toward sex, and their current attitudes and practices. Typically, they are encouraged to speculate on relations among these factors; such speculation is also the inclination of those doing the research.

In the second form, subjects are exposed to specific examples of sexually explicit material; their responses are then solicited by interview. Often they are interviewed twice, once before and once after exposure, so that correlation of the two interviews may reveal changes in attitude attributable to exposure.

Other kinds of inquiry range from electronic measurement of penile turgidity to investigation of possible "biological triggers" stimulated by sexually explicit material.[11] (It is perhaps noteworthy that this latter type of study is conducted almost exclusively on males.) These would seem to be, at least potentially, the most "scientific" approaches, insofar as they address measureable and testable characteristics. Curiously, such studies as a genre appear to have the lowest credibility, even among social researchers themselves.

State of the Research

To this observer, the state of research into the consequences of exposure to sexually explicit material is best described as a shambles. Its culturally loaded vocabulary, with a largely negative bias, goes

unexamined. Its primary subject, "pornography," is inconsistently defined or not defined at all. Examples referred to in the research are rarely identified; the few that are annotated are never described, discussed or analyzed; even among those that are identified, there is no consistency from study to study or subject to subject. Subject populations are treated as homogeneous although, particularly on such charged issues, heterogeneity seems more likely. Research instruments are variously flawed and rarely subject to repeated use by different groups of researchers; thus any correlation of results between studies is highly arbitrary. Further, all the research addresses only shifts in attitude, not changes in behavior, and only short-term shifts at that; there are no controlled longitudinal studies, certainly none that provide evidence of any link between exposure to sexually explicit material and sexually deviant behavior. Finally, the research itself is fundamentally contaminated by the context in which it takes place, as church, state, and a large segment of the general population advocate the assumption that such a link must exist.

Certainly the only research that the field itself now treats as in any way paradigmatic, the experiments of Malamuth and Donnerstein,[12] claims at most that men exposed under clinical conditions to explicit sexual material with a strongly violent aspect will for a short time thereafter be slightly more tolerant than previously of depicted or reported behavior in which sexuality and violence are interlaced. This is neither a radical proposal nor a discovery that suggests provocative new paths for inquiry. As my late Aunt Dorothy would have said, "Any fool could have told them that."[13]

The philosopher of science Thomas Kuhn (who, I note, *cautioned against and disowned* any application of his ideas to fields outside the perimeters of hard science) proposed that the advancement of scientific knowledge depends on the establishment of what he called *paradigms* — models, ideas of the way things work. Such a model must be "sufficiently unprecedented to attract an enduring group of adherents away from competing modes of scientific activity. Simultaneously, it [must be] sufficiently open-ended to leave all sorts of problems for the redefined group of practitioners to resolve. [Those] whose research is based on shared paradigms are committed to the same rules and standards for scientific practice. That commitment and the apparent consensus it produces are prerequisites for normal science, i.e., for the genesis and continuation of a particular research tradition."[14] Kuhn adds

that a paragigm proves "able to guide [a] whole group's research. Except with the advantage of hindsight, it is hard to find another criterion that so clearly proclaims a field a science."[15]

Such a model, as Kuhn points out, is a hypothesis. But, unlike most hypotheses, it includes "law, theory, application and instrumentation together."[16] This makes the hypothesis testable; in effect, the paradigm-as-hypothesis announces the experiments that will be necessary if it is to be either confirmed or invalidated. Kuhn also states that "it remains an open question what parts of social science have yet acquired such paradigms at all."[17]

If we were to operate on the theory that the field of research into the consequences of exposure to sexually explicit material is at a pre-paradigm stage, that would go far toward explaining what I described less charitably as the "shambles" of its current state — particularly its condition of being all variables and no constants.

Is It Really Social Science?

If, as Kuhn argues, what "clearly proclaims a field a science" is the establishment and investigation of at least one paradigm, then the field of research into the consequences of sexually explicit material is clearly not now a science. Some would be inclined to say not *yet* a science. I would suggest that it will never be one.

In this essay I have eschewed the term "social science," substituting instead the terms "social research" and "social studies." That is because I do not believe these fields are in any meaningful way sciences. Certainly they do not hold themselves to the rigorous standards of inquiry of the hard sciences: clarity of definition, testing of hypotheses, repeatability of experiments, standardized instrumentation, careful accounting for variables, and procedures to minimize variables, among others. Such methodological strictures are unheard of in social research. Substituted for them, instead, are the hallmarks of *pseudoscience*: a highly jargonized vocabulary and the technique of quantifying anything that appears to lend itself to being numbered.

There are numerous motives for this aspiration to the status (and I use that word advisedly) of science, most plausibly this: science has become mythologized in our time as the highest form of both theoretical and practical inquiry, with the result that it is the most socially prestigious, most academically supported, and most governmentally and corporately funded scholarly activity. Thus workers in the fields of so-

cial research and sometimes even the arts don the trappings of what they conceive of as science "in the hope that the prestige of science with attach to their work."[18]

In a most useful and provocative recent essay, Neil Postman, himself a scholar of the impact of communications technology on culture, proposed that the fields of social research rethink themselves. After demolishing any claim his fellow researchers (or he himself!) might make that they were "doing science," Postman posited an alternative: "[Our] work is a form of story-telling. . . . To put it plainly, all of the so-called social sciences are merely subdivisions of moral theology . . . the purpose of social research is to rediscover the truths of social life; to comment on and criticize the moral behavior of people; and finally, to put forward metaphors, images, and ideas that can help people live with some measure of understanding and dignity."[19]

Viewed in that light, the futile aspiration of social research to the mantle of scientific respectability is not only doomed to failure but is the cause of another, even more crucial failure: the failure of these fields to fulfill their true task, the work of the storytellers and the moralists. Both those failures — the production of bad or pseudo-science, and the refusal to acknowledge and embrace the obvious impulse toward moral argument — are exemplified in the research on the consequences of exposure to sexually explicit material.

Social Research/Social Policy

It seems essential that both the inherent failings and the problematic context of the research in question be acknowledged. That research neither originates in a vacuum nor lives its active life in one. It is produced in a hopelessly contaminated environment — contaminated by intellectual laxity and the hidden agendas of funding sources, among other infectants. Upon completion (sometimes, indeed, even before publication), it enters an arena whose occupants are less concerned with the acquisition of knowledge than with the affirmation of their beliefs.

The post-publication history of the research of Malamuth and Donnerstein is an excellent case in point. As noted previously, these studies were restricted in scope. Their subjects were for the most part college-age male psychology students "participating for extra credit."[20] The tests were conducted under laboratory conditions, so-called, not real-life situations; responses obtained were short-term only; they indi-

cated temporary shifts in attitude, but provided no evidence of changed behavior in either the short or long term. The researchers themselves were commendably cautious in extrapolation from their acquired data, indicating what they recognized as its limitations and urging further research into the questions it raised.

Yet, despite these strictures, their study became part of the basis for the Indianapolis anti-pornography amendment drafted by Dworkin and MacKinnon.[21] That amendment, in turn, became the model for such amendments now under consideration around the country (despite the fact that the original Indianapolis version was declared unconstitutional by the Federal District Court).[22] To their credit, both Malamuth and Donnerstein have gone on public record to reiterate cautions on extrapolation from their work, specifically disowning the notion that they'd proved exposure to sexually explicit material leads to violent sexual behavior.[23] Nevertheless, the material continues to be used by pro-censorship/anti-pornography forces, cited sometimes by name and sometimes categorically (as in the locution, "Recent research has shown that. . . .")

Obviously, scholars cannot be held responsible for every misinterpretive use to which their efforts might be put. Nor is it possible to build into any piece of scholarship sufficient protection to prevent its distortion by someone who refuses to respect its parameters. But much of what makes social research so attractive to those in political and legislative realms is that it comes packaged with the seal of approval that its assumed status as "science" brings with it.

The image of science and scientists currently held by the American public is rich enough to warrant a semiotic analysis beyond the scope of this paper. However, it is safe to say that a high degree of credibility — linked in part to an assumption of impartiality — attaches to anything bearing the *imprimatur* of science. Hence, to the extent that social research presents itself under that rubric, it *courts* the misuse and abuse of its conjectures. Unless and until the several fields of social research are willing to step out from under the banner of science, they will be in considerable part responsible for what is done in their name.

Such a step might help to restore to story-telling and moral theology the dignity they once enjoyed; it would also no doubt prove costly, at least in the short run, to the fields in question, since story-telling and moral theology rank far below science on the scale of social prestige

and fundability. Pragmatically, therefore, such a major shift would be extremely painful; all there is to recommend it is its intellectual integrity and professional ethicality.[24]

Summary

Thus research into the consequences of sexually explicit material is qualitatively questionable and easily impeachable on several levels, its very status as science arguable. The fact that it is produced under social conditions frowning on one set of possible results while approving of their opposites makes the likelihood of impartial inquiry negligible.

If, with all these *caveats*, current research is taken at face value, what can it be said to substantiate to any degree?

• In the case of pedophilia (sexual abuse of children), pornography — defined as pictures, films, videotapes and audiotapes of children engaged in explicitly sexual activity — plays a part in the majority of criminal cases studied by one researcher. Notably, the *production* of such material is a frequent feature of pedophilia, and is legally and diagnostically considered an aspect of the abuse.[25]

• By their middle teens, a large proportion of Americans — 80% of boys, 70% of girls — will encounter sexually explicit material, generally of a heterosexual orientation. Encounters with material on oral and/or anal sex, sado-masochism, pedophilia, homosexuality, or other variations are far less frequent. The majority's encounter with basic heterosexually oriented material appears to be a rite of passage and a group activity; "the experience seems to be more a social than a sexual one."[26]

• Although it is historically true that most sexually explicit material has been produced by men for men, this was not always the case; the *Kama Sutra* of India and the "pillow books" of Japan were sexual instruction manuals specifically for the tutoring of young women. The Judeo-Christian and Muslim cultures appear to be the only ones to exclude such tutelage from the rites of passage and early phases of marriage.

• An increasing amount of sexually explicit material, "hard-core" as well as "soft-core," is being produced by and for women.[27] It appears unlikely that women find such material less arousing than do men.[28] Moreover, I could find no study that addressed female sex offenders in relation to such material — despite the fact that the ringleader of the nation's largest "kiddie porn" operation turned out to be a woman.[29]

• Many Americans produce sexually explicit material for their own pleasure or for exchange with others, on an amateur level. Computerized "bulletin boards" commonly list names of people who wish to trade sexual fantasies via modem. Sexually-oriented magazines, and an increasing number of general-audience publications, include extensive "personals" listings that offer and/or solicit sexually explicit photos and correspondence. Photographers in many parts of the country now offer to make what are discreetly called "boudoir photos" for women to give to the men (or women, perhaps) in their lives.[30] Amateur nude photography, and even imagery of sexual activity, is a commonplace in photo-processing labs. One magazine runs a monthly "Girl Next Door" feature, with reader-provided images, subsequently gathered into an annual.[31]

• Evidence indicates that sex offenders — particularly rapists and pedophiles — generally have had *less* exposure to sexually explicit materials than the average.[32] Since anti-pornography forces cite rape and child abuse as the most heinous presumed consequences of the material they seek to legislate away, it seems they are either unaware of this finding or deliberately suppressing it. This is understandable, as it suggests that the material specifically serves an educational or "safety-valve" function, particularly for those prone to criminal sexual behavior. That in turn would suggest that the material has socially beneficial aspects.

• Exposure to "certain forms of pornography, those which foster the association of violence and sexuality, may exert an appreciable influence on the way we both perceive and deal with aggression."[33] However, the evidence is far from clear-cut; particularly murky is the effect of long-term exposure and the correlation, if any, between temporary attitude shifts and actual behavior (for example, sexually violent action or non-intervention when such action occurs).[34]

• There are also legitimate therapeutic uses for sexually explicit materials.[35]

So we are really just beginning to explore what one writer describes as "an area in which there are few certainties and little evidence to support arguments on either side of the controversy."[36] That being the case, I will leave the final word to two of the researchers themselves.

[T]here are highly diverse and complex functions and effects postulated by writers on this subject. To date, researchers have dealt with only a small portion of these possibilities. Frequently the focus in

research has been on rather limited questions. . . . [A] great deal of additional research remains to be undertaken to address the complex issues raised.[37]

(1987)

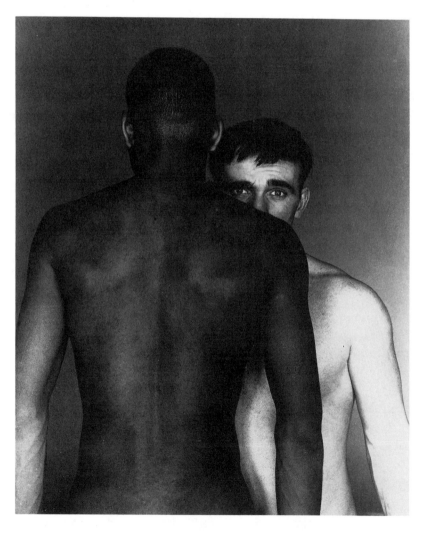

George Platt Lynes, *Untitled*, 1952; collection of The Kinsey Institute.

THE ARRIVAL OF THE EXPLICIT:
CONTEMPORARY EROTIC PHOTOGRAPHY

Sex. Or, perhaps more appropriately:
SEX.
It's hardly surprising that this three-letter word and everything it stands for should be so persistent a source of confusion and stress for Americans. We are, after all, a young and naïve nation still, founded by Puritans who were deluded by their conviction that the natural erotic impulses of human beings were the Devil's work. Castigation, mortification, repression — these are America's ingrained, traditional responses to human sexuality. Such traditions die hard.

Yet die they do, when die they must — and every tradition that denies human beings something of their own essence is doomed to disappear. Sometimes such customs vanish through attrition; sometimes they are more actively terminated.

The current state of ferment in which America's sexual mores are engulfed indicates that our traditions in that regard are in the process of change — a change that looks to be rapid, dramatic, and far from smooth. Court battles, legislation at all levels of government from local to federal, social and political activism by sexual minorities, artwork in all media and diverse forms of popular culture: a startling variety and enormous quantity of attention is presently focused on one or another manifestation of a contemporary social crisis over human sexuality.

Child-porn legislation. Orange-juice queen Anita Bryant's homophobic diatribes. Heated legislative debates over the appropriate age for sexual consent. The assassination of homosexual politician Harvey Milk in San Francisco. Legal redefinition of the ground rules for cohabitation. Erotic books, pop songs, movies and TV programs celebrating all varieties of lust. Sex manuals for senior citizens. An ever-mounting rate of teen-age pregnancy and venereal disease. The continued barring of contraception advertisement from TV. Furious protest over sex education in the classroom. And, even as I write, they're still taking *Catcher in the Rye* off the shelves of high-school libraries to keep adolescents from being contaminated by an Anglo-Saxon word

they can find in most contemporary dictionaries[1] and virtually any public lavatory in the western hemisphere.

In short:

SEX.

Photography is not the cause of this crisis, by any means. Yet photography is to be found consistently at center stage in this sociocultural melodrama, and certain kinds of photographs are among the hottest subjects of this national debate. The connection between photography and this uproar over sexuality seems inarguable. Consequently, there may be some value to pinpointing that link and exploring the nature of that relationship. What is the erotic in photography?

To begin with, what do we mean by *erotic? Webster's New International Dictionary* (Second Edition) offers us the following, as a basic working definition:

> e•rot´ic, *adj.* 1. Of, pertaining to, or treating of, sexual love; amatory.
> 2. Strongly affected by sexual desire; as, an *erotic* person.

This is useful as a jumping-off point for speculation, but is not quite precise enough for our purposes. It only hints at one essential distinction that must be elaborated in order to annotate the difference between *photographs about sexuality* and *sexy photographs.*

This distinction is necessary if we are to approach the erotic in photography with any degree of critical coherence. To use the division suggested by *Webster's,* we can say that there are images in which eroticism is the subject, and others in which it is the content. Some photographic works are explicitly about various aspects of human sexuality, yet are non- and even anti-erotic in their effect on the viewer. Conversely, there are others wherein no specific sexual activity takes place, yet whose affect is eroticizing.

As an example of the former, I would offer the kinds of illustrative photographs used in the more discreet sex manuals. Here, typically, we are shown a handsome heterosexual couple demonstrating the physical postures necessary for the various sexual positions. Certainly these must be considered photographs about sexuality. Yet, at least in my own experience, the decidedly clinical tone of these images (coupled, certainly, with the flesh-colored body stockings with which the actors are usually garbed) convert them into emotionally detached and unprovocative diagrams. As an instance of the latter form, we could certainly consider Edward Weston's classic "Shell, 1927." This is a luminous study of a chambered nautilus set against a black background.

Weston himself vigorously denied any conscious intent of erotic symbolism on his own part in making this photograph. Yet it has struck many viewers — including a large number of visually sophisticated artists and critics — as a highly erotic work; indeed, according to apocryphal stories, it was censored on the occasion of at least one exhibit of Weston's work, on the grounds that it was too sexually provocative. The consistency of this response suggests that, whatever Weston may have meant to do with his subject, he in fact created a visual metaphor whose content was distinctly erotic.

Sexuality is a vital outlet for self–expression and creativity. Given the complexity and richness of human imagination, there is hardly anything that is not sexually provocative to someone. Studies of human sexual response, from Kinsey to Masters and Johnson, affirm that an astonishing range of objects, sensations and events function as erotic triggers. Consequently, we could assume that virtually any photograph is potentially eroticizing.

Yet such generalizations do not lead to understanding; they merely emulsify useful distinctions. What is worthy of our attention, in my opinion, is a significant phenomenon: that at a time of radical redefinition of social norms and mores regarding sexuality, a considerable body of photography is appearing that actively addresses this issue from several standpoints.

One of the most noteworthy characteristics of the phenomenon is that much of this exploration is not taking place *sub rosa* — in under-the-counter material or in the slightly more accessible but still much-maligned format of the so-called "skin" magazines. Rather, its arena presently encompasses forums that we take very seriously and reserve for the highest levels of discourse — such as museums, galleries, "serious" photography books and magazines — and includes the pages of periodicals generally considered to exemplify the concept of "high-class," such as *Vogue* and the *New York Times Sunday Magazine*. To whatever extent one can say that the appearance of anything in those contexts indicates a level of cultural acceptance and certification, one would have to conclude that in America today the explicit in photography has arrived.

•

The most visible signs of this acceptance are to be found in the photographs now being made and used for fashion and commercial purposes.

The connections between sex and advertising have long been established. Market researchers concern themselves with the "sex appeal" of products, often building it into a marketable item's visual image — the harem-guard virility of "Mr. Clean," for example, or the blatant phallicism of "Tickle" deodorant. Vance Packard explored some of the implications of these "hidden persuaders" in his book of that title, written several decades ago. More recent observers of mass media and advertising — among them Paul Byers and Erving Goffman — have scrutinized the sexual signifiers of kinesics (commonly known as "body language") in the interface between personal behavior and advertising.

Going several steps further, Wilson Bryan Key, author of the books *Subliminal Seduction* and *Media Sexploitation*, has argued that sexually connotative words and images are covertly implanted in magazine, newspaper, and TV imagery, of both commercial and photojournalistic origin. Whether one is persuaded by Key's evidence or not, those purportedly responsible for these subterfuges would seem to be carrying sexual coals to Newcastle. Why be so furtive and roundabout when one can be direct and to the point?

Bloomingdale's, the New York City department store, acknowledged that option several years ago, when it published French photographer Guy Bourdin's lingerie photographs in a catalogue that has since become a collector's item. One function of lingerie is certainly sexual seduction, a fact implicit in most lingerie promotion. Bourdin's images, however, were in effect sexual scenarios in which the lingerie functioned as accessories. The lead image offered a hesitant and abashed young woman in bra and panties, her wedding dress and veil flung over a chair, with a man's hand and tuxedoed arm beckoning her imperiously from the edge of the frame: the prelude to the defloration of the bride. The subsequent photographs created an insulated world whose atmosphere was redolent of the *Story of O*: submissive women, opulent estate-like surroundings, and such sexual signifiers as dildoes, snapshots of men in women's underwear, and phallus-shaped flowers. Far from being presented in covert fashion, this catalogue was printed in large quantities, mailed to Bloomingdale's credit-account customers, made available by request at the store, and inserted into the *New York Sunday Times*. Some of the images were even blown up as life-size transparencies, and used to decorate the store. Such mild *scandale* as this created was effectively exploited for further publicity by the store.

One could list dozens of other fashion and commercial photog-

raphers in whose work an equally explicit sexual content is often to be found: Helmut Newton, Chris von Wangenheim, Deborah Turbeville, Richard Avedon, John Hedgecoe, and Rebeccah Blake are among those whose names will be familiar. Blake, indeed, not only makes such images for commercial purposes, but also made the color photographs used in the film *The Eyes of Laura Mars*. Those meta–images — and the film itself — can thus be seen as paradigms of current attitudes toward this usage of photography among the professionals who produce it.

Laura Mars was a confused movie that richly merited the oblivion into which it sank so rapidly. Its central confusion mirrored that of its protagonist, the fashion photographer portrayed by Faye Dunaway. Dunaway, as Mars, is shown as inextricably entangled in the world of media hype — represented by both the provocative but mindless imagery she produces to help merchandise extravagant clothing, and the provocative but mindless display techniques employed to hustle her imagery in galleries as *haut–chic–cum–Art*. Yet despite the fact that she works entirely directorially, is essentially disconnected from anything or anyone outside the cocoon of the high-fashion world, and makes only images crafted to sell expensive products to the middle and upper classes, she persists in conceptualizing herself as a kind of photojournalist, an observer, even a social commentator, reporting on or mirroring society objectively. Repeatedly, she disclaims any responsibility for the effect of her images as instrumental in creating the social climate of her time.

Anyone so addicted to self-serving moral obtuseness deserves what she gets — which, in Mars's case, was to be stalked through a silly film by the *deus ex machina* of a schizophrenic police lieutenant. The film raised significant issues — concerning the connections between photography and society, and between photography and voyeurism — but did so only for titillation, and as a feeble gesture toward what used to be called "redeeming social significance." Yet these are moral questions that deserve our most serious consideration.

The image held in stasis (as distinct from the kinetic imagery of films and videotapes) is an icon. Icons that are produced in sufficient quantity to be disseminated throughout a culture — this would include the work of most prominent commercial photographers — are the embodiments of a mythology. The differences between a mythology and a report are enormous. The function of a coherent report is to particularize, annotate, and inform; that of a myth is to generalize, symbolize,

and extrapolate. What, then, is the mythology underlying the current trend in fashion and commercial photography?

Essentially, it is a mythology of decadence. The "good life" to which we are induced to aspire by this imagery includes not only a wide range of presumably desirable consumer goods that are both non-functional and exorbitantly priced, but also such behavioral options (presented as no less desirable) as careless, wasteful destruction of expensive merchandise and interpersonal hostility ranging in severity from beating to murder. The sexual component of this myth is cold, fetishistic (directed as much at objects as at human beings), androgynous, self-obsessed, non-reproductive, and integrally linked to destruction and violence. It recalls nothing so clearly as pre-war Germany in its emotional inflections and implications — and, indeed, often refers to that epoch quite specifically.

As a manifestation of our sexual *zeitgeist*, this mythology is revealing and disturbing — particularly unsettling, indeed, because it is perhaps the most prevalent (or at least the most highly visible) sexual mythology of our time. Yet in considering the erotic in photography it cannot be overlooked. For it is the prevalent imagery in any mode or genre that defines the context within which all other related imagery is viewed and interpreted. The most pervasive sexual iconography of our time is to be found in the elaborate, imaginative, socially ratified scenarios of fashion and commercial photography, and in the simplistic, repetitive, anatomical stock shots of the "skin" magazines. Because these set the cultural tone for the erotic in photography at this time, they must be understood as reference points for photographers — even for those photographers who wish to present a radically different vision of sexuality.

Yet, regardless of one's acceptance or rejection of the sexual attitudes underpinning the new eroticism in those formats I've just mentioned, it is essential to recognize at the same time that this imagery has been instrumental in establishing a climate of tolerance for erotic imagery in general — that is, it has in its own way helped to legitimatize the theme of human sexuality as a subject of photographic inquiry. In the long run, that may well prove to be its major contribution to this photographic dialogue on that subject.

•

That dialogue has certainly been a long time coming. The subject of sex remained taboo in "serious" photography for much longer

than its interdiction in the other creative media. For instance, despite all its ostensible "humanism," Edward Steichen's editorial *magnum opus*, *The Family of Man*, avoided the subject of human sexuality almost completely. The show and book contained many images of young lovers necking in public, as well as photographs depicting marriage, childbirth, and parenthood. But the activity central to those was suggested by only one image: a somewhat ambiguous Wayne Miller photograph in which a grimacing woman's hand clutches a man's bare shoulder. Even that inclusion was considered daring at the time (1955), and raised some small furor. Tame and even timid as it may seem by today's standards, that image and its presentation in that context could be considered a precedent of sorts for what has followed.

Yet it certainly was not taken as such. Despite the *imprimaturs* implicit in the Museum of Modern Art's auspices, Steichen's endorsement, and Miller's status as Steichen's right-hand man, no further photographic study of human sexual interaction was publicly presented in the United States in the context of "serious" photography until Richard Kirstel's landmark exhibit, "Pas de Deux," opened at New York City's Exposure Gallery in early 1969 — fourteen years later.

So far as I have been able to determine, this was the first time a U.S. photography gallery had presented imagery explicitly depicting sexual intercourse — and the first time a creative photographer had the courage to exhibit such work here. (This is not to suggest that no one had made such images previously. Indeed, there are erotic photographs by Man Ray and Henri Cartier-Bresson that date back to the 1920s and '30s. But they had never been exhibited or published — at least not in this country.)[2]

Despite the fact that the exhibit — which was mounted in a Lower East Side storefront space — drew over 7,000 visitors during its run, it received little attention from the photography press. Much of what commentary it did evoke was both confusing and confused; one (female) critic, for example, complained that the images were too romantic and did not show enough genital detail! Nonetheless, the fact that the exhibit opened and ran without legal difficulties of any kind[3] certainly established a major precedent — and, apparently, opened a door.

Within the next few years, erotic imagery bearing the signatures of serious photographers and sponsored by reputable galleries, art institutions, periodicals and book publishers surfaced in a steady stream.

Some of these works were, like Kirstel's, explorations of the visual aspects of lovemaking itself. Examples would include John Brook's book-length sequence on the cyclical nature of human sexuality, *A Long the Riverrun*, (1970); Elsa Dorfman's suite, *His Idea*, (1973); an autobiographical sequence by Arthur Freed, published in *Evergreen Review* at around the same time; related work by Michael Semak, a Canadian photographer, and the late Dean Brown; and Philip Masnick's studies of homoerotic acts. In mood and style these are all very different pieces of work; their relationship is thematic.

These works all attempt to convey in visual terms the photographers' varied responses to the intimacy of sexual experience. These photographers were not directing professional models in simulations of sexual behavior. Rather, they were photographing family, friends, acquaintances — and even themselves, in some instances — in the sexual act. That their presence-by-permission affected the behavior of those they photographed, and thus impacted on the images, is unquestionable; as Heisenberg's uncertainty principle in physics informs us, observation alters the event observed. Yet these photographers' curiosity as to what took place at the interface between the privacy of sexual interaction and the publicness of photographic exposure produced fascinating and often moving results. I would stress that these were not always eroticizing: Kirstel's work is tinged with melancholy, Dorfman's is somewhat remote, Masnick's is anguished and violent.

Concurrently, another group of photographers were addressing the sociological phenomenon of public sexual activity — a flamboyant, often defiant exhibitionism that sprang up in the 1960s. Charles Gatewood exhibited and published (in *Sidetripping*) some of the results of his persistent investigation of America's subcultures, ranging from the Dionysiac revelers of Mardi Gras to the participants in New York City's sexual underworld. Bruce Davidson offered his essay on topless nightclub dancers, "Men's Bar." The psychosexual dualities of female impersonators were probed sympathetically by Julio Mitchel in his sequence, "Backstage," and exploited mercilessly by George Alpert (in *The Queens*). Bob Adelman and his textual collaborator, Susan Hall, provided insights into the lives of pimps and prostitutes in *Ladies of the Night* and *Gentleman of Leisure*. And Larry Clark, whose first book, *Tulsa* — one of the major photo essays of the past decade — had a sexual component, began a still-ongoing and unpublished series titled "Teenage Lust."[4]

It is this collective body of work examining actual sexual be-havior from many standpoints that I would encompass within a cat-egory we might label "The Real Thing." Recent additions to this list would include Susan Meiselas's *Carnival Strippers*, about the women who work in burlesque sideshows; Roswell Angier's *A Kind of Life: Conversations in the Combat Zone*, which concentrates on Boston's red–light district; a soon–to–be–published book on adolescent sexuality by Stephen Shames; several sequences by Barbara Alper that have been exhibited but not yet published; and Eric Kroll's *Sex Objects*, which explores in words and images the lives of women who work in massage parlors. Additionally, although the images were made decades ago, Brassai's *The Secret Paris of the '30s* certainly belongs in this group, especially since its publication in 1976 can be partly attributed to the appearance of the large volume of imagery under discussion here.

•

Along with the presentation over the past decade of the material discussed above, we have also witnessed a simultaneous flow of work from diverse sources that approaches the theme of sexuality from a quite different standpoint. Its intent is not to report on or describe the actual sexual acts of others, but rather to create photographically persuasive and evocative interpretations of sexual fantasies. Work in this form — which I've dubbed "Fantasex," a title borrowed from a book of sexual games — tends to be directorially made; that is, the photographer is generally staging an event from which he or she intends to derive an eroticizing image. The actual erotic quotient of the event photographed, insofar as the libidos of its participants are concerned, is essentially irrelevant to the success of the resulting image, and is in no way its real subject.[5]

The fashion and commercial imagery discussed earlier in this essay provides the most familiar examples of this genre. And their mak-ers, in many cases, also create work that may be stylistically similar but that is not product-oriented.

David Hamilton, for example, works both commercially and for his own purposes. His forte is a fairly narrow realm of sexual fan-tasy: pubescent Nordic girls adrift in a remote dreamworld devoid of adults, children, and males of any age. Curiously, although it is a stereo-typical "dirty old man" projection, Hamilton's vision receives consider-able approval from female viewers. Perhaps the implications of inno-cent lesbianism have something to do with this — or it may be traceable

to the very real sensuousness of his settings, gestures, and tonalities. In any case, though I find Hamilton's books in this vein — which include *Dreams of a Young Girl, Sisters,* and *Bilitis* — to be repetitive visually and limited emotionally, he is a master craftsman who does what he does very well indeed.

Helmut Newton, who also works commercially, has so far published two volumes of erotic photography, *White Women* and *Sleepless Nights.* Newton's work is the polar opposite of Hamilton's: hard-edged where Hamilton is soft-focus, violent where Hamilton is gentle and lyrical.

In contrast to both of these stands Duane Michals. Michals, who also works extensively as a magazine photographer, has been consistently prolific in his personal work, which has dealt with many sexual themes — among them voyeurism, rape, fetishism, and homosexuality. Indeed, Michals's latest book, *Homage to Cavafy,* is also the photographer's own move out of the closet. However, though the issues Michals raises are often disturbing, there is a confessional frankness to his method that is both reassuring and liberating.

Work in the directorial mode is, by its nature, collaborative to a considerable extent. Often, therefore, it is hard to tell whose fantasy is being acted out — the photographer's, or the subject's. John Ashley, for example, has spent the past several years observing the antics of a group of young transvestites in the Kentucky hills. With their active cooperation, he is preparing a book-length suite of images entitled *Pagan Babes.* Working also with transvestites, but under studio conditions, French photographer Gilles Larrain created his book, *Idols,* which was edited by Ralph Gibson. Arthur Tress, whose directorial work in the past has often contained sexual undercurrents, has presented two recent exhibits on explicitly homosexual themes: "Phallic Fantasies" and "Men Between Themselves." Homoeroticism has also been a frequent theme in the work of Robert Mapplethorpe. The rediscovery in the last few years of the turn-of-the-century male nudes of Baron Wilhelm Von Gloeden — staged tableaux with young boys posed as fauns and satyrs — seems part and parcel of the increasing acceptance of openly homoerotic photography. Karin Szekessy and Irina Ionesco, in contrast, have created roughly equivalent worlds whose orientation is almost exclusively female.

Even the sexual component of narcissism has found its poets. Lucas Samaras, in his book *Samaras Album,* and Pierre Molinier in his

sequence *Lui-Même*, explored the nooks and crannies of their own sexual identities, often functioning as both seducer and seducee simultaneously. Another intricate statement of personal sexual sensibility — though much more extroverted — is Ralph Gibson's *Days At Sea*, the concluding volume of his black-and-white trilogy. *Days at Sea*, as the title suggests, is an evocation of a sailor's sexual fantasies, triggered by mundane objects whose sexual connotations are amplified in highly erotic vignettes. The result is a work that seems at one and the same time fictional and autobiographical.

Not surprisingly, erotic imagery itself is the subject of imagery by a number of photographers. Much of Robert Heinecken's work over the past decade has addressed itself to the relationship between eroticism, "pornography," and the violence of American culture. Heinecken has created numerous works that incorporate "found" erotica from magazines and other sources. He has also reworked such imagery into large collages on canvas (in his "clichés-Vary" series), and, most recently, has been producing SX-70 image-text works that parody what Kurt Vonnegut calls the "wide-open beavers inside" school of X-rated magazine publishing.

Similarly, Joyce Neimanas reworks frames from pornographic movies that are carefully selected, enormously enlarged, hand–colored and combined with fragments of handwritten text. Using another method to explore the infrastructure of vernacular erotica, Steve Kahn made his way through the bondage subculture of southern California to create a sequence of images that begin as "artsy" bondage pictures, gradually parody the form, and culminate in a conceptualized, metaphorical vision of bondage that turns the act into a social commentary whose sexual origins are almost indecipherable. A parodic impulse underlies some of the images in Les Krims's book of manipulated SX-70 photographs, *Fictcryptokrimsographs*; Krims employs a variety of sexual signifiers in these visual puns, but his intent is clearly to satirize rather than eroticize.

•

If this were an attempt at a comprehensive study of the erotic in photography, the size of the list so far would at least quadruple. O. G. Rejlander, E. J. Bellocq, Edward Weston, Diane Arbus and dozens of others would have to be considered. That history remains to be written; this space is demonstrably insufficient for it. My purpose in singling out those photographers I've mentioned so far has been simply to offer

a sampling of image-makers whose work is representative of the wide variety of current approaches to the subject of human sexuality.

At the same time, I do not wish to suggest by this that the photographers I have grouped here are part of a movement. That term implies organization, interaction, programs, manifestoes, and collective purpose, among other things. What we are witnessing is nothing so structured as that. One of the most fascinating aspects of the phenomenon under discussion is that it gives every sign of being a spontaneous, unplanned, yet widespread manifestation of a deep concern and curiosity about this controversial subject.

The range in style, professional background, gender and/or sexual preference, attitude, and geographic location among these photographers is so great that it is difficult to find much in common among them other than their attention to this particular subject. (Age may perhaps be another link: most of those mentioned so far are between the ages of thirty and forty-five, which means that their formative years in the medium were transsected by either the liberating court battles of the 1950s or the liberated spirits of the 1960s.)

No less significant, in my estimation, is the fact that the past decade can hardly be thought of as a period of untrammelled artistic expression. The targets of censorship may often seem whimsically chosen, and the logic behind it is always shaky at best, but over the past ten years it has been oppressively clear that — particularly since the Burger Supreme Court's "local community standards" decision in June of 1973 — the incidence of censorship is on the rise again.

Keeping track of all photographically related instances of censorship may well be an impossible task. But what follows is a list of a few recent instances and/or ongoing situations that merit the consideration of everyone concerned with preserving what I have come to call "freedom of vision."

• Larry Flynt, publisher of *Hustler* — a magazine whose enormous circulation is sufficient proof that it meets the "local community standards" of citizens across the nation — was put on trial as a pornographer in the Midwest. As a direct consequence of publicity surrounding the court case, there was an assassination attempt that left him permanently paralyzed. That particular trial was called off, but others against him are underway. Flynt may well be to this cycle of censorial activity what Ralph Ginzburg was to the last wave of Comstockery — the man they love to hate.

• In February of 1978, New York State Senator John Marchi publicly attacked Eric Kroll's book, *Sex Objects*, as a "patently pornographic book" and "cheap trash." Republican conservative Marchi's blast made headlines — which, apparently, was his main intent — but he picked a strange target: the book is a sociologically–oriented study of women who work in massage parlors and similar environs, presented in classic photo-documentary style. Marchi's ploy was the vote-grabbing "misuse of taxpayers' money" routine, trotted out because Kroll had received a New York State Council on the Arts grant for this project. (To my chagrin, I must confess that I am one of Marchi's constituents — though not one of his supporters.)

• In October of 1977, an exhibit titled "Dead Women" was presented at the Photoworks Gallery in Boston. The work is a suite of image-text pieces by Karen Kent and John Puffer, whose intent was to "comment on the plight of women in the Midwest." The pieces are oblique and ironic in tone, yet patently feminist in outlook. Nonetheless, two unknown women saw fit to protest what they apparently perceived as sexism by stealing two of the works off the wall — and returning them two days later, in ashes. Because the photographic portions of these works were one-of-a-kind Polaroid prints, they cannot be replaced or duplicated.

• In May of 1978, the police in Providence, Rhode Island raided the opening of a group photography show titled "Private Parts." They seized almost half the work on exhibit at the gallery, apparently making their selections randomly. The police department's case against the work was so jerry-built ("improper seizure" was only the beginning) that it drew judicial reprimands and was thrown out of court, to the severe embarrassment of the Providence law enforcement system. A countersuit for damages is now underway. Those "damages" are not symbolic: the Providence police so thoroughly abused the work seized that virtually all of it — including a number of one-of-a-kind pieces — was injured or destroyed.[6]

I could go on. And on. Such instances abound. If they are not yet the rule, they are no longer the exception. Censorship is a cyclical disease, and it is now at a highly contagious stage. Many Americans assumed that the censorship battles of the 1950s and early 1960s — over such literary works as *Lady Chatterley's Lover* and *Tropic of Cancer*, and such verbal causes as the west coast's Free Speech Movement — had settled that issue once and for all, by establishing clear guide-

lines. This may have been true, but only for a spell; the Burger Supreme Court (which I am convinced is Richard Nixon's revenge on America) put an end to that brief period of safety.

For those of us concerned with the visual arts generally and photography specifically, the assumption that visual imagery was protected by the First Amendment may well have been a major error. For decades, the concept of "freedom of speech" was construed to cover not only the spoken and written word but all forms of creative expression — dance, theater, music, painting, pantomime and all the other major and minor media. However, a concerted drive by pro-censorship forces is now underway, bent on eliminating constitutional protection of the arts by employing divide-and-conquer tactics.

For example, arch-conservative spokesman Ernest Van Den Haag, addressing the American Bar Association by invitation in October of 1977, made the following astonishing statement: "The Amendment guarantees apply only to cognitive speech and *not to music, pictures or poetry*, let alone nude dancing and other types of obscenity." (Italics mine.)

The effect of such a perversely narrow interpretation of the Constitution would be to strip most of the arts — even including poetry, which Van Den Haag inexplicably excludes from the category of "cognitive speech" — of First Amendment protection. That the U.S. Supreme Court has not officially adopted this interpretation is hardly a guarantee that the rights of visual artists and their audience are secure. Indeed, Van Den Haag's interpretation is already the working assumption of numerous censorship operations.

Consider, for example, the state of Maryland's Film Board, through which all films publicly shown in the state must pass for rating — rating that, in turn, often depends on cutting. The board's guidelines strictly forbid its members to listen to the soundtrack while making their decisions. In this way, the board cannot be accused of abridging freedom of speech *per se*. Board members examine only the film's visual components. But they are not prohibited from making such cuts as they deem necessary in the visual structure of the film. And, of course, one cannot cut the visuals without eliminating an equivalent amount of the soundtrack. Yet this tortuous subterfuge maintains the illusion that the right to freedom of speech has not been violated.

Therefore, to the question of what legislation unequivocally asserts that photographers and other visual communicators have the right

to free expression, we find a simple answer: None. None at all.

Contrary to the line of reasoning offered by strict Constitutionalists like Van Den Haag, the absence of specific constitutional protection for the visual media was not a deliberate act of exclusion on the parts of our founding fathers. When the Constitution was drafted, the visual arts as such had no general audience, and the visual media played only a small and secondary role in mass communications. No one could have foreseen that, only half a century after the signing of the Declaration of Independence, a communications technology based on a democratically accessible image-making device would arise — nor that this technology would rapidly evolve into a system making possible the almost instantaneous transmission of imagery on an international and eventually interplanetary scale.

The Constitution was written in an age when virtually all information was transmitted by words. Today, at least fifty percent of our information is disseminated via imagery, most of it photographic in origin. Additionally, a vast audience for the visual arts has developed in our society, attentive to the work of a growing number of visual artists. It is apparent that pro–censorship forces, both private and governmental, are ever anxious to control all forms of communication and creative expression, not simply the written and spoken word. Thus it is imperative that those who believe in and fight for freedom of expression for the citizenry of this society begin to consider *freedom of vision* as an inalienable right, a corollary of freedom of speech, no less crucial and in many ways far more endangered.

Given the blind faith of Americans in the legal system as the battleground for all ideas, it seems essential to establish legal precedents in support of freedom of vision. To some extent, this could be achieved on a state-by-state basis. Yet what is truly needed here is a clarification of the scope of the First Amendment, and the explicit equation of the right to freedom of vision with the right to freedom of speech. There seem to be only two means of achieving this: The first is through a coherent interpretation of the First Amendment by the U.S. Supreme Court, specifically extending that amendment's protection to visual material; the second is through the passage of a constitutional amendment specifically protecting visual communication.

The latter would be by far the more difficult to achieve, yet I believe that ultimately it will prove to be the only effective way to accomplish this goal. Supreme Courts come and go; the appointments

thereto are highly political in nature; and, as we have seen in the past few years, their interpretations of a two-hundred-year-old document, which itself is couched in broad and often antiquated terms, can vary drastically.

Consequently, the only way in which we can ensure the recognition of freedom of vision as a right in itself is to have it permanently established as such — and the only way to accomplish that is through constitutional amendment.

An *ad hoc* committee on freedom of vision is currently being formed, and may do its work under the aegis of the Society for Photographic Education. Its members — all of whom will have had direct personal experience on the receiving end of censorship — will attempt to keep a watch on current legislation, court cases, and other relevant manifestations, and may also eventually recommend courses of action to protect freedom of vision.[7] Yet their efforts will be meaningless without a broad base of active support, from the general public and especially from those who are most directly affected by this situation: the audiences for and practitioners of the various forms of visual art and communication.

Let me put it bluntly: If you are a photographer, you cannot consider this issue one that is remote from your life. Recent Supreme Court decisions, ostensibly unrelated to the subject at hand, have empowered the U.S. police and court system to seize and search through the files of professional journalists (including photojournalists) and private citizens as well, and have legitimatized "fishing expeditions" that require no specific grounds other than suspicion. What's on your walls, and in your collection of books and photographic prints? What's in your work prints, your contact sheets, your negatives? Do you, amateur or professional, consider them to be private and legally protected? The Supreme Court of the United States does not.

•

It has not been my intent in this essay to argue for or against any particular form of human sexual activity, nor to make a case for any specific photographic approach to the subject. Rather, I've tried to provide a preliminary overview of what could be described as a photographic dialogue on the subject of human sexuality. This overview is necessarily sketchy and incomplete, but I hope it will serve to indicate that this dialogue within photography is closely linked to the larger debate on this issue now taking place throughout our society. If I have an axe to

grind in this regard, it is not one of favor or disfavor regarding specific sexual practices or attitudes, but of support for the continuation and expansion of the debate itself. I am convinced that if we are to achieve a healthy maturity as a culture, we must come to terms with our own sexual natures — for sexuality and culture are inextricably linked. It is precisely because this imagery is so emotionally charged and controversial that it merits our scrutiny and serious consideration. Photography, I believe, will play a central role in this culture's sexual coming of age — but that will only take place if we permit all voices to be heard and all visions to be seen.

(1979)

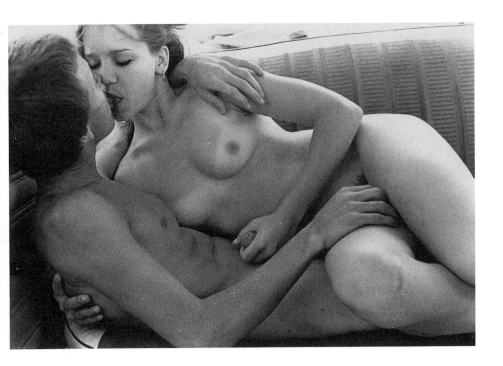

Larry Clark, *Untitled*, 1972; courtesy Luhring Augustine, New York.

LOCAL COMMUNITY STANDARDS STRIKE AGAIN

Every once in a while someone offers me the opportunity to change functions drastically by curating an exhibit instead of critiquing it. This hasn't happened very often — only four or five times to date — but when it does I tend to accept; I find I learn a lot from standing on the other side of the line.

Last fall I received such an invitation from the gallery of a cultural center in the heart of my own community. I was born and raised in Manhattan, but I live on Staten Island, and though most people think of me as a "New York critic" (with all the attitudes that presumably attach to being rooted in Gomorrah), the community in which I've chosen to reside, work, and raise my son is not typically New Yorkish, nor even typically urban. Separated from the metropolis by a half-hour ocean voyage on one corner and the world's second-longest single-span suspension bridge on the other, Staten Island is determinedly suburban and even small-town in its appearance, politics, and attitudes.

Having lived here for the last thirteen years, I feel myself to be very much a member of my community. I'm in the PTA, and a local civic association; I've donated time and energy and whatever weight attaches to my name to a good number of neighborhood self-help programs. I pay taxes here, take part in local elections, and think of myself as a fairly average, unremarkable citizen.

There are quite a few other people I know out here whom I consider to be kindred spirits. And, since we're all part of this community, I think that we — and, for that matter, I — represent "local community standards" as well as anyone else.

I suspect this is beginning to seem like a peculiarly autobiographical digression, so let me get back to the story. Over the years, I've familiarized myself with what's happened and is happening on Staten Island insofar as photography is concerned — not much, to put it briefly. So when I was asked to put together this exhibit, I decided that it should serve an educational function for the audience. To that end, I structured the show around the silver print as a unique and rapidly disappearing vehicle for photographic expression, and invited five photographers who I think of as master printers to exhibit extended thematic groups of silver prints: Roy DeCarava, Allen A. Dutton, Richard Kirstel, Michael

Martone, and Julio Mitchel. I titled it "Silver Sensibilities."

The result was, if I do say so myself, a knockout: two large, handsome, connected rooms filled with over 140 pieces of diverse and powerful work. I was excited and provoked by the show, as were many of the more than one thousand people who saw it during its three-week run. Certainly it met *my* community standards. Even the photographers seemed pleased. But, shortly after it opened, the head of the cultural center that houses the gallery received the following letter of complaint.

> Dear Mr. S— :
> Last month I had the pleasure of visiting the Newhouse Gallery at Snug Harbor for the [John] Noble Exhibit which was just glorious and for which I thank you.
>
> I visited the Gallery about a week ago and had brought some young members of my family. There was an exhibition of photographs. I was very sorry that I had suggested the trip to the Gallery. Many of the photographs were outright pornography. The exhibit had a generally low-class view of life in mind I believe, but this is no excuse to show pornography. This type of show one would not expect to find in a "cultural" center where one takes family and friends. I think whomever is responsible for the choice of exhibits should be reminded that Staten Island needs a cultural center for the whole family. I will now hesitate to suggest any young people visit the Newhouse Gallery.
>
> I should think that if you wanted community support you would give the community decent and not degrading exhibits such as the one I have mentioned. This is in my opinion not of a "cultural" nature.
>
> Thank you.
> Yours very truly,
> /s/ Kathleen G—

The director of the gallery turned this missive over to me and asked me to draft a response. The act of doing so evoked a great many thoughts and feelings — about censorship, freedom of speech, and freedom of vision; about my rights and responsibilities as a member of my community; and about the repressive, mean-spirited, sanctimonious posturings of the man who was about to be elected President and his entourage, whose hostility toward the First Amendment and toward the arts was already a matter of record. I'm sure that much of this found its way into my response. Here, then, is what I think of as my first position paper for the Reagan years. I'm sure it won't be my last.

Dear Mr. S— :

As curator of the "Silver Sensibilities" photography exhibit currently at the Newhouse Gallery, I'd like to respond to the recent letter about this show from Ms. Kathleen G—.

It is of course difficult to reply directly to a statement as full of vague descriptions and emotion-laden value judgments as hers. "Decent," "low-class view of life," "degrading," and "outright pornography" are terms that require definition if we're going to argue meaningfully about specific pictures.

From her letter, I would guess that the work in the show that disturbed her was that of Allen A. Dutton and Michael Martone. As indicated in my wall label, Dutton's imagery is a suite of collage fantasies depicting an exclusively female world. Since the women in these images engage in no sexual activity of any kind, I can only assume that Ms. G— finds female nudity itself (or a humorous portrayal of it) to be offensive. That saddens me, for her sake, but hardly makes the imagery either "degrading" or "outright pornography."

The piece by Michael Martone that may have upset her is a rephotographed image from a brochure advertising erotic literature, across which the photographer has laid a light bulb. The resulting print is captioned "We Are the Lightbulb." This image is part of an excerpt on exhibit from a book-in-progress titled *Notes from a Moving Ambulance*. In the context of this excerpt — which is a sequence concerning the author's adolescence and young manhood — this image is positioned between a self-portrait and a portrait of the photographer's mother. It is clearly intended to express an adolescent's shock at the discovery of the rawness of human sexuality. Anyone who took the trouble to read Martone's extensive accompanying text, or to scrutinize the sequence as a whole, can see that this image is hardly intended to titillate the viewer, and is integral to the work's overall purpose.

I say this to explain these images, not to defend them. They need no defense. This exhibit is, so far as I can determine, the most important show of contemporary photography ever presented on Staten Island. It includes work of five of today's major photographers. Their stature in their own field is apparent from their extensive national and international exhibitions and publications, their inclusion in major museum collections, and their positions on the faculties of respected art institutes and colleges. They are demonstrably serious artists, prominent in their own field. And, like all artists, prominent or not, and like all citizens of this country, they share the right of freedom of expression.

This is not to say that Ms. G— (or anyone else) is obligated to *like* the work of any or all of them. But let us keep in mind that it's not the job of the Newhouse Gallery to present only work that everyone will like (since no such work exists), nor even work that everyone will find inoffensive.

Contrary to Ms. G—'s claim, Staten Island does *not* need yet another museum or gallery "for the whole family." If you're looking for someplace where you can take unsophisticated children and conservatively minded adults without disturbing their preconceptions or confronting them with provocative contemporary art, Staten Island offers you a wide variety of publicly supported choices: The Staten Island Institute of Arts and Sciences, the Tibetan Museum, High Rock Conservation Center, Richmondtown and the Richmondtown Museum — and, of course, the Children's Museum in Stapleton. Additionally, there are many sections of the Snug Harbor Cultural Center itself that provide what we might call "family fare."

But what Staten Island needs desperately, and has not had until now, is a gallery with the courage and conviction to support and display the more difficult, challenging, adventurous and experimental kinds of contemporary art. I think it is to the credit of the Newhouse Gallery (and its director, Daniel Werner), and to the credit of the Cultural Center as a whole, that work of an intellectually and emotionally provocative nature is sponsored there on occasion. The audience for such work on Staten Island is sizeable, and forms a real part of the Cultural Center's constituency; that audience also has rights, which should not be denied.

I would suggest to Ms. G— that she should exercise the same precautions in recommending the Newhouse Gallery to children as she would in recommending the movie house: read the reviews and, if in doubt, preview the work. As she herself points out, there is much at the gallery of a milder nature. She cites the John Noble show, but fails to mention that, concurrent with "Silver Sensibilities," Gallery 3 is showing an unusually safe set of paintings that would only offend someone who believes art should be more than a repetition of cliches. I shudder to think of the gallery's future if we demand that it exhibit nothing that could be unsettling to an eight-year-old mind. Like our libraries, our art institutions are charged with the awesome responsibility of preserving, protecting, and making available the full range of *adult* experience and creative expression — to which, judiciously, the young may be allowed the privilege of access.

The gallery, it should be noted, did post a notice suggesting that parents preview the exhibit. That, by the way, is a precaution the

Museum of Modern Art did not feel was necessary for its recent Picasso extravaganza, which was visited by several hundred thousand children. The very first room of that exhibit contained Picasso's early sketches of oral sex in Barcelona; the exhibit as a whole contained a variety of nudes (many in fantasized situations) and much explicit erotica. To the best of my knowledge, no one was scandalized by this.

What is most depressing about Ms. G—'s letter is that the work in question is not only fine and moving but is, by comparison with much other current art work in all media, conservative in both style and content. Nothing in this show would raise an eyebrow at any gallery or art museum in Manhattan. If the Newhouse Gallery is to fulfill its mandate to bring the best of contemporary art to Staten Island, then Staten Islanders will have to be ready to accept an education in what constitutes the full range of ideas under exploration by these artists. We are very close in time to the twenty-first century. It is long past time for Staten Islanders to realize that we cannot continue to pretend that we live in the nineteenth.

Yours truly,
/s/ A. D. Coleman

(1981)

NOTES

Foreword

1. Oxford University Press, 1979; second edition, expanded, University of New Mexico Press, forthcoming.

2. With one exception: "The Autobiographical Mode in Photography." This essay, which dates from 1975 but felt like it belonged here, is the only ringer in the book; all the others were produced during the period indicated in the book's subtitle, 1979-1989.

3. *Critical Focus: Photography in the International Image Community* (Munich: Nazraeli Press, 1995).

4. And where it didn't. For example, while there are occasional references to artists and theorists associated with Postmodernism, the activities of that movement, if one can call it such, are largely absent from these pages. I had serious reservations over both the theory and the practice called Postmodernism; rather than rushing to judgment, I decided to let those engaged with this set of ideas sort them out, while I digested them quietly. Readers who want to know what I concluded are advised to seek out my volume of recent reviews and commentaries, *Critical Focus*.

5. At the end of each essay or lecture, I've indicated the date of its first publication or delivery. On the Credits page, at the book's conclusion, I've ascribed each essay to the periodical that sponsored its debut. Whenever, in its form within these pages, an essay differs considerably from its original printed version, the publication in which that revised version appeared is also identified. Other relevant information concerning the publication history of some of these texts appears in the endnotes.

6. As a consequence, the reader will note, certain passages recur in several essays on related themes. I've decided to let these reiterations stand, in the interest of continuity within each essay and fidelity to the original appearance of these pieces.

7. *Depth of Field: Essays on Photography, Mass Media and Lens Culture* (Albuquerque: University of New Mexico Press, forthcoming).

8. As a doctoral candidate in the Communications Arts and Sciences program, SEHNAP, New York University.

9. (New York: Ridge Press/Summit Books, 1977).

Choice of Audience/Choice of Voice

This is the complete text of a lecture delivered at the National Conference of the Society for Photographic Education, Stevensville, NY, March 17, 1980.

1. "Writing the Truth: Five Difficulties," translated by Richard Winston, in *Art in Action: Twice a Year 1938-1948, 10th Anniversary Issue* (New York: Twice A Year Press, 1948), p. 126.

2. Indeed, one local critic in that region is trying to do just that. Significantly,

his background is in photography, his primary vehicle a regionally oriented photography newsletter.

Context and Control

1. Shames subsequently sued the Iranian government in the World Court for this misappropriation of his work, eventually winning a small cash settlement.

The Fox Talbots Were Iffy

1. The Beaumont and Nancy Newhall Curatorial Fellowship endowed by Ansel and Virginia Adams (to the tune of $250,000) was inaugurated in March of 1977. MoMA called this funding of a permanent staff position "a very generous bequest" and "the most important gift in the history of the Department."

2. It turned out to be Sommer and Robert Adams. Winogrand never won either award.

3. In fact, it was not at all oversimplistic on my part to hypothesize this connection; however, it was disingenuous — indeed, perhaps even *deceitful* — of Adams to deny it. See the Postscript to "Photography at MoMA: A Brief History," elsewhere in this volume.

Weegee as "Printmaker": An Anomaly in the Marketplace

This essay was written in 1981, but only the "Biographical Note" at its end was published then. The main text went unpublished until 1984.

1. Lyons, Nathan, Syl Labrot and Walter Chappell, *Under the Sun: The Abstract Art of Camera Vision* (New York: Aperture, 1972; reprint of original edition of 1960).

2. A more extended discussion of these and other relevant issues can be found in a series of articles I authored on collecting photography that appeared in *Camera 35*, Vol. 25, nos. 3-9, March-September 1980.

3. Such study has been made possible by the production of the portfolio *Weegee: N.Y.C. 1939-1946*. A collaboration between master printer Sid Kaplan and the project's consultant and technical advisor, Aaron Rose, this limited-edition folio contains fifty images from its titular eight-year period, all printed full-frame (*i.e.*, showing the entire negative). This performs an invaluable service, by allowing us to see the images as Weegee himself originally saw them, and to compare that vision with what finally made its way into print. The portfolio was published by Weegee Portfolios, Inc., New York City, in 1982.

On the Dole: Revamping Public Funding for the Arts

1. Publication of the original version of this essay was immediately preceded by the publication of an account of my own activities as a 1976 NEA Art Critics Fellow. Passages from that essay, "In the Spirit of Fellowship" (*Lens' On Campus*, Vol. 7, no. 5, October 1985), are incorporated into this version.

2. See his article, "And Another Thing," in the *Village Voice*, Vol. 26, no. 20, p. 45, May 13-19, 1981.

Damn the Neuroses! Full Speed Ahead! or, Thoughts on the Free-Lance Life

1. The article in question, by Warren Kronenberg, appeared in the Winter 1980 issue of *The Flyer*, published by the GAP Workshop.

2. The good doctor's assumption that all free lances are male is sociologically most naïve, but psychologically most revealing.

3. Rieff, Philip, *The Triumph of the Therapeutic: Uses of Faith After Freud* (New York: Harper & Row, 1966).

Identity Crisis: The State of Photography Education Today

This is an expanded and revised version of a speech delivered at the Second Annual Photography Congress of the Maine Photographic Workshops in Rockport, Maine, Monday, August 17, 1987.

1. The university originated circa 1100, though the "great century of university growth was the thirteenth." Wieruszowski, Helene, *The Medieval University: Masters, Students, Learning* (New York: D. Van Nostrand Co., 1966), p. 16.

2. "The university, like the parliament, is a creation of the Middle Ages." *Ibid.*, p. 5.

3. Schachner, Nathan, *The Medieval Universities* (New York: A. S. Barnes/ Perpetua, 1962; original edition, 1938), p. 1.

4. Haskins, Charles Homer, *The Rise of Universities* (Ithaca: Cornell University Press, 1979; first edition, 1923), p. 9.

5. Haskins, *op. cit.*, p. 11. Strasser cites " . . . the elements of the original university idea: A corporation of individuals from many places, which includes at least a plurality of professors, all parties being dedicated — though in varying degrees — to the pursuit of at least one branch of higher learning, upon the successful completion of which they will be granted the license to teach their discipline anywhere." In Strasser, M. W., "Educational Philosophy of the First Universities," in Radcliff Umstead, Douglas, *The University World: A Synoptic View of Higher Education in the Middle Ages and Renaissance*, Medieval and Renaissance Studies Committee, Vol. II (Pittsburgh: University of Pittsburgh, 1973), p. 5.

6. Haskins, *op. cit.*, pp. 24-25.

7. *Ibid.*, p. 91.

8. E.g., Haskins, *op. cit.*, pp. 4-5.

9. Strasser, *op. cit.*, p. 17.

10. Rait, Robert S., *Life in the Medieval University* (Cambridge: Cambridge University Press, 1931), p. 138.

11. Haskins, *op. cit.*, p. 91.

12. Rait, *op. cit.*, pp. 133-134.

13. Strasser, *op. cit.*, p. 11.

14. *Ibid.*, p. 11.

15. *Ibid.*, p. 14.

16. *Ibid.*, p. 15

17. *Ibid.*, p. 20.

18. Boime, Albert, *The Academy and French Painting in the Nineteenth Century* (New York: Phaidon, 1971), p. 1.

19. Gardner, Helen, *Art Through the Ages* (New York: Harcourt, Brace & World, 1959, fourth edition), pp. 290-91.

20. *Ibid.*, pp. 290-91.

21. Boime, *op. cit.*, pp. 1-2.

22. See Pevsner, Nikolaus, *Academies of Art* (New York: Macmillan, 1940).

23. Gardner, *op. cit.*, pp. 369-370.

24. *Ibid.*, pp. 290-91.

25. Boime, *op. cit.*, p. 1.

26. *Ibid.*, p. 2.

27. *Ibid.*, p. 2.

28. *Ibid.*, pp. 4-5.

29. *Ibid.*, pp. 4-5.

30. *Ibid.*, p. 5.

31. Hayek, F. A., *The Counter-Revolution of Science: Studies on the Abuse of Reason* (Indianapolis: Liberty Press, 1979).

32. The literature on the Bauhaus, and its photography curriculum, is enormous. For more on the Institute of Design, see Traub, Charles, ed., *The New Vision: Forty Years of Photography at the Institute of Design* (Millerton, New York: Aperture, 1982).

33. "No Future for You: Speculations on the Next Decade in Photography Education," in *Light Readings*.

Polaroid: Toward a Dangerous Future
Sections of this essay are drawn from a review of the book *One of a Kind* that appeared in *Polaroid Close-up*, Vol. 11, no. 1, Spring 1980.

1. (Boston: David R. Godine, Publishers, 1979), p. 5.

2. Not that those consequences should be discounted. In his unauthorized history of the Polaroid Corporation, *The Instant Image: Edwin Land and the Polaroid Experience* (New York: Stein & Day, 1978), Mark Olshaker offers his own summation of the aesthetic agenda built into the Polaroid process: "By removing both technical and temporal barriers, Land feels that the picture-taker is put in a truer and more direct relationship with his subject. He need be concerned only with the 'what' of his interest, and not with the 'how' of conveying it." (P. 9) Land himself, in "One Step Photography," an essay he contributed to *The Photographic Journal* in January of 1950, presented his imagistic credo thus: "By making it possible for the photographer to observe his work and his subject matter simultaneously, and by removing the manipulative barriers between the photographer and the photograph . . . the photographer by definition need think of the art in the taking and not in making photographs." (Cited in Olshaker, pp. 56-57.) We might extract from this some potent and hardly neutral beliefs inherent in the Polaroid systems: that the meditative relationship to materials of the photographer-as-printmaker is a "barrier"; that the emphasis in photography should be on "taking" rather than "making; that process is to be truncated, production accelerated; that the "what" of one's subject matter is more important than the "how" of one's representation.

3. Gibson, Ralph, ed. (New York: Lustrum Press, 1979).

4. *Loc. cit.*, pp. 9-20.

5. "Photography Re-invented," *Exposure,* Volume 17, no. 4, p. 12.

6. Olshaker, p. 6.

Photography Criticism: A State-of-the-Craft Report

This is the complete text of a lecture delivered at the Photographers Forum sympo-
sium, "Contemporary Trends in Photographic Criticism," held at the New School
for Social Research, New York, N.Y., May 18, 1979.

1. This was the second of three such conferences that I organized between
April of 1976 and December of 1977. The assessment referred to here, "The Sec-
ond Conference on Photographic Criticism: Summing Up," appeared in a special
supplement to *Afterimage* that served as a partial proceedings of that event (Vol. 5,
no. 3, September 1977). See also my essay "Two Conferences on Photographic
Criticism: A Report and A Proposal," *Afterimage*, Vol. 4, no. 5, November 1976.
Several papers from the third conference in this series were published in *Camera
Lucida*, Vol. 1, no. 1, Fall 1979.

Memoirs of a Circuit Rider

1. Following the advice of his guru, Misani subsequently left photography to
open a bakery. (I invent nothing; I only report.) *Print Letter* was absorbed into the
magazine *European Photography*.

2. The text of my presentation was subsequently published — in German only
— in the anthology *Zusammenfassung von Vortragen der Sammlung Fotografis
von 1979-1980* (Wien, Austria: Staatliches Länderbank, 1981). Extracts were pub-
lished, in both English and German, in *Print Letter* No. 28 (Vol. 5, no. 4), July/
August 1980.

3. Flüsser's subsequently published treatise, *Towards a Philosophy of Pho-
tography* (Göttingen, West Germany: European Photography, 1984), is evidence
that I underestimated him — or that much of his substance was lost in the im-
promptu translation. It also convinces me that he is safe from accusations of theo-
retical insufficiency.

4. Willmann and a group of colleagues have been publishing this handsome,
useful journal, *Camera Austria*, ever since.

Silverplating the Dandelion: The Canonization of Father Flye's Snapshots

1. "[*On Photography*] *is not about photography!* [Emphasis in the original.]
. . . Now you've got me. I said it, and I didn't mean to say it. It's not about photog-
raphy, it's about the consumer society, it's about advanced industrial society. I
finally make that clear in the last essay. It's about photography as the exemplary
activity of this society. I don't want to say it's not about photography, but it's true,
and I guess this is the interview where that will finally come out. It isn't, it's about
photography as this model activity which has everything that's brilliant and inge-
nious and poetic and pleasureful in the society, and also everything that is destruc-
tive and polluting and manipulative in the society. It's not, as some people have
already said, against photography, it's not an attack on photography. . . .
[Photography's] been one of the great sources of pleasure in my life, and it seemed
to me obvious that that was the origin of the book. It's about what the implications
of photography are. I don't want to be a photography critic. I'm not a photography
critic. I don't know how to be one." These statements appear in Victor Bockris's
interview, "Susan Sontag: The Dark Lady of Pop Philosophy," *High Times*, March
1978, p. 36.

2. *Through the Eyes of a Teacher: Photographs by Father James Harold Flye*, edited by Donald Dietz and David Herwaldt; Foreword by Robert Coles (N.P.: Boston, 1980).

3. The exhibit toured for two years through the South.

Slim Pickings in Hog Heaven: Garry Winogrand's *Stock Photographs*

1. Winogrand, Garry, *Stock Photographs: The Fort Worth Fat Stock Show and Rodeo* (Austin: University of Texas Press, 1980).

2. Brand, Jonathan, "[Critic's Choice:] The Most Sophisticated Seeing That Ever Came Out Of A Zoo," *Popular Photography*, Vol. 63, no. 6, December 1968, p. 139.

Photography at MoMA: A Brief History

1. "On the Subject of John Szarkowski," *Picture*, No. 8, 1978. Reprinted in *Light Readings: A Photography Critic's Writings, 1968-1978*, second edition, revised and expanded (Albuquerque: University of New Mexico Press, forthcoming).

2. Paul Hill and Thomas Cooper, *Dialogue with Photography* (New York: Farrar, Straus, Giroux, 1979), p. 390.

3. "Monkeys Make the Problem More Difficult," in *The Camera Viewed*, edited by Peninah Petruck (New York: E.P. Dutton, 1979), Vol. II, p. 125. Ansel Adams, on the other hand, told Georgia O'Keeffe he thought the book was "atrocious," and wrote to Weston that what he saw as its leftist bias "gave me a hernia," according to Russell Lynes.

4. See the essay "Making History," elsewhere in this volume.

5. See Coleman, "The 'Useful' Photographs of Edward Steichen," *Photoshow*, No. 2, 1980.

6. *Dialogue with Photography*, pp. 391-92.

7. Quoted in Russell Lynes's delightfully irreverent "unauthorized biography," *Good Old Modern: An Intimate Portrait of the Museum of Modern Art* (New York: Atheneum, 1973), p. 259. Lynes, who provides a juicily detailed account of the whole affair, paints Steichen's role as that of a self-serving, power-hungry ogre.

8. This exhibit also marked the beginning of Steichen's long-term collaboration with Grace Mayer, who subsequently joined his staff as Assistant Director, helping especially to organize the rapidly growing but increasingly ramshackle collection.

9. John Szarkowski acknowledges that there has been "a double standard in the photography collection, a double standard of formality in terms of acquiring work. So much has been inexpensive, ephemeral, and gifts from photographers." (Lynes, *op. cit.*, p. 328.)

10. The 1977 William Eggleston show, Szarkowski's first sponsorship of a photographer working in color, was a newsworthy anomaly in this regard.

11. "Open Letter," *loc. cit.*

12. Mozley, "A Gathering of Friends," *Aperture*, no. 79, 1977, p. 3.

13. Cauman, Samuel, *The Living Museum: Experiences of an Art Historian and Museum Director — Alexander Dorner* (New York: New York University Press, 1958), p. 8

Making History

1. Chahroudi, Martha, "Contemporary Bias and the Time-Displaced Photograph," *Afterimage,* Vol. 5, nos. 1 and 2, May-June 1977, pp. 39-40.

2. This finally appeared as Volume 21, no. 4 of *Exposure,* the journal of the Society for Photographic Education, in the winter of 1983.

3. New York: Farrar/Straus/Giroux, 1979.

4. *Ibid.,* variously, pp. 162-63, 210.

5. The distinction, hardly insignificant, was summed up well by Richard Trench, writing circa 1857 on the role of the lexicographer: ". . . [I]t is no task of the maker of [a dictionary] to select the good works of a language . . . [since] the business which he has undertaken is to collect all the words, whether good or bad, whether they do or do not commend themselves to his judgment. . . . He is an historian of it, not a critic." He is quoted in Sledd and Ebbitt, *Dictionaries and THAT Dictionary* (Glenview, Illinois: Scott Foresman and Co., 1962), pp. 36-39. For more on the matter of William Mortensen, see my essay "Disappearing Act," *Camera Arts,* January/February 1987. An expanded and revised version of this essay will appear in my forthcoming book *Depth of Field.*

6. *Loc. cit.,* pp. 407-08.

7. Schulberg, Budd, "Why Write It When You Can't Sell it to the Pictures?" *The Saturday Review,* Vol. 38, no. 36, September 3, 1955, p. 6.

8. Newhall completed the revisions of his work, which he published in 1982, dying several years later. Gernsheim published several sections of his revision as separate volumes, and passed away this year, 1995. This essay's appearance here I dedicate to their memories.

Some Notes on the Photography Book

Portions of this essay first appeared in my Introduction to a facsimile reprint of *Land Of The Free,* by Archibald MacLeish (New York: Da Capo Press, 1977), one volume in a group of reprint editions for which I served as Series Advisor. Some other passages are paraphrased from an interview with me published in Tom Dugan's *Photography Between Covers: Interviews with Photo-Bookmakers* (Rochester, NY: Light Impressions, 1979), pp. 197-208.

1. For an examination of the specific issues implicit in the Morris trilogy, see the 1976 essay "Novel Pictures: The Photo Fiction of Wright Morris," in my book *Light Readings.*

2. See my Introduction to the reprint edition, cited above.

3. From "Lee Friedlander," an interview with Sue Allison, published in *American Photographer,* Vol. 12, no. 3, March 1984, p. 59.

Color Photography: The Vernacular Tradition

1. Holme, Charles, ed., *Colour Photography and Other Recent Developments of the Art of the Camera* (London/Paris/New York: The Studio, 1908), p. 10.

Is Criticism of Color Photography Possible?

This is a slightly-amended version of an address presented at the International Center of Photography's "Color Symposium," held on March 22, 1980 in New York City.

1. Lüscher, Max, *The Lüscher Color Test* (New York: Washington Square Press, 1969).

The Autobiographical Mode in Photography

Though originally conceived and drafted as a single extended essay, this survey was published in two parts in *Camera 35*. It appears here in its intended form for the first time.

1. Eisenhower, Julie Nixon, Introduction to *Eye On Nixon* (New York: Hawthorn Books, 1972), pp. 5-8.

2. Friedlander, Lee, *Self Portrait* (New City, NY: Haywire Press, 1970, n. p.).

3. *Samaras Album* (New York: Whitney Museum of Art/Pace Editions, 1971).

4. The volume of work encompassed by this mode has expanded enormously since this was first written. Particular works and entire *oeuvres* by such as Cindy Sherman, Gilbert and George, Sol LeWitt, Gaylord Herron, Larry Clark, Aneta Sperber, Gerard Malanga, plus literally dozens of others, would have to be included in an updated version. Any comprehensive survey of the form has necessarily become a book-length project in itself, beyond the scope of this modest outline. It is my immodest hope that the central structures and issues I have identified here will provoke or prove useful in such an inquiry.

The Photographic Still Life: A Tradition Outgrowing Itself

1. Koningsberger, Hans, *The World of Vermeer* (New York: Time, Inc., 1967), p. 101.

2. *Ibid., loc. cit.*

3. Given the relative slowness of painting as an imaging technology (at least prior to the 1950s), and the lack of sophisticated refrigeration and preservation techniques in the centuries preceding ours, there may have been a more pungent motive for this isolation; apocryphal tales of studio tables piled with carefully arranged and rapidly deliquescing animal and vegetable matter are recorded in the annals of western art.

4. It has been argued by Eugenia Parry Janis, in her introduction to *One of a Kind: Recent Polaroid Color Photography* (Boston: David R. Godine, 1979), that the reason so much still-life imagery has been produced utilizing Polaroid materials is that the Polaroid technology is uniquely suited to the still-life impulse. A more likely explanation can be found in the fact that Polaroid, unique among manufacturers of photographic equipment and supplies, has been extremely generous in loans and gifts of its products to creative photographers, as well as in the purchase (or acquisition by trade) of those photographers' results for Polaroid's several collections. Polaroid not only displays those results in its own headquarters, but sponsors and even helps to finance exhibition and publication of these images and others by those whom the company generically labels "Polaroid photographers." Certainly the still life is as admirably suited for presentation in corporate boardrooms or elsewhere under a corporate aegis as it is for the dining rooms of the bourgeoisie. For more on this specific subject, see the essay, "Polaroid: Toward a Dangerous Future," elsewhere in this volume.

5. Scott, Dixon, "Colour Photography," in *Colour Photography and Other*

Recent Developments of the Art of the Camera, edited by Charles Holme (London/ Paris/New York: The Studio, 1908), p. 8.

6. *Ibid.,* pp. 7-9.

7. Kostelanetz, Richard, "An ABC of Contemporary Reading," *Precisely: One,* November 1977, p. 32.

Hybridization: A Photographic Tradition

This essay began its life as a commissioned introduction to the catalogue for the traveling exhibition "Photofusion," organized under the auspices of the Department of Exhibitions, Pratt Institute, New York. In that form it was first published in January of 1981. Considerably revised, it subsequently appeared in *ARTnews* (Vol. 80, no. 4, April 1981 — under the unfortunate title, "What Happens When You Cross a Photograph With a Rock?"); *Camera 35* (Vol. 26, no. 4, April 1981); and *Photo-Communique* (Vol. 3, no. 3, Fall 1981). The present expanded version is previously unpublished.

1. For an excellent analysis of the historical roots of this resistance to mixed-media work on the part of historians and critics, see Patricia D. Leighten's excellent essay, "Critical Attitudes toward Overtly Manipulated Photography in the 20th Century," published in two parts in *Art Journal,* Vol. XXXVII, no. 2, Winter 1977, pp. 133-138, and Vol. XXXVII, no. 4, Summer 1978, pp. 313-321.

2. The problem may in fact go much deeper. The word *hybrid* comes from the Latin *hybrida,* which in turn is derived from a Greek word meaning *insult* and/or *outrage.* Here we have an etymology that reveals a basic epistemological bias of western culture.

3. Newhall corrected this bias in the final edition of his work, published in 1982.

4. Bunnell's rationale for "Photography into Sculpture" can be found in *Arts in Virginia,* Vol. 11, no. 3, Spring 1971, pp. 18-24. It is reprinted in his book, *Degrees of Guidance: Essays on Twentieth-Century American Photography* (New York: Cambridge University Press, 1993), along with a version of his curator's text for "Photography as Printmaking."

Collaborations Through the Lens: Photography and Performance Art

This essay began its life as a commissioned contribution to the monograph *DOC•U•MEN•TIA* (San Francisco, CA: Last Gasp, 1987), a collection of photographs of performance art by f-stop Fitzgerald.

1. "Photography and Performance Art," in *Photography as Performance: Message Through Object & Picture,* exhibition catalogue (London: The Photographers' Gallery, 1986), p. 43.

2. Kuhn, Thomas, *The Structure of Scientific Revolutions* (Chicago: University of Chicago Press, 1970), p. 16.

3. David Briers articulates this quaint belief as follows: "Good photographs of Performance Art capture its momentary, 'fugitive' aspect, and have the quality of crime reportage photography, or of photographs taken during seances. . . . Joseph Beuys, well able to secure crisp in-focus documentation of his performances if he wanted, authorised much blurred, bleached out, or apparently damaged photographic

evidence of them . . ." *Op. cit.*, pp. 44-45. My own early response to what I see as the counterproductive *naïveté* of this notion can be found in my 1971 essay "Photography and Conceptual Art," reprinted in *Light Readings: A Photography Critic's Writings, 1968-1978* (New York: Oxford University Press, 1979), pp. 72-73.

4. Of his work with the Interplayers, one segment of which became the sequence of images interpreting their production of Robinson Jeffers's *Dear Judas*, White wrote in 1953, "Dorothea [Lange] tells me that the 'found as is' [i.e., a 'documentary' or production-stills approach] reduces theater to illusion and worse. . . . I take as my real purpose to evoke in these actors the meaning of their roles more powerfully than they have yet felt it . . . if I can. I must work so as to let them see and feel that I am the living mirror of their part." A decade earlier, during his first experiments, he observed, "The close-up camera in a mysterious way penetrates the walls of the theater. Acting to a camera extends audiences in time and explodes theater in space." These quotes are from his monograph, *Mirrors Messages Manifestations* (Millerton, NY: *Aperture*, 1969; second edition 1982), pp. 84-93.

5. "[L]ike a wedding photographer, the photographer of Performance Art is usually seeking to represent the occasion and in its own terms and 'at its best,' more often than not having been commissioned by the artist or the venue so to do." Briers, *Op. cit.*, p. 43.

6. "Performing for the Camera: A Discussion," in *Photography as Performance*, p. 15.

Candy Camera, Censored Cheesecake

This essay had several incarnations, periodically revised as the lawsuit in Iowa progressed. It first appeared as "The Candy is Dandy but Where's My Cheesecake?" in *Lens' On Campus*, Vol. 6, no. 1, (Feb. 1984). Under its present title, it made its way to *Penthouse Letters*, Vol. 3, no. 11, (Nov. 1985), and the *Center Quarterly* #41, Vol. 11, no. 1 (1989). This final version appeared in *ETC.: A Review of General Semantics*, Vol. 47, no. 2, Summer 1990.

1. In *DaVinci's Bicycle: Ten Stories by Guy Davenport* (Baltimore and London: Johns Hopkins University Press, 1979), pp. 121-130.

"Porn," Polls and Polemics: The State of Research on the Social Consequences of Sexually Explicit Material

1. Blakeley, Mary K., "Is One Woman's Sexuality Another Woman's Pornography?" *Ms.*, Vol. 13, no. 10, April 1985, pp. 46-7.

2. Goodman, Walter, "Pornography: Esthetics to Censorship Debated," *New York Times*, August 13, 1984, Section C, p. 1. (Report of a symposium, subsequently published in *Harper's*, Nov. 1984.)

3. Faust, Beatrice, *Women, Sex, and Pornography* (New York: Macmillan, 1981), p. 20.

4. Michelson, P., *The Aesthetics of Pornography* (New York: Herder & Herder, 1971), p. 5.

5. Malamuth, Neil and Victoria Billings, "Why Pornography? Models of Functions and Effects," *Journal of Communication*, Summer 1984, p. 118.

6. Lawrence, D. H., "Pornography and Obscenity," in *Sex, Literature and Censorship* (New York: Compass Books, 1959), p. 9.

7. Kronhausen, Drs. Eberhard and Phyllis, *Pornography and the Law: The Psychology of Erotic Realism and "Hard Core" Pornography* (New York: Ballantine Books, 1959), p. 18.

8. Kaplan, Abraham, "Obscenity as an Esthetic Category," in Rist, Ray C., *The Pornography Controversy: Changing Moral Standards in American Life* (New Brunswick, NJ: Transaction Books, 1975), p. 22. Reprint of a 1955 essay.

9. Peckham, Morse, *Art and Pornography* (New York: Basic Books, 1969), p. 37 ff.

10. *Op. cit.*, p. 118.

11. E.g., the Meese Commission-sponsored work of Dr. Judith Reisman. See report by Larry Bush, "Blinding Us with Science: The Antiporn Activist as Reaganite," *Village Voice*, March 20, 1984, p. 19.

12. Malamuth, Neil and Edward Donnerstein, *Pornography and Sexual Aggression* (Orlando, FL: Academic Press, 1984).

13. Dorothy Seeman, founding editor of the magazine *L'Officiel USA*.

14. Kuhn, Thomas S., *The Structure of Scientific Revolutions* (Chicago: University of Chicago Press, 1970), pp. 10-22.

15. *Ibid.*, p. 22.

16. *Ibid.*, p. 10.

17. *Ibid.*, p. 15.

18. Postman, Neil, "Social Science as Theology," *ETC.: A Review of General Semantics*, Vol. 41, no. 1, Spring 1984, pp. 26-32.

19. *Ibid.*, p. 32. The accuracy of Postman's description of the underlying motives of social research is demonstrated by the following passage:

> Forsaking any notion of maintaining a "value-free" posture in the face of the politicization of one's research, the social scientist can assume an advocacy role in creating dialogue and political discussion in the public arena of this society. . . . *Put positively, the social scientist must become political in a manner not typical of current politicians. By so doing, the social scientist engaged in policy research unifies both his methodological approach to causal analysis and his political response to publics.* (Emphasis in the original.) *For the manner in which the social scientist assigns cause to certain actors or events ultimately exhibits a political point of view.* (Emphasis mine.)

This quote is from Ray C. Rist's "Polity, Politics and Social Research: A Study in the Relationship of Federal Commissions and Social Science," included in Rist, ed., *The Pornography Controversy: Changing Moral Standards in American Life* (New Brunswick, NJ: Transaction Books, 1975), p. 265. In addition to proving Postman's point, this bizarre statement exemplifies the corruptive intellectual contortions necessary to reconcile the impulses of the moral theologist with the posture of the scientist.

20. Pally, Marcia, "Ban Sexism, Not Pornography," *The Nation*, Vol. 240, no. 25, June 19, 1985, p. 796.

21. Duggan, Lisa, "Censorship in the Name of Feminism," *Village Voice*, Vol. 29, no. 42, Oct. 16, 1984, p. 12.

22. *Ibid.*, p. 42. See also Blakeley, Mary K., *op. cit.*, *loc. cit.*

23. Duggan, *op. cit.*, p. 12; Pally, *op. cit.*, pp. 795-796; Blakeley, *op. cit.*, p. 44.

24. For an acerb dissection of the uselessness, as *science*, of social research on this subject, see James Q. Wilson, "Violence, Pornography and Social Science," in Rist, *op. cit.*, pp. 225-243. Notably, despite his critique, Wilson adheres to the usage "social science."

25. Burgess, Ann Wolbert, with Marieanne Lindeqvist Clark, *Child Pornography and Sex Rings* (Lexington, MA: Lexington Books, 1984.) See also Rush, Florence, *The Best Kept Secret: Sexual Abuse of Children* (New York: McGraw-Hill).

26. *The Report of the Commission on Obscenity and Pornography* (New York: Random House, 1970), pp. 24-25.

27. See, for example, Molly Colin, "Women Tuning in To Porn," *Mother Jones*, January 1985; and L. Gould's "Pornography for Women" in Gagnon, John H., ed., *Human Sexuality in Today's World* (Boston: Little, Brown & Co, 1977). Examples of woman-produced erotica can be found in the anthology *Powers of Desire: The Politics of Sexuality*, edited by Ann Snitow, Christine Stansell, and Sharon Thompson (New York: Monthly Review Press, 1983); *Pleasures*, edited by Lonnie Barbach (New York: Doubleday, 1985); and *Pleasures: The Secret Garden of Sexual Love Between Women*, edited by Odette (New York: Warner Books, 1978). Pauline Reage's *Story of O* and *Return to the Chateau* are well-known, as is Erica Jong's *Fanny*, an elaboration of John Cleland's story. At least one hard-core film company, Femme Productions, is woman-owned, its output woman-directed.

28. The production and consumption of male-produced material, of such female-produced and directed material as mentioned in note 14, and of magazines such as *Playgirl*, gives evidence to this effect. See also *Report of the Commission on Obscenity and Pornography*, p. 28, and Goldstein, Michael, and Harold S. Kant, *Pornography and Sexual Deviance* (Berkeley: University of California Press, 1973), pp. 21-24.

29. "The Mother of Kiddie Porn?" *Newsweek*, Vol. 103, no. 4, Jan. 23, 1984, p. 70, a report on the arrest of Catherine Wilson. Her conviction was reported in the *New York Times*, July 1, 1984, p. 14.

30. AP release, "Some think a naughty nudie makes a nice Christmas present," *Staten Island Advance*, Dec. 2, 1983.

31. *Gallery* magazine.

32. Goldstein & Kant, *op. cit.*, pp. 60-66; *The Report of the Commission on Obscenity and Pornography*, pp. 31-32.

33. Yaffe, Maurice, ed., introduction to *The Influence of Pornography on Behaviour* (London & New York: Academic Press, 1982), p. xiv.

34. Goldstein and Kant, *op. cit.*, p. 32: "The few existing studies on long term effects of exposure to pornography have focused on the response of sex offenders to erotic stimuli as adults. No really good studies exist that attempt to trace and relate early experiences with pornography to later sexual adjustment. . . . Such an investigation requires a longitudinal approach, best accomplished through an intensive interview technique. . . ."

35. Yaffe, *op. cit.*, p. 143. See also P. Gillan, "Therapeutic Uses of Obscenity," in R. Dhaven and D. Davies, eds., *Censorship and Obscenity* (Totowa, NJ: Rowman & Littlefield, 1978), and W. C. Wilson, "Can Pornography Contribute to the Prevention of Sexual Problems?" in C. B. Qualls, J. P. Wincze, and D. H. Barlow, eds., *The Prevention of Sexual Disorders: Issues and Approaches* (New York: Plenum Publishing Corp., 1978).

36. Yaffe, *op. cit.*, p. xiv. As he notes a few pages earlier (p. xii), "Pornography does not have only one set of consequences."

Consider also (though its source is not scholarly) the following autobiographical account from feminist Betty Dodson. Thinking her vagina was ugly, she was shown "split beaver" photos in sex magazines by her boyfriend. "By the time we had gone through several magazines together, I knew what women's genitals looked like. What a relief! In that one session, I discovered that I wasn't deformed or ugly. . . . [Y]ears of therapy hadn't made a dent in my body loathing. . . . Just thirty minutes of viewing pornography had made me 'cunt positive' and dramatically changed my life." Dodson then went on to create a set of photos of women's vaginas for a slide presentation at the 1973 N.O.W. Women's Sexuality Conference in New York City; it received "a long, loud, standing ovation." See Dodson, Betty, *Selflove and Orgasm* (New York: Betty Dodson, Publisher, 1983), pp. 34-41.

37. Malamuth and Billings, *op. cit.*, pp. 127-128.

The Arrival of the Explicit: Contemporary Erotic Photography
This essay was first published under the title "Erotica: The Arrival of the Explicit." It is ironically indicative of the current state of affairs that the editors of *Camera 35*, while eager to run the essay, felt unable to illustrate it with examples of most of the work to which the text refers, due to fear of loss of subscribers and distributors. Post-publication treatment of this issue of the magazine by its distributors, a number of whom refused to handle it (resulting in a significant loss of circulation), was evidence that these fears were amply justified.

1. Indeed, according to a recent *New York Times* report by Fred Hechinger ("Wave of Censors Hits the Schools," May 8, 1979) they're even trying to ban the dictionaries!

2. It should be noted that there is an enormous difference between American and European attitudes toward things sexual. An example: André Kertész recalls that when Beaumont Newhall was assembling the Museum of Modern Art's first historical survey of photography ("Photography 1839-1937"), he wanted to include several of Kertész's "Distortions" series — female nudes that Kertész had photographed reflected in a funhouse mirror. One of those Newhall wished to use — No. 172 in the recently-published book of these images — shows the model's pubic hair. Newhall told Kertész that he would only exhibit this image if Kertész would crop that part out — which would have meant cutting off half the image and converting it from a vertical to a horizontal! "With the sex in, it's pornographic; without it, it's art," Newhall told Kertész. Kertész refused; Newhall picked an alternate image.

3. This work was subjected, subsequently, to some bizarre legal/political machi-

nations in Baltimore, Maryland. What transpired was very much to the point of this essay, but is far too complex to summarize here. A detailed account, originally published in *The New York Times*, can be found in my book, *Light Readings*.

4. After one publisher committed to the project backed out for reasons of self-protection, Clark issued the book himself under his own imprint, in 1983.

5. For example, in the previously mentioned Bloomingdale's catalogue by Guy Bourdin, there is an image of a pajamaed young woman sailing horizontally through the air into the arms of her lover. In the picture, they are both beaming broadly. It is one of the most cheerful, wholesomely sexy pictures in the series. In the actual shooting session, however, this female model was flung bodily at the male model some four dozen times, and eventually passed out from the stress involved. One can hardly imagine a less erotic experience. . . .

6. The suit was finally won, years after the event. Baruch Kirschenbaum, one of the witnesses on the side of the artists, offered a rich, provocative speculation on the case and its implications to the 1983 National Conference of the Society for Photographic Education, under the auspices of the SPE's Ad Hoc Committee on Censorship & Freedom of Vision. The text of his presentation, titled "Private Parts," can be found in *Exposure*, Vol. 22, no. 3, Fall 1984.

7. Such a committee was eventually formed, in the spring of 1982, under the auspices of the Society for Photographic Education. It was called the Ad Hoc Committee on Censorship & Freedom of Vision. From the time of its formation until early 1985, I served as its chair. Since my resignation, the committee has been inoperative.

INDEX

Titles of artworks, names of plays, movies, and books are in italics; titles of exhibitions, articles and essays, and TV programs are quoted.

CREDITS

"Choice of Audience/Choice of Voice" was first published in *Exposure*, Vol. 18, no. 1, Winter 1980.

"Context and Control" was first published in *Photoshow*, Vol. 1, no. 1, March-April 1980, under the title "C."

"The Fox Talbots Were Iffy" was first published in *Camera 35*, Vol. 27, no. 3, March 1982. The "Postscript" is previously unpublished.

"Weegee as 'Printmaker': An Anomaly in the Marketplace" was first published in the *Center Quarterly*, Vol. 6, no. 1, Fall 1984. The accompanying "Biographical Note" was first published in *Art Express*, Vol. 1, no. 3, November-December 1981.

"Interesting Conflicts" was first published in *Lens' On Campus*, Vol. 8, no. 1, February 1986.

"On the Dole: Revamping Public Funding For The Arts" was first published in *Lens' On Campus*, Vol. 7, no. 6, November 1985, under the title "On the Dole." This version appeared in *A Critique of America*, November-December 1987.

"Damn the Neuroses! Full Speed Ahead! or, Thoughts on the Free-Lance Life" was first published in *Camera 35*, Vol. 26, no. 10, October 1981, under the title "Thoughts on the Freelance Life."

"Identity Crisis: The State of Photography Education Today" was first published in *The Photo Review*, Vol. 12, no. 2, Spring 1989. This version is previously unpublished.

"Polaroid: Toward A Dangerous Future" was first published in *Photoshow*, No. 3, July/August 1980.

"Photography Criticism: A State-of-the-Craft Report" was first published in *Camera Lucida: The Journal of Photographic Criticism*, Vol. 1, no. 1, Fall 1979, under the title "A State-of-the-Craft Report."

"The Hand with Five Fingers; or, Photography Made Uneasy" was first published in *Lens' On Campus*, Vol. 7, no. 4, September 1985, under the title "Photography Made Uneasy." This version appeared in *A Critique of America*, January/February 1988, under the title "The Five Fingers: Photography Made Easy."

"Memoirs of a Circuit Rider" was first published in *Camera 35*, Vol. 25, no. 11, November 1980.

"Silverplating the Dandelion: The Canonization of Father Flye's Snapshots" was first published in *VIEWS: A New England Journal of Photography*, Vol. 2, no. 2, Winter 1981.

"Slim Pickings in Hog Heaven: Garry Winogrand's *Stock Photographs*" was first

published in *Camera 35*, Vol. 26, no. 8, August 1981, under the title, "Slim Pickings in Hog Heaven."

"Photography at MoMA: A Brief History" was first published in *ARTnews*, Vol. 78, no. 8, October 1979, under the title "The Impact on Photography: 'No Other Institution Even Comes Close.'" The "Postscript" is previously unpublished.

"Making History" was first published in *Camera 35*, Vol. 24, no. 9, September 1979.

"Some Notes on the Photography Book" was first published in *Camera 35*, Vol. 26, no. 11, November 1981.

"Color Photography: The Vernacular Tradition" was first published in *The SoHo News*, May 21, 1980.

"Is Criticism of Color Photography Possible?" was first published in *Camera Lucida*, no. 5, 1982.

"The Autobiographical Mode in Photography" was first published in two parts in *Camera 35*, under the titles "Autobiography in Photography" (Vol. 19, no. 8, November 1975) and "Subjective Imagery" (Vol. 19, no. 9, December 1975).

"The Photographic Still Life: A Tradition Outgrowing Itself" was first published in *European Photography*, no. 14, April/May/June 1983, in both English and German. This version appeared in the *Journal of American Photography*, Vol. 2, no. 2, October 1984.

"Hybridization: A Photographic Tradition" was first published in *ARTnews*, Vol. 80, no. 4, April 1981, under the title "What Happens When You Cross a Photograph With a Rock?" This version is previously unpublished.

"Collaborations through the Lens: Photography and Performance Art" was first published in *The Photo Review*, Vol. 10, no. 4, Fall 1987.

"Candy Camera, Censored Cheesecake" was first published in *Lens' On Campus*, Vol. 6, no. 1, February 1984 under the title "The Candy is Dandy but Where's My Cheesecake?" This version appeared in *ETC.: A Review of General Semantics*, Vol. 47, no. 2, Summer 1990.

"'Porn,' Polls and Polemics: The State of Research on the Social Consequences of Sexually Explicit Material" was first published in two parts in *Women Artists News*, Vol. 11, no. 5, Winter 1986/87 and Vol. 12, no. 1, February-March 1987.

"The Arrival of the Explicit: Contemporary Erotic Photography" was first published in *Camera 35*, Vol. 24, no. 9, September 1979, under the title "Erotica (The Arrival of the Explicit)."

"Local Community Standards Strike Again" was first published in *Camera 35*, Vol. 26, no. 5, May 1981.

LIST OF PHOTOGRAPHS

A. D. Coleman; photo by f.stop Fitzgerald

ABOUT THE AUTHOR

Since 1967, A. D. Coleman's influential essays and critical articles on photography, art, mass media, and other subjects have appeared in a wide variety of publications both in the United States and abroad. He is the photography critic for the *New York Observer*, and contributes regularly to *Cover*, *Photo Metro*, *Photography in New York*, *Luna Cornea* (Mexico), *European Photography* (Germany), and *Juliet Art Magazine* (Italy). He publishes his own newsletter, *C: The Speed of Light*, on the World Wide Web, at http://plaza.interport.net/byocafe.

Coleman's previous books include *The Grotesque in Photography* (1977); *Light Readings: A Photography Critic's Writings, 1968-1978* (1979); *Looking at Photographs; Animals* (1995), a book for children; and *Critical Focus: Photography in the International Image Community* (1995). He has received an Art Critic's Fellowship from the National Endowment for the Arts, a Reva and David Logan Grant in Support of New Writing in Photography, and an Erna and Victor Hasselblad Foundation Grant for research toward a cultural history of the lens from 1550-1840. In 1993 he was a Guest Scholar at the J. Paul Getty Museum, and in 1994 resided in Sweden as a Fulbright Senior Scholar.

typographic design: Barbara Bergeron
cover design: MOG